Acknowledgements

*This book is dedicated to Daisy and Hollie Pooke,
and to Rachel, Sam and Hannah Whitham.*

QUOTATIONS

p. xxii Julian Stallabrass, *High Art Lite: British Art in the 1990s*,
Verso Books, 1999 **p. 2** Marcel Duchamp, 'The Creative Act'
(1957), in Kristine Stiles and Peter Selz (eds), *Theories and
Documents of Contemporary Art: A Sourcebook of Artists'
Writings*, University of California Press, 1996 **p. 20** Michael Fried,
'Three American Painters' (1965), in Charles Harrison and
Paul Wood (eds), *Art in Theory, 1900–2000: An Anthology of
Changing Ideas*, Blackwell, 2003 **p. 21** Comte de Saint-Simon,
'The Artist, the Savant and the Industrialist' (1825), in Charles
Harrison and Paul Wood, with Jason Gaiger (eds), *Art in Theory,
1815–1900: An Anthology of Changing Ideas*, Blackwell, 1998
p. 25 Clement Greenberg, 'Modernist Painting' (1960), in Charles
Harrison and Paul Wood (eds), *Art in Theory, 1900–2000: An
Anthology of Changing Ideas*, Blackwell, 2003 **p. 28** Clement
Greenberg, 'Avant-garde and Kitsch' (1939), in Charles Harrison
and Paul Wood (eds), *Art in Theory, 1900–2000: An Anthology
of Changing Ideas*, Blackwell, 2003 **p. 31** Claes Oldenburg,
'Documents from The Store' (1961), in Charles Harrison and
Paul Wood (eds), *Art in Theory, 1900–2000: An Anthology of
Changing Ideas*, Blackwell, 2003 **p. 35** Robert Morris, 'Notes on
Sculpture 1–3' (1966–67), in Charles Harrison and Paul Wood
(eds), *Art in Theory, 1900–2000: An Anthology of Changing
Ideas*, Blackwell, 2003 **p. 36** Rosalind Krauss, 'Sculpture in the
Expanded Field', in *The Originality of the Avant-garde and
Other Modernist Myths*, MIT Press, 1986 **p. 37** Sandy Nairne,
State of the Art: Ideas and Images in the 1980s, Chatto and
Windus and Channel Four, 1987 **p. 38** Hannah Higgins,
Fluxus Experience, University of California Press, 2002

p. 38 Richard Huelsenbeck, 'En Avant Dada' (1920), in Charles
Harrison and Paul Wood (eds), *Art in Theory, 1900–2000:
An Anthology of Changing Ideas*, Blackwell, 2003 p. 40
Hal Foster, 'Subversive Signs' (1985), in Charles Harrison and
Paul Wood (eds), *Art in Theory, 1900–2000: An Anthology
of Changing Ideas*, Blackwell, 2003 p. 83 Jaime Stapleton,
Text Commentary on Juan Bolivar, New British Painting,
Cornerhouse Publications, 2004 p. 88 'De Stijl Manifesto 1'
(1918), in Charles Harrison and Paul Wood (eds), *Art in Theory,
1900–2000: An Anthology of Changing Ideas*, Blackwell, 2003
p. 91 http:/www.thisistomorrow2.com p. 94 Louisa Buck, *Moving
Targets: A User's Guide to British Art Now*, Tate Publishing, 1998
p. 94 Sarah Kent, *Shark Infested Waters: The Saatchi Collection
of British Art in the 90s*, Philip Wilson Publishers Ltd, 1994
p. 95 Angus Pryor interview with Grant Pooke, July 2008 p. 97
ecva.org/exhibition/Gifts2009/Dolamore.htm p. 99 Rosalind
Krauss, 'Sculpture in the Expanded Field', in *The Originality of the
Avant-garde and Other Modernist Myths*, MIT Press, 1986 p. 123
www.tate.org.uk (Originally published as Jean Wainwright, 'An
Interview with Mark Wallinger', *Audio Arts Magazine*, vol. 19,
nos 3 & 4, 2001) p. 129 Bertolt Brecht, 'Popularity and Realism'
(1938), in Charles Harrison and Paul Wood (eds), *Art in Theory,
1900–2000: An Anthology of Changing Ideas*, Blackwell, 2003
p. 130 www.tonidove.com p. 132 Hal Foster, 'Subversive Signs'
(1985), in Charles Harrison and Paul Wood (eds), *Art in Theory,
1900–2000: An Anthology of Changing Ideas*, Blackwell, 2003
pp. 133 and 134 http://www.tract-liveart.co.uk p. 138 Carolee
Schneeman, *Imagining Her Erotics. Essays, Interviews, Projects*,
MIT Press, 2002 p. 139 Jill O'Bryan, *Carnal Art: Orlan's Refacing*,
University of Minnesota Press, 2005 p. 142 www.britishcouncil.org
p. 146 Helen Luckett, *Walking in My Mind: Exhibition Guide*,
Hayward Gallery, 2009 p. 148 Claire Bishop, *Installation Art:
A Critical History*, Tate Publishing, 2005 p. 150 Richard Wilson,
The Eye, 2001 p. 152 Peter Bürger, *Theory of the Avant-garde*,
University of Minnesota Press, 1984 p. 156 James Hall, 'Maurizio
Cattelan: Tragic Pantomime', in *Apocalypse: Beauty and Horror
in Contemporary Art*, Royal Academy of Arts, 2000 p. 157
Julian Stallabrass, *High Art Lite: British Art in the 1990s*,

Verso Books, 1999 **pp. 158–159** Robert Morris, 'Notes on
Sculpture 1–3' (1966–67), in Charles Harrison and Paul Wood (eds),
Art in Theory, 1900–2000: An Anthology of Changing Ideas,
Blackwell, 2003; Michael Fried. 'Art and Objecthood' (1967), in
Charles Harrison and Paul Wood (eds), *Art in Theory, 1900–2000:
An Anthology of Changing Ideas*, Blackwell, 2003 **p. 160** Maurice
Merleau-Ponty, *The Phenomenology of Perception*, Routledge,
1998 **p. 161** Claire Bishop, *Installation Art: A Critical History*,
Tate Publishing, 2005 **pp. 162 and 163** Nicolas Bourriaud,
Relational Aesthetics, Les Presses du Réel, 2002 **p. 167** Banksy,
Wall and Piece, Century, 2006 **p. 172** Michael Heizer *et al.*,
Michael Heizer. *Sculpture in Reverse*, Museum of Contemporary
Art, Los Angeles, 1984 **p. 173** J. Dickie, *The Independent on
Sunday*, 20 October 2002 **p. 175** Lucy Bannerman, *The Times*,
25 October 2007 **p. 177** James Hall, *Hall's Dictionary of
Signs & Symbols*, 2nd rev. edn, John Murray, 1996 **p. 185** John
Berger, *Ways of Seeing*, Penguin Books, 1977 rev. edn **p. 191**
http://www.culturebase.net **p. 192** Sophie Phoca and Rebecca
Wright, *Introducing Postfeminism*, Icon Books, 1999 **p. 195**
http://www.saatchi gallery.co.uk/artists/jenny_saville.htm **p. 198**
Mignon Nixon and Cindy Nemser Eva Hesse *(October Files)*, MIT
Press, 2002 **p. 200** *Paul Celan: Poems*, trans. Michael Hamburger,
Carcanet New Press, 1980 **p. 205** *Newsnight Review*, BBC2,
15 December 2006; *Front Row*, BBC Radio 4, 14 December 2006
p. 205 Jonathan Jones, an interview with Jake and Dinos
Chapman, *The Guardian*, 31 March 2003 **p. 207** Banksy, *Wall
and Piece*, Century, 2006 **p. 209** Okwui Enwezor, 'The Black
Box' (2002), in Jason Gaiger and Paul Wood (eds), *Art of the
Twentieth Century: A Reader*, Yale University Press, 2003 **p. 216**
http://www.magazines.documenta.de/ geschichteo. html?&L=1
p. 221 Paul Arendt, 'Orgies and battles promised at Paul McCarthy's
pirate theme park', *The Guardian*, 27 September 2005 **p. 223**
www.aleksandramir.info **p. 227** Robert Ayers, 'Jeff Koons', *Artinfo*,
25 April 2008 (www.artinfo.com) **p. 227** Robert Hughes, 'That's
Showbusiness', *The Guardian*, 30 June 2004 **p. 232** Andy Warhol,
The Philosophy of Andy Warhol (From A to B and Back Again),
Harcourt Brace Jovanovich, 1975. The quote has been used in
numerous sources, including http://www.quotationspage.com/quote

p. 241 Clement Greenberg, 'Avant-garde and Kitsch' (1939), in Charles Harrison and Paul Wood (eds), *Art in Theory, 1900–2000: An Anthology of Changing Ideas*, Blackwell, 2003 p. 243 Jonathan Glancey, 'Magic to Stir Men's Blood', *The Guardian* 12 December 2002; Nick Hackworth, *Times Review*, 25 June 2005 p. 244 Sean O'Hagan, 'Bono and Hirst Head Art Sale to Fight Aids', *The Observer*, 3 February 2008 p. 246 http://www.magazines. documenta.de/geschichteo. html?&L=1; Tom Horan, 'The Olympics of the Art World', *Daily Telegraph*, 28 June 2004 p. 248 www.tracey-emin.co.uk p. 251 Okwui Enwezor, 'The Black Box', in *Documenta 11 Exhibition Catalogue*, Hatje Kantz, 2002.

COLOUR PLATES

Plate 1 Theo van Doesburg, *Counter Composition XIII, 1925–1926.* Oil on canvas: 49.9 × 50 cm (19.65 × 19.68 in.). Peggy Guggenheim Collection, Venice © AKG Images.

Plate 2 Richard Hamilton, John McHale, John Voelcker, Group 2, *This is Tomorrow*, 1956 (1991 reconstruction). Wood, paint, fibreglass, collage, foam rubber, microphone, film projectors: approx. 4 m (13.12 ft) at highest point. Hood Museum of Art, Dartmouth College, Hanover, New Hampshire, USA. Photo: Graham Whitham.

Plate 3 Matthew Barney, *Cremaster 1, 1995.* Production still © 1995 Matthew Barney. Photo: Michael James O'Brien. Courtesy: Gladstone Gallery. C-print in self-lubricating plastic frame: 111 × 136.5 × 2.5 cm (43.7 × 53.7 × 1 in.) each. Edition of 6.

Plate 4 Romuald Hazoumé, *Dream*, 2007. 421 plastic oil containers, glass bottles, corks, cords, photograph mounted on board: Installation area 1660 × 1200 cm (54.46 × 39.37 ft), photograph 250 × 1250 cm (8.2 × 41 ft), boat 177 × 1372 × 128 cm (5.8 × 45 × 4.2 ft) Kassel Documenta 12, Germany. Photo: Graham Whitham © ADAGP, Paris and DACS, London, 2010.

Plate 5 Sanja Iveković, *Poppy Field*, 2007. Field of Papaver rhoeas and Papaver somniferum, 6590 qm, loudspeakers, revolutionary

songs, performed by Le Zbor (CRO) and RAWA (AFG), Friedrichsplatz, Kassel. With support from the Gender Equality of the Government of the Republic of Croatia. Co-produced by Thyssen-Bornemisza Art Contemporary for Documenta 12, Kassel Friedrichsplatz, Kassel, Germany. Photo: Graham Whitham.

Plate 6 Marc Quinn, *Self*, 2001. Blood (artist's), stainless steel, perspex, refrigeration equipment: 205 × 65 × 65 cm (80.11/16 × 25.9/16 × 25.9/16 in.) © Marc Quinn. Photo: Stephen White. Courtesy: Jay Jopling/White Cube (London).

Plate 7 Maurizio Cattelan, *La Nona Ora*, 1999. Mixed Media: Painted wax, fibreglass resin, clothes, stainless steel, volcanic stone. Dimension: Lifesize. Installation: Kunsthalle Basel 1999. Courtesy: Maurizio Cattelan Archive. Photo: Attilio Maranzano.

Plate 8 Anselm Kiefer, *Your Golden Hair, Margarete*, 1981. Oil, emulsion, and straw on canvas: 130 × 170 cm (51.2 × 66.9 in.). Collection Sanders, Amsterdam © Anselm Kiefer. Courtesy: Gagosian Gallery.

Plate 9 Damien Hirst, *Mother and Child Divided*, 1993. Steel, GRP composites, glass, silicone sealants, cow, calf, formaldehyde solution: dimensions variable. © Tate, London, 2010 and © Damien Hirst. All Rights Reserved, DACS 2010.

Plate 10 Cindy Sherman, *Untitled (No. 224)*, 1990. Colour photograph: 111.8 × 137.2 cm (48 × 38 in.). Courtesy of the Artist and Metro Pictures.

Plate 11 Peter Doig, *The Architect's Home in the Ravine*, 1991. Oil on canvas: 200 × 275 cm (78.7 × 108.3 in.). Courtesy: Victoria Miro Gallery and the Saatchi Gallery, London © Peter Doig.

Plate 12 Gary Hume, *Hermaphrodite Polar Bear*, 2003. Glass on aluminium: 198 × 150 cm (77.15/16 × 59.1/16 in.) © Gary Hume. Photo: Stephen White. Courtesy: Jay Jopling/White Cube (London).

Plate 13 Richard Wilson, *20:50*, 1987. Used sump oil, steel. Dimensions variable. Courtesy: Saatchi Gallery, London. © Richard Wilson, 2009.

Plate 14 Fiona Rae, *Night Vision*, 1998. Oil and acrylic on canvas: 243.8 × 213.4 cm (96 × 84 in.) © Fiona Rae; Courtesy: Timothy Taylor Gallery, London, Tate Collection.

Plate 15 Angus Pryor, *The Deluge*, 2007. Oil based paint and builder's caulk on canvas: 240 × 240 cm (94.5 × 94.5 in.) © Angus Pryor. Photo: Jez Giddings.

Plate 16 Mark Dolamore, *The Pyramid Art*, 2004. Nitrocellulose on polyester and wood: 76 × 67 cm (29.9 × 26.4 in.) © Mark Dolamore. Photo: Jordane Coustillas.

HALFTONES

Figure 1.1 Anthony Caro, *Early One Morning*, 1962. Steel and aluminium painted red: 290 × 620 × 333 cm (114.2 × 244.1 × 131.1 in.). © Tate, London, 2010.

Figure 1.2 Man Ray, *Gift (Le Cadeau)*, 1921 (1940 limited edition replica). Flat iron with tacks: 15.3 × 9 × 11.4 cm (6 × 3.5 × 4.5 in.). Museum of Modern Art, New York. © Man Ray Trust/ADAGP, Paris and DACS, London-Telimage, 2010.

Figure 2.1 Donald Judd, *Untitled*, 1971–2. Anodized aluminium and Plexiglas. Each unit: 120.7 × 152.1 × 152.1 cm (47.5 × 59.9 × 59.9 in.). St Louis Art Museum, St Louis. Photo: Graham Whitham © Judd Foundation. Licensed by VAGA, New York/DACS, London, 2010.

Figure 3.1 Jeff Koons, *New Hoover Convertibles, Green, Red, Brown, New Shelton Wet/Dry 10 Gallon Displaced Doubledecker*, 1981–7. Vacuum cleaners, Plexiglas and fluorescent lights: 251 × 137 × 71 cm (98.8 × 53.9 × 28 in.). © Tate Gallery, London, 2010 and DACS.

Figure 3.2 Marina Abramović, *Balkan Baroque*, 1997. Dimensions variable. Photograph from performance. © Marina Abramović. Courtesy: Marina Abramović and Sean Kelly Gallery, New York. DACS, London, 2010.

Figure 3.3 Victor Burgin, *What does possession mean to you?*, 1976. Photolithographic print poster, edition of 500: 124 × 84 cm (48.8 × 33.1 in.). © Courtesy Victor Burgin, with permission.

Figure 3.4 Shirin Neshat, *Rebellious Silence*, 1994. Black & white RC print and ink photograph taken by Cynthia Preston: 27.5 × 35 cm (10.8 × 13.8 in.). Edition 10 © Shirin Neshat. Courtesy: Gladstone Gallery, New York.

Figure 4.1 Paul McCarthy, *Caribbean Pirates (Captain Morgan)*, 2001–05. Dimensions variable. Multimedia installation. In collaboration with Damon McCarthy. Installation view, Stedelijk Museum voor Actuele Kunst Ghent, 2007. Photo: Dirk Pauwels. Courtesy: the artist and Hauser & Wirth.

Figure 4.2 Banksy, graffiti image known as *Yellow Line Flower*, 2008. Approx. 250 cm high (98.4 in.) Bethnal Green, London, 2008. Banksy image courtesy of Pest Control Office. Photo © Graham Whitham.

Figure 4.3 Andy Goldsworthy, *Hanging Tree No.1*, 2007. Tree and stone wall. Exhibited at the Yorkshire Sculpture Park, 2007–08. Photo: Jonty Wilde. Courtesy of Yorkshire Sculpture Park.

Figure 4.4 Antony Gormley, *Angel of the North*, 1994–98. Steel: 20 × 54 m (65.6 × 177.2 ft) Gateshead, UK. Photo: Graham Whitham.

Figure 5.1 Grayson Perry, *Golden Ghosts*, 2001. Earthenware: 63.2 × 26.8 × 26.8 cm (24.9 × 10.6 × 10.6 in.). Tate Gallery, London. Courtesy: Victoria Miro Gallery and the Saatchi Gallery. © Grayson Perry.

Figure 5.2 Jake and Dinos Chapman, *Great Deeds Against the Dead*, 1994. Mixed media 277 × 244 × 152.5 cm (109.1 × 96.1 × 60 in.). Saatchi Collection. © Jake and Dinos Chapman. Courtesy: Jay Jopling/White Cube (London).

Figure 6.1 The Baltic Centre for Contemporary Art, Gateshead, UK. Opened 2002. Photo © Graham Whitham.

Preface

The authors would like to thank the publishers, including Harry Scoble, Helen Rogers and Lisa Grey, for supporting this venture. Our appreciation to the members of Hodder's picture research department and to all those artists who have agreed permissions to reproduce images of their work, with particular thanks to Jordane Coustillas, Mark Dolamore, Richard Hamilton, Kate and Gary Hume, Angus Pryor, Bob Falla and Violet Yuell.

Every effort has been made to include a relatively balanced range of visual examples (and media) within this book, subject to the usual constraints of space, permissions and costs. Unless otherwise referenced or stated, the opinions and comments in this book are those of its authors.

Contents

Meet the authors xiii
Only got a minute? xiv
Only got five minutes? xvi
Only got ten minutes? xviii

1 **Introduction: contemporary art and aesthetics –
 theories of art making** 1

2 **The prehistory of contemporary art** 12
 Section 1 Defining terms 12
 Section 2 The neo-avant-garde 24
 Section 3 Reading contemporary art 39

3 **Contexts for contemporary art** 44
 Section 1 The march of history 44
 Section 2 Money makes the art go around 60
 Section 3 Reality isn't what it used to be 68

4 **Forms of contemporary art** 81
 Introduction 81
 Section 1 Painting, mixed media and sculpture 83
 Section 2 Photography 104
 Section 3 Film, video and digital media 116
 Section 4 Performance 132
 Section 5 Installation 146
 Section 6 Land and environment art 167

5 **Themes and issues in contemporary art** 181
 Introduction 181
 Section 1 Gender, sex and abjection 185
 Section 2 Politics, difference and the global 198
 Section 3 Popular culture, the media, celebrity
 and consumerism 218

6 Displaying and buying contemporary art **232**
 Section 1 Contemporary art and the market – buying art 232
 Section 2 Displaying contemporary art 241
 Section 3 Honouring contemporary art – contemporary
 art awards 247
 Taking it further **252**
 References **274**
 Index **278**

Credits

Front cover: © Sabine Scheckel/Riser/Getty Images

Back cover: © Jakub Semeniuk/iStockphoto.com, © Royalty-Free/Corbis, © agencyby/iStockphoto.com, © Andy Cook/iStockphoto.com, © Christopher Ewing/iStockphoto.com, © zebicho – Fotolia.com, © Geoffrey Holman/iStockphoto.com, © Photodisc/Getty Images, © James C. Pruitt/iStockphoto.com, © Mohamed Saber – Fotolia.com

Meet the authors

Welcome to *Understand Contemporary Art*!

Since you have picked up this book and are reading it, we imagine that you have an interest in contemporary art. Like many other people, you probably find contemporary art as challenging as it is fascinating. There is no doubt it is a complex and difficult area of our culture and one that in many ways defies explanation. But, by the same token, it also demands interpretation. If you have little or no knowledge of contemporary art or, like many others, find it difficult to understand, this book has been designed to help develop your interest by encouraging you to think about, comment upon, and reach judgements about it. Equally, if you already have a good understanding of contemporary art, reading this book should help you to enhance and refine your visual and interpretative skills.

There are many books about contemporary art. Some are histories, others are critical surveys, and yet others claim to explain a varied and opaque phenomenon that sometimes seems purposely to avoid clarification by encouraging complex and wordy analysis. We have attempted to avoid such an approach, believing that lucid and accessible language is necessary for 'teaching yourself' contemporary art. Our shared educational and professional experience also suggests that understanding something is best achieved through active learning, so throughout this book we pose questions designed to help you think about and reflect upon the information and ideas presented. These questions are followed by points of discussion aimed at helping you not only to expand your understanding, but also to develop your own thoughts and views about contemporary art. As you read this book, we hope that you will become more confident in your ability to 'read' works of contemporary art and that you will appreciate that learning about them can be a very meaningful and highly rewarding experience.

Graham Whitham and Grant Pooke, 2010

Only got a minute?

Perhaps the one thing that makes contemporary art so controversial is that, unlike art of any previous time, its various forms (that is, how it is made) are frequently beyond what we would conventionally and traditionally consider as art. Where there was once a relatively clear distinction between something that was art – a painting or a sculpture, for instance – and something that was not art – a refrigerator, perhaps – this is not necessarily the case with contemporary art.

In 2005 the Russian artist Irina Korina created an arrangement of refrigerators, freezers and washing machines in Brussels's Albertina Square. While we might regard this with scepticism, amusement, disapproval or bewilderment, Korina's *White Goods* was presented as a work of art. Some would argue that assembling domestic appliances in a city square fails to meet the criteria of skill, creativity and originality we conventionally expect art to display; others, however, would say that

such a work illustrates contemporary art's capacity to communicate in a way that other forms and disciplines, be they a book, a theatrical performance or a television programme, cannot.

Whatever you think about contemporary art, there is no doubt that it attracts and confounds in equal measure. But teaching yourself to understand contemporary art is not at all like teaching yourself to play the piano or learning to speak German, where rules, specific skills or techniques can be applied. Therefore, this book offers a broad understanding of the contexts, roles and purposes of contemporary art which should form the basis for an informed and knowledgeable encounter with it. Ultimately, this will lead to a greater appreciation and enjoyment of a complex, varied and fascinating subject.

5 Only got five minutes?

Imagine an interior space not unlike a warehouse, with subdued lighting, piles of newspapers and cardboard boxes, but arranged so that you can walk between them, as if through a labyrinth. You follow a path between these stacks and when you reach the centre, hanging from the ceiling are three huge chandeliers, brilliantly white with concentric circular tiers and curving swags. They resemble fantastic wedding cakes but, on closer examination, you see that each one is made from individual plaster casts of human bones.

What you are experiencing is a 2009 work of art called *In the Eyes of Others* by the British artist Jodie Carey. While the visual impact of the work and the sheer audaciousness of the endeavour are impressive, you may well be left wondering what the purpose of the work is, what it might mean, and how one should respond to it. Such questions are often asked about art and, more especially, contemporary art. To some extent, we can readily accept that a painting made in oils on canvas, framed and hung on the wall of an art gallery, is art, and we rarely question its status. This is because there are well-established traditions that confirm oil painting as art. Contemporary art, however, seems to break with these conventions and, as a result, we are separated from any certainty we had, leading us to ask such fundamental questions as 'What makes this art?'

There are no finite answers to such questions. In a very general sense, the only things that differentiate Carey's work from Michelangelo's *David* or Picasso's *Guernica* are the historical circumstances of its creation and the form it takes: all works of art are about making, communicating, feeling and looking, and their conception, invention and overall purpose are fundamentally the same, with no monopolies on meaning and interpretation. However, contemporary visual practice frequently challenges us because it appears to have broken with the established conventions.

In fact, it would be more accurate to say that it has evolved from a tradition of dissent and rebellion against those conventions.

Unlike the rules of a card game or a round of golf, how we receive and understand art cannot be 'taught' in any literal sense; there are no 'right' or 'wrong' answers to what is seen, felt and experienced. But, as with many things, an engagement with art rests upon foundations of knowledge and understanding. In the case of contemporary art, because its forms are often different from those we would typically expect, as in Carey's installation, we cannot always draw upon historical precedents to assist our understanding, although such precedents do exist.

Equally, in order to be able to interpret contemporary art, we need to know and understand the social, political, economic and philosophical circumstances of its creation. Contemporary art tackles diverse themes, ideas and issues, from the politics of gender and identity, to considerations of ecology and globalization, and the vexed relationship of art to consumerism and popular culture. It is also intimately linked to one of the largest and most lucrative markets in the world, where buying, collecting and investing in art seems to collide with its other, less materialistic purposes, meanings and values.

It is, in part, contemporary art's complex relationship with the past and the present, with commodity culture and with something that seems to transcend mere materialism, that make it so intriguing. But in order to teach yourself to understand contemporary art, it is important not only to have a knowledge and understanding of its histories, contexts and forms, but also to approach it with a fresh eye and an open mind.

10 Only got ten minutes?

Please take a few moments to look at Plates 1, 6, 7 and 10 in this book. If you were asked to characterize your response in one word to each example, what would it be and why?

You probably have different responses to each work. After all, one is an abstract painting, one a mould of a head made from frozen blood, one a sculpture reminiscent in style of a Madame Tussaud's waxwork, and another a photograph. However, at one level, the only appreciable thing which these very disparate objects, images and constructions have in common is that they have been designated works of art, and as such are judged to have some degree of cultural value or significance.

Some of these examples may appear more familiar than others. A partially disguised self-portrait by the American photographer and film-maker Cindy Sherman (Plate 10) and an abstract painting by the Dutch artist Theo van Doesburg (Plate 1) share some of the recognizable conventions of 'art' insofar as they are two-dimensional images customarily wall hung in a gallery, although there the similarity mostly ends. One is an entirely abstract painting with a geometric style undertaken in the modernist tradition; the other is a photographic pastiche, or stylistic imitation, of a depiction of the Roman god of wine, Bacchus, by the sixteenth-century Italian painter Caravaggio.

But what about Maurizio Cattelan's installation, *La Nona Ora* (Plate 7), which depicts the Pope being struck by a meteor, or Marc Quinn's sculpture *Self* (Plate 6), a cast of the artist's head filled with just over nine pints of his own blood? As relatively unfamiliar as these two examples may first appear, they use and adapt both older and more recent conventions of art making and meaning. Although very different in medium, subject and style from the initial van Doesburg and Sherman examples, they nevertheless share some similar antecedents and influences. An attempt to

understand what links and distinguishes these very different art objects, and those arising from other recent art practices, is one of the approaches you might take in teaching yourself contemporary art.

As you can see from the four examples you have looked at, forms of contemporary art are diverse. In a visit to an art gallery you are just as likely to encounter a photograph, a performance, a film or an installation as you are a painting. Furthermore, the subjects of contemporary art are equally varied. Traditional forms such as still life, figure compositions and landscapes are no longer the norm; instead, observations and comments on globalization, politics, gender and cultural difference are.

In its myriad forms, styles and media, contemporary art remains one of the most provocative subjects within the cultural landscape. Often described as difficult, opaque, resistant to straightforward interpretation, pretentious and even a colossal confidence trick, the one thing about which we can be sure is that contemporary art is challenging. This, together with its sometimes provocative and confrontational character, and its capacity to stimulate argument and discussion, means that it can beguile and frustrate in equal measure. In teaching yourself contemporary art, you will never be able to resolve these tensions and ambiguities, since they are fundamental to contemporary art's character, but you should become closer to revealing and finding value and meaning from them.

Despite the apparent difficulty in understanding it, public and critical fascination with contemporary visual art is at a record high, an interest which, incidentally, appears to be recession proof. Tickets for so-called 'blockbuster' art shows curated by London's Tate Modern at Bankside, New York's Museum of Modern Art (MoMA), or the Pompidou Centre in Paris are regularly sold out, with queues extending around the block. Cities such as Basel in Switzerland, Kassel in Germany and Venice, Italy, are well known for hosting international art fairs and biennials, while some of the art world's most famous figures rank alongside A-list Hollywood celebrities. The public and media appetite for what they do and say

remains undiminished; works of contemporary art, whether, a 9-m spider titled *Maman* by Louise Bourgeois, or Carsten Höller's *Test Site*, a series of funfair slides installed in the Turbine Hall of Tate Modern in 2006, are the iconic symbols of the new millennium.

Alongside the fascination with artistic spectacle and personality, there is criticism from various quarters that some aspects of contemporary art are somehow fraudulent, suggesting, to use the cliché, the 'emperor's new clothes' syndrome. One fairly recent example has been a British daily newspaper sponsoring a regular 'Not the Turner Prize Award' in opposition to the Turner Prize, which is presented annually at London's Tate Gallery. To some extent this might be seen, of course, as a promotional ploy, appealing to a particular audience demographic and a stereotypical reading of contemporary art. But it nevertheless reflects a palpable and more serious unease among sections of the general public, in addition to that voiced by some artists themselves, as well as by particular art critics, art historians and newspaper columnists.

The art historian Julian Stallabrass, for example, famously coined the term 'High Art Lite' to characterize the superficial blandishment or appearance of high art, but without the associated intellectual content or conceptual challenge. He had in mind, among others, work by artists such as Damien Hirst, including the installation *Mother and Child, Divided*, a bisected cow exhibited with her calf (Plate 9). In his account *High Art Lite: British Art in the 1990s*, Stallabrass notes: 'when Hirst's work is seen as a whole...the combination of Hammer-style schlock and high-art Minimalist rigour becomes obvious. The innovation was to bring the two together...Beyond the schlock, however, there is a vacuous quality which is the work's defining characteristic' (Stallabrass, pp. 26–7).

In addition to concerns voiced by other, widely read critics such as Robert Hughes, Brian Sewell and David Lee (editor of the art newspaper *The Jackdaw*), practising artists have also raised concerns in relation to what is perceived to be the direction of contemporary art. In particular, the Stuckists, a grouping of

contemporary figurative painters, have consistently argued that various recent trends in art are not only vacuous, but also that they reflect a pragmatic and unholy alliance between private galleries (concerned with the next cultural and artistic novelty) and the acquisitions policies of leading public galleries, which are wedded to spectacle and media attention.

Opposition to forms of modern and contemporary art is nothing new. The work of the French painters Gustave Courbet and Edouard Manet in the mid-nineteenth century also provoked critical debates which hinged on the appearance or style of their work and its content or subject matter. But what is arguably of equal interest is the context through which we might attempt a reading of the unfamiliar and the new (and the not so new). Specifically, how might such work be interpreted and on what basis might we reach judgements about its value, quality or meaning? These are difficult but important questions fundamental to an informed awareness of contemporary art.

Even after reading this short introduction, the initial responses to the four plates we asked you to look at may have been modified. In order to form opinions and judgements of any real value about such a contentious subject as contemporary art, it is necessary to be informed about it. Only in this way will you be able to comment on and discuss the subject meaningfully.

1

Introduction: contemporary art and aesthetics – theories of art making

When we visit an art gallery or museum, we spend time looking at works of art and, in giving them this attention, we expect some 'benefit'. In other words, we look at works of art in order to derive something back from them that is more than simply entertainment. We might think of this as looking for meaning in art, which could vary from an aesthetic effect to an insight into a particular topic, issue or personal concern. But the encounter between a work of art and the viewer is not always straightforward. Works of art are, on the whole, demanding; they require the viewer to enter into a tacit compact that involves various forms of communication and an understanding of visual conventions.

On the whole, we are relatively comfortable doing this with more traditional types of art such as naturalistic paintings; they make fewer demands on us because we can immediately identify their content (since it is naturalistic) and recognize their form (since painting is a well established and generally understood means of making art). But faced with an abstract 'subject' or contemporary forms such as performance, land art or installation, we are likely to be less comfortable; they are less familiar and, consequently, make more demands on us. Since contemporary art is frequently unconventional in both form and subject matter, we are inclined to find it difficult and challenging.

In 1957, long after he had seemingly abandoned making art to become a reclusive chess grand master, the French artist Marcel Duchamp (1887–1968) addressed an audience in Texas, USA. His career had begun before the First World War and, looking back on his life and some of the controversies around his earlier art practice, Duchamp made the point that there was good art and bad art, but that bad art, just like a bad emotion, was still worthy of the name (Duchamp in Stiles and Selz (eds) (1996), pp. 818–19). In other words, what was important was how and why we came to a judgement about which art was considered worthy and which was not.

One way we might determine the quality of art is by applying aesthetic values. Aesthetics is the term given to the field of knowledge concerned with making judgements of value in relation to art practice. It arose from the Greek word 'aesthesis' – literally that which is perceived through the senses. In the eighteenth century, aesthetics was centrally concerned with ideas of beauty, taste and the basis on which such claims might be made and sustained. However, the term is also sometimes used more generally to refer to an artist's or period's overall style – Picasso's aesthetic or a Baroque aesthetic, for example.

Please look at *The Architect's Home in the Ravine* (Plate 11), a painting by Peter Doig (b.1959).

▶ *This is a figurative representation of a chosen subject; that is, it attempts to depict recognizable objects. It is an example of mimesis, an attempt to mirror, or mimic, aspects of the world around us. Within the traditions of Western art making, the theory of mimesis is rooted in the Classical period and was developed during the Renaissance. It was associated with the invention of single-point perspective, the structuring of pictorial space which gave the illusion that the spectator was literally looking into a believable depth. In effect, it created the illusion that a flat painting was an actual window onto the world. Mimetic works of art were admired and this supported attempts to make them ever more sophisticated representations of the world around us.*

> ▶ *Up until the mid-nineteenth century, the success of an art work was broadly judged on the artist's ability to suspend our disbelief that (in the case of a painting) we were looking at a flat surface covered in pigment. Mimesis became a benchmark of quality which underpinned the making and evaluation of art throughout the art academies of the Western world.*

But why and how is this theory relevant to modern and contemporary art?

Please look at *Counter Composition XIII* (Plate 1), a painting by Theo van Doesburg (1872–1944) and consider it in relation to Doig's painting.

> ▶ *Although this is not the beginning of the challenge to mimesis or naturalism, it belongs to a tradition of abstraction within art making. That is, the artist does not literally attempt to depict the world as he does in* The Architect's Home in the Ravine, *but the forms, shapes and colours he uses signify meaning in other, less direct and literal ways.*
>
> ▶ *van Doesburg's linear and geometric aesthetic evokes the experience of the world indirectly through metaphor and allusion rather than through mimesis, as does Doig's picture. According to certain ideas and interpretations of abstract art, a form that became fashionable in the early decades of the twentieth century, art should be judged on the aesthetic or pictorial effect which arises from the combination of colours, lines, shapes, and so on. In Doig's painting, we might make a judgement, if only partially, based on its ability to depict reality. Literally speaking, van Doesburg's picture does not 'depict' anything, but it is possible to see in its clear colours and flat shapes an attempt to capture a transcendent reality, partially realized in the high-rise urban cityscapes of Mondrian's adopted homeland and refuge, the United States.*

To take another example, please look at the abstract sculpture *Early One Morning* (Figure 1.1) by Anthony Caro (b.1924).

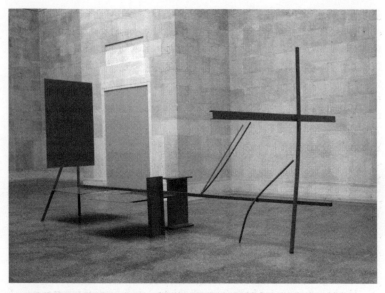

Figure 1.1 Anthony Caro, Early One Morning, 1962. Steel and aluminium painted red: 290 × 620 × 333 cm (114.2 × 244.1 × 131.1 in.). Tate Gallery, London.

▶ *Like the van Doesburg painting, Caro's work is not figurative; it does not represent a person, a scene or a literal object. Instead, we are encouraged to respond to the spatial and formal inter-relationships of the steel and aluminium struts. It seems that Caro was concerned with the syntax and rhythm of the sculpture's constituent parts and how viewing the work in the round can offer differing perspectives on both the parts and the whole.*

In the case of both van Doesburg's painting and Caro's sculpture, our response may not just be to what is seen, but to what is acquired through an imaginative association of what these examples evoke for us. Resemblance, or mimesis, is therefore not the only – or necessarily even a sufficient – basis for responding to works of art.

The appearance of abstract art just over a hundred years ago, and its status, meaning and validity, especially in relation to mimetic art, has engaged art critics, art historians and the public

at large ever since. Mimesis in art has had a long history. By the end of the nineteenth century it had become synonymous with what was understood as 'art', but, by introducing forms that were not mimetic, works by artists such as van Doesburg and Caro questioned this convention. Consequently, new definitions of art had to be found, one of which understands the term as a 'family resemblance'.

Please look again at some of the examples of art practice discussed so far. You may also wish to look at some of the other plates and figures in this book.

> ▶ *In terms of materials, form and content, they appear very different and distinct. But, according to the theory of 'family resemblance', what we should look for is whether these examples share particular similarities, rather than exact symmetries, in the same way that members of a family might share similar but distinct characteristics.*
> ▶ *The best that we can hope for from this theory, by way of attempting a useful definition of contemporary art, is that paintings, sculptures, installations, performances, films and so on, demonstrate sufficient attributes that enable their shared identification as 'art'.*

The advantage of this approach is that art is understood as an open and flexible concept to which additions can be made. However, a major problem with this theory of art is that it makes no distinction between exhibited and non-exhibited properties. So for example, while with broadly mimetic paintings such as those by Doig, the stylistic similarities may be obvious, there may be instances where this is not so, as with Richard Wilson's *20:50* (Plate 13) or a work of conceptual art, where the artist might not produce an object at all. The attempt to circumvent this limitation with the 'family resemblance' approach to art has provided the context for another way of understanding what 'art' is and this is known as the Institutional Theory of Art.

The Institutional Theory is closely associated with the American aesthetician George Dickie (b.1926). It has been influential both

in explaining and accounting for a wide range of modern art, presenting as it does two basic criteria for an object's designation as 'art':

1 *An object or practice has to be changed in some way by human agency or intervention.*
2 *An object or practice has to be displayed or exhibited within a gallery or art world context.*

How might we apply this theory in practice?

Please look at *Gift* (Figure 1.2) by Man Ray (1890–1977).

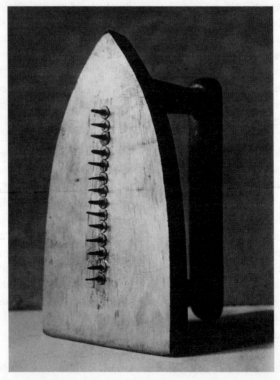

Figure 1.2 Man Ray, Gift, 1921 (1940 limited edition replica). Flat iron with tacks: 15.3 × 9 × 11.4 cm (6 × 3.5 × 4.5 in.). Museum of Modern Art, New York.

> ▶ Rows of nails have been welded to the surface of a painted flat iron, an intervention which prevents the resulting object being used to achieve its original (practical) purpose.
> ▶ This gesture meets the first criterion of Dickie's theory, since the object has been refashioned and altered by human agency or intervention.
> ▶ Secondly, Man Ray had this object exhibited several times, so meeting the second of Dickie's criterion that requires the sanction and implicit endorsement of the art world. According to Dickie's Institutional Theory, this object can be admitted to the classificatory category of art.

For its supporters, the Institutional Theory has an elegant simplicity. In addition, it is an inclusive and pragmatic way of accounting for the bewildering range of practices, objects, ideas, performances and interventions that have typified aspects of modern art practice over the past 40 years or so. However, there are some problems with it.

As you have doubtless noticed, Dickie's theory makes no comment on whether something is a good or bad example of art. Perhaps accepting that such judgements of quality or value may be difficult, the theory sidesteps them altogether by simply understanding art as a wide and neutral category of cultural practice. Furthermore, the second criterion is, on closer inspection, also problematic. If something is displayed or exhibited within a gallery or art world context, it has been accepted by the 'art world'. But we might ask, is there even such a thing? If we mean galleries or perhaps art journalists, curators, critics or even art historians, can we accept their confirmation of something when they may have promotional interests and self-seeking motives? Moreover, can we even talk about there being something approaching art world approval when that 'world' is, itself, so varied and fragmented with frequently competing or, at the very least, highly different, agendas, interests and personalities?

Despite these issues, Dickie's theory has become widely referenced, not least because it seems to account for the expanse of practice and activity which routinely claims the mantle of art. Ultimately,

perhaps we should be less concerned about debates on whether something is art, or if it 'looks' like art. Instead, perhaps we should pragmatically concede 'art' as a wide-ranging, descriptive category and get on with the more challenging and interesting issue of how to evaluate whether the example we are presented with is good, average or indifferent. That said, what benchmarks should we use?

If art has long ceased to be about mere appearance, or mimesis, perhaps we should look at the quality and effort of its construction, its social relevance (assuming that we can agree on what the terms or precise criteria for this might be), or whether the underlying idea or concept behind its making is innovative and original.

These issues provide the basis to complex and lengthy debates within art history and aesthetics – the philosophy associated with evaluating and responding to art – and as such are beyond the scope of this book. However, what can be said here is that judgements and ideas about art are culturally and historically based. That is, they change through time, mediating the subjective and relative interests and values of patrons, audiences and the artists themselves. There really are no monopolies on the interpretation of art and claims to its ultimate value or meaning. Instead, we should be alert and receptive to the contexts of its making, all the more so with contemporary art, where we may lack both the historical and cultural distance to make clear discriminations of intention and significance. In this lie the intentions of *Understand Contemporary Art*.

WHAT IS 'CONTEMPORARY ART'?

Most terms to do with period and style in art are problematic, primarily because no artist or the work she or he produces conforms to predetermined definitions. However, in order to understand the complexities of art, we look for similarities and differences in the appearance of works (form and style) and locate them within periods (context).

We have used the term 'contemporary art' to indicate work produced from approximately 1980. In doing this we intend to distinguish more recent art from earlier manifestations, which are generally defined as 'modern'. Other terms exist for art of this post-1980 period, such as 'late modernism' and 'postmodern', but 'contemporary' does have the advantage over these other terms in that it implies art of recent times.

However, as we have noted, art terms are fraught with problems and the adjective 'contemporary' is no exception. While it most obviously refers to work produced in the relatively recent past, it also implies art that is, on the whole, unconventional in its appearance, production and ideas. We wish to include both interpretations in this book. For example, a work such as Peter Doig's *The Architect's Home in the Ravine* (Plate 11) is contemporary in that it was painted in 1991 but it is conventional in its mimetic representation of a landscape made using traditional materials. Fiona Rae's *Night Vision* (Plate 14) is, like Doig's work, a painting on canvas made in the 1990s, but it is abstract, which makes it less conventional. Gary Hume's *Hermaphrodite Polar Bear* (Plate 12), a work from 2003, is also a painting but it is not mimetic in the sense of Doig's picture, nor is it abstract like Rae's; it represents something that we can recognize, albeit in a simplified manner. However, its medium and support are not conventional, being more usually associated with industry than art.

The relationship between art produced in the past 30 or so years and art of the late nineteenth and first half of the twentieth centuries is discussed in the next chapter, but what is clear is that we can identify changes in art practice in the second half of the twentieth century. Consequently, we need to characterize and differentiate them from what had gone before, hence the distinction between 'contemporary' and 'modern'.

Suggestions for further reading

Eleanor Heartney, *Art and Today*, Phaidon, 2008

Jörg Heiser, *All of a Sudden. Things that Matter in Contemporary Art*, Sternberg Press, 2008

Simon Leung and Zoya Kocur (eds), *Theory in Contemporary Art: From 1985 to the Present*, Wiley Blackwell, 2004

Gill Perry and Paul Wood (eds), *Themes in Contemporary Art*, Yale University Press, 2004

Grant Pooke and Diana Newall, *Art History: The Basics*, Routledge, 2008

Sarah Thornton, *Seven Days in the Art World*, Granta, 2008

Katherine Stiles and Peter Selz (eds), *Theories and Documents of Contemporary Art: A Sourcebook of Artists' Writings*, University of California Press, 1996

Brandon Taylor, *Art Today*, Laurence King, 2004

Peter Timms, *What's Wrong with Contemporary Art?* University of New South Wales Press, 2004

Useful websites:

http://en.wikipedia.org/wiki/Contemporary_art
http://www.axisweb.org
http://witcombe.sbc.edu/ARTHcontemporary.html

THINGS TO REMEMBER

▶ Art is demanding, especially contemporary art with its often unconventional and unfamiliar forms.

▶ Art represents, although it does not always depict. In other words, it stands for something but does not necessarily resemble that thing in a naturalistic or mimetic way.

▶ In the early twentieth century, abstract art challenged the established pictorial conventions of mimesis, creating the need for a new definition of what art was. One classification uses the analogy of 'family resemblance' while another is the Institutional Theory of Art. Both are open and flexible ways of identifying art but neither engages with the vexed question of artistic quality. Moreover, the Institutional Theory is prey to the vagaries of galleries, dealers, curators, critics and art historians.

▶ Judgements and ideas about art change with historical and cultural circumstances.

▶ Contemporary art is a term used to distinguish more recent art; this book considers art from about c.1980 as contemporary. Modern art is generally understood to encompass a wider chronological period, generally accepted as c.1860–c.1960.

2

..

The prehistory of contemporary art

In this chapter you will learn:
- *some essential terms and definitions and how they are used in relation to modern and contemporary art*
- *how contemporary art has its origins in earlier forms of modern art*
- *how aspects of post-war modern art challenged existing artistic conventions, establishing the initial direction of subsequent practice*
- *how much contemporary art demands an active and discursive engagement from the viewer.*

Section 1 Defining terms

Having broadly established what we mean by 'contemporary art', we can now explore its origins, which we suggest lie in the three decades following the end of the Second World War. Considering art practice before the 1980s is important because it should enable identification and understanding of the cultural and historical basis of the art of our own time. In other words, knowing something about contemporary art's prehistory will enhance an awareness of the ideas, interests, themes and concerns of contemporary practitioners. After all, contemporary art did not simply appear; it was both a continuation of, and a reaction to, previous forms

of making art and to broader debates concerning its meaning and purpose.

At the end of this chapter, you should be able to recognize the extent to which the art of our own time (contemporary art) is, to a greater or lesser degree, connected with particular aspects of art of an earlier period, notably that between the 1950s and the end of the 1970s. This is unsurprising because art evolves, either as a continuation, response, synthesis or even a rejection of previous practice. However, what is at stake here for many critics and art historians is whether, during these three decades, art underwent a substantial change. Did it shift from what it had been, so initiating something new, or did it develop as a modified extension of earlier twentieth-century art, so forming a continuation of previous aspirations and practices?

Most art historians would agree that between the 1950s and the end of the 1970s art changed significantly from what it had been before, arguing that the artistic philosophies and ideas established during this period laid the foundations for what we now view as contemporary art. Some commentators characterize this as the end of one cultural period, which they call 'modernism', and the beginning of another, which is identified as 'postmodernism'. Conversely, others consider that much of the artistic practice from the 1950s onwards was little more than a continuation of earlier modernist avant-garde work, although significantly modified by contemporary circumstances and experience. Some of them characterize this as 'late modernism' and hesitate to embrace the idea of postmodernism as a different set of values or even as an identifiable period label.

These very different interpretations are further complicated by critics who claim that postmodernism is reactionary and consciously opposed to the values of modernism, but more of this later.

So that you can make your own mind up about these issues and debates, it is important that you have an understanding of the

terms being used here, namely modernism, postmodernism, late modernism and avant-garde. So, let us first clarify these terms and then explore some examples of art produced after 1945. This should help us characterize the art and ideas of the relatively recent past and give us an understanding of contemporary art's origins and antecedents.

Insight

It is important to appreciate that there are no finite or authoritative definitions of the terms **modernism, postmodernism, late modernism** and **avant-garde**, but rather a variety of interpretations about which you will ultimately have to decide which are the most plausible.

The term **modern** comes from the Latin stem *modo*, which literally means 'just now'. Naturally, where that 'just now' happens to be is a matter of perspective, experience and outlook. But the idea of the 'modern' is central to debates about whether contemporary art is significantly different from what went before, or whether it essentially continues previous ideas, interests, themes and practices, or intentionally contests them.

The word modern is sometimes used as a surrogate for contemporary, meaning here and now, the up-to-date and the present. However, it is well to remember that everyone thinks of themselves as modern at the time they live. For instance, in the fifteenth and sixteenth centuries those people who contributed to, or were aware of, what we now call the Renaissance, regarded themselves and the period in which they lived as modern. But some art historians and cultural commentators have labelled the period between c.1860 and c.1960 as modern, in much the same way as we now classify the fifteenth and sixteenth centuries as the Renaissance. So if we accept the term modern as defining an art historical period, we have to acknowledge that in the 1960s 'modern art' came to an end and that we might use the term 'postmodern' to characterize what followed. But, as we have noted, some commentators question the idea of modernism's demise and postmodernism's existence. In order to examine this apparent

conflict, we need to consider the other meanings attributed to modern.

So how might we recognize the modern when we actually look at examples of art? Some art historians apply the term modern to the appearance of art, that is, its form and/or its content. Like many art historical terms used in this way, such as realism, symbolism, expressionism, and so on, the modern encompasses an array of different types, forms and styles of work.

Please look at Plate 1 and Figure 1.2. These are two examples of modern art produced within a few years of each other. Considering the mediums used and their subject matter, can you identify differences between them?

> ▶ *You might have recognized that the painting by Theo van Doesburg (1883–1931) (Plate 1) employs a conventional art medium – paint on canvas – whereas the Man Ray (1890–1977) (Figure 1.2) is highly unconventional, being a mass-produced object – a domestic iron – with other mass-produced objects – nails – attached. You might also have identified the van Doesburg painting as having no recognizable subject – it is abstract; the Man Ray piece is recognizable for what it is – an iron with nails added.*

The completely different appearances of these two examples make it difficult to see why both are considered as examples of 'modern art' if we understand this simply as an artistic style. The only similarity seems to be that they were made within two decades of each other.

Why do you think these apparently different works are regarded as examples of modern art?

> ▶ *Modern art is not a style (that is, having a repertoire of similar visual characteristics), but is regarded by some commentators as emblematic of a particular approach or sensibility. They maintain that a consistent feature is a conscious effort to be different from*
> *(Contd)*

accepted artistic conventions. In this sense, modern art represents a radical type of practice, opposed to established and, arguably, conservative forms of art making. After all, we sometimes hear people claim that they don't understand modern art, which may be because it does not correspond to their conventional expectations of what art should be. In other words, it may not be a figurative or abstract painting or even an object which references identifiable subject matter or experiences. Therefore, while the van Doesburg and the Man Ray look dissimilar, both are unconventional in the way they approach the idea of representation.

Using the term modern to brand all post-1860 art that is radical in the way it is made and looks (its form) and/or its subject matter (its content) might be thought more confusing than illuminating. This is principally because there is such a diverse and disparate range of art, as the van Doesburg and Man Ray examples illustrate. A more confined and coherent interpretation of the term was promoted by some twentieth-century critics, arguably the most influential being the American art critic Clement Greenberg (1909–94). Without going into too much theoretical detail, Modernism, which was the name Greenberg gave to this interpretation, was characterized in four significant ways:

1 *The best art emphasized form over content, which in effect meant a development and paring down of the medium towards abstraction.*

2 *The value and meaning of art was inherent within those formal characteristics considered to be distinctive of the medium – for example, in painting, the two-dimensional surface, shape and colour; in sculpture, the syntax and articulation of forms in space, the physical potential of the materials, and the undisguised use of those materials. Also, works of art had to operate exclusively within the unique characteristics of the medium; for instance, three-dimensional forms (real or illusionistic) were the province of sculpture and two-dimensional effects were domain of painting. In short, Modernist art was medium specific.*

3 *The best Modernist art valued aesthetic effect over social meaning or political message.*

4 *Modernist art produced a rarefied experience for the viewer, one independent and different from the experiences of everyday life and from the concerns of society.*

Please look at Plate 1 and Figure 1.2 again, and also at Figure 1.1. Which of these examples do you think fails to meet the criteria of Modernism listed above, and why?

▶ van Doesburg's painting (Plate 1) and Caro's (b.1924) sculpture (Figure 1.1) are abstract and so more readily privilege form over content (their content is, to all intents and purposes, the materials they employ and the form these take). On the other hand, Man Ray's piece (Figure 1.2) is an iron with nails and so, in a sense, has content – a subject – which determines its form – the way it looks.

▶ Both the van Doesburg and the Caro each seem to explore the formal characteristics of their medium; van Doesburg's painting contains only flat colours and shapes, while Caro's sculpture is a composition where forms and space appear to play an equal role and do not seem to represent anything other than what they are. In contrast, Gift is three-dimensional although it hardly exploits spatial effects, but because it is made from recognizable, everyday objects, we are more aware of this than the formal character of the materials being used.

▶ Gift's familiarity – an iron, albeit with nails attached – challenges us to find aesthetic value, whereas Counter Composition XIII and Early One Morning, largely because they have no recognizable subject, almost force us to look at what they actually are: a painting and a sculpture. In doing this, we might separate our experience of art from our everyday experiences.

Greenberg's concept of Modernism has played an important role in the evolution of today's art, not because it influenced contemporary art practice and art criticism as such, but because it was so stridently challenged by them. Excluding Man Ray's *Gift*,

and many other examples, from the canon (or established list) of so-called 'significant' and 'good' art because they did not correspond to Modernist artistic values (as listed above), was regarded by many as elitist and discriminatory. As a result, by the mid-twentieth century, Greenberg's Modernism was under attack from makers and supporters of art that refused to be medium specific.

Such practice engaged in various ways with everyday social experiences, favouring content and meaning over form and aesthetic effect. By the late 1960s, the tables had turned on Modernism; art that had conformed to its criteria was perceived as unfashionable and criticized as non-Modernist art had once been. Interpreted like this, Modernism can be understood as the dominant critical theory of mid-twentieth-century Western art, an outlook that was superseded by its antithesis, which some have termed postmodernism.

Insight

Do not be confused by different uses of the term modernism. Just consider it defining a tendency in art made between the c.1860s and c.1960s that is radical in form and/or content. Greenberg's Modernism (we will distinguish it by using a capital M) is a critical theory focusing on some of this art that he and like-minded commentators regarded as 'significant' because it corresponded to their artistic criteria. However, while there is some overlap between examples of 'modern art' (understood as a tendency) and some which is defined as 'Modern' from a critical point of view, the two do not necessarily reference the same examples of art.

If the term 'modern' can have various meanings in art, then **postmodern** is no easier to pin down. Literally understood, postmodern means 'after just now', or more simply, after the modern. The use of the term implies that modernism as a style and as a period has come to an end, although it is rather less specific about what has replaced it!

We can say that postmodernism is not a style of art and neither is it necessarily a clearly identifiable artistic approach. As we have seen,

despite modernism's stylistic diversity, its conscious difference from accepted artistic conventions might give it some sense of unity and purpose. But postmodernism does not seem to have any consistent characteristics. Indeed, it could be said that its inconsistency of approach and apparent lack of aims are its only consistent features.

Equally, if Greenberg's Modernism claimed that art's value resided in those formal qualities particular to the medium – colour, shape and flatness in painting, for instance – and not in its content, or subject matter, postmodernism denies such a singular view; it is regarded as pluralist, meaning that it embraces a variety of differing views and approaches. Furthermore, there was often something ideological and principled about modernist art. For example, van Doesburg's paintings present us with an image of harmony and equilibrium, a condition that was somehow intended to be transferred to society in order to improve it; Man Ray's *Gift*, which confronted accepted conventions, was perhaps a critique of the society that advocated them. In fact, many commentators have characterized postmodernism as permissive and depthless, having none of the social and moral aspirations associated with modernism.

All in all, postmodernism presents us with cultural manifestations, art among them, that are indefinable as types or styles, but which are often characterized by irony, parody, the appropriation of past art, and so on. In this way, it seems to represent the uncertainty and, one might say, insecurity of changed social, economic, political and cultural conditions in the later twentieth century (which we will explore in the next chapter).

The term postmodern was in common use from the 1970s but by the end of the century it was losing its credibility. So nebulous was it as an aesthetic and cultural term that it came to be used as a catch-all for any art that presented itself as somehow reflecting the contemporary world. Consequently, some critics began to question the actual existence of the postmodern as a cultural category at all, while others regarded it as reactionary in its dismissal of modern art's aspirations and misguided in encouraging egotistical tendencies, which leads us to the idea of late modernism.

Greenberg's more confined, or refined, view of modern art led him and other Modernist critics to identify artists whose work they believed to have special importance and value. In the mid-1960s Michael Fried (b.1939), a critic who was close to Greenberg, noted that Manet, the Impressionists, Seurat, Cézanne, Picasso, Braque, Matisse, Léger, Mondrian, Kandinsky and Miró were 'among the finest painters of the past hundred years' (quoted in Harrison and Wood (2003), p. 788). Fried claimed that the work of these artists showed an inclination to favour form over content and aesthetic effect over meaning. Such examples were also understood to exploit formal characteristics that were distinct to the medium, preserving art as an experience independent from everyday life (that is, the principles of Modernism). He then linked these same characteristics with the work of his contemporaries, such as Kenneth Noland, Jules Olitski and Frank Stella, all of whom painted abstract, flat colour pictures.

Whether you agree or not with Fried's list, or his views about the development of modern painting, the point we want to make is that in selecting certain artists as 'among the finest painters of the past hundred years', other artists are excluded and, consequently, not considered to be as significant; van Doesburg and Caro are part of the Modernist canon, whereas Man Ray is not. And not just Man Ray. Modernist critics marginalized Dadaists and Surrealists, Italian Futurists, Russian Constructivists, realists and countless others because they saw their work as lacking value by not privileging form over content, aesthetic effect over message, not being medium specific, and so on.

Such a selective interpretation led some art historians and critics to question not only Modernist readings, but also the idea that modern art came to an end in the 1960s with the introduction of a new set of values, which had been identified as postmodern. What was reasoned by some to be postmodern was for others not new at all but a continuation of certain aspects of earlier twentieth-century modern art. Although recognizing a response to current circumstances, some commentators acknowledged there were aspects of contemporary art that applied similar practices and

debates to those used by modern artists associated with the avant-garde earlier in the century. In effect, this constituted a refusal to accept that modernism had ended, as supporters of postmodernism claimed, and that contemporary art should be understood more as a continuation of certain aspects of modern art. Hence the term **late modern** was coined.

Insight

It is important to remember that the meaning of terms is dependent on the context of their use and upon the interests of those who use them. You should also consider that there are differing critical valuations which have variously sponsored particular kinds of artistic practice and traditions at the expense of others. For instance, rather than understanding the shift from modernism to later forms (postmodernism, late modernism, contemporary, or whichever term you prefer) as a linear process, it can equally be understood as a cyclical development. For example, Duchamp's ready-mades (see p. 52), regarded as a precursor to more recent art, were being made in the first decades of the twentieth century. Similarly, recent performative and ephemeral work can be associated with Dada, which also dates to this earlier period.

Some tendencies of the earlier twentieth century, such as Dada, Surrealism, Russian Constructivism and realism, are often categorized as **avant-garde**. Originally a military term meaning the scouting party or advanced guard of an army, avant-garde was first used in relation to the arts in a French text published in 1825, which exhorted artists to 'spread new ideas among men' (quoted in Harrison and Wood (1998), p. 40). These 'new ideas' were associated with the political doctrine of socialism and so, at its inception as an art term, the avant-garde was associated with political and social radicalism.

By the early twentieth century, avant-garde had become synonymous with the term modern art, in the sense of being different from accepted artistic conventions. Understood in this way, avant-garde

was losing its more specific meaning as a politically and socially motivated art.

In 1974 the German literary theorist Peter Bürger (b.1936) published *Theory of the Avant-garde*, which claimed that certain tendencies of inter-war art (Bürger focused on Dada and Surrealism) attempted to engage critically with the concerns of everyday life, a phrase denoting social, economic, political, moral, philosophical, cultural and other shared circumstances of nations, communities, groups and individuals. He also claimed that avant-garde was different from modern art, which had increasingly separated and detached itself from these circumstances (as we saw expressed in the ideas of Greenberg and Fried). However, Bürger concluded that the inter-war avant-garde (he called it the 'historical avant-garde') had ultimately failed because the strategies it employed, such as using unconventional materials to confront accepted artistic conventions, as in Man Ray's *Gift* (Figure 1.2), never operated effectively as a critique of the society that generated such conventions.

Please look again at Plate 1, Figure 1.1 and Figure 1.2. Which of them would you regard as Modernist, which is avant-garde, and why?

▶ *Both van Doesburg's painting (Plate 1) and Caro's sculpture (Figure 1.1) would be regarded as Modernist, in the way that Greenberg and Fried used the term. Since they have no readily discernible subject, we are thrown back on their formal qualities – their colour, forms, shapes and so on – to find 'meaning' in them.*

▶ *In contrast, Man Ray's work (Figure 1.2) is less obviously about aesthetics because it is an everyday object, albeit modified. Furthermore, the modification (the addition of nails) subverts the object's use. Using an iron to create a work of art might be seen as trying to engage with the everyday; adding nails appears to destabilize this. Rather than an aesthetic effect, Gift summons up ideas of aggression, alienation and harm.*

▶ *Gift is not Modernist; Counter Composition XIII and Early One Morning are. However, all three works are modern, both*

> *chronologically and in that they differ in appearance, and, in the*
> *case of the Man Ray and the Caro, in the use of materials, from what*
> *we would more conventionally regard as art.*

As well as discussing aspects of modern art he defined as avant-garde, Bürger also identified some post-1945 artistic practices as having continued the aspirations of the 'historical avant-garde' (he called this post-war manifestation the 'neo-avant-garde'). But he considered the 'neo-avant-garde' ineffectual as a means of critical opposition to the political and cultural elite because it was, in his view, merely repeating the failed strategies used by the 'historical avant-garde'. Furthermore, 'neo-avant-garde' work, widely purchased by museums and collectors, was quickly institutionalized by the very elite with which it had sought to take issue.

Although he had charted the failed project of the avant-garde, Bürger's text suggested how art had attempted to intervene in aspects of the social, political, economic, moral, philosophical and cultural order of everyday life with the purpose of bringing about positive change.

What was important for the evolution of contemporary art was the challenge this presented at precisely the time Modernist ideas of art's autonomy from socio-political concerns were being disputed. Bearing in mind the terms discussed and defined above, let us now look at some of the developments in art between the 1950s and the 1970s. This should enable us to explore how much, how significantly, and in what ways, art of this period can be seen to have prompted the practices of the past 30 years.

Insight

Our discussion of terms has led us to suggest that contemporary art (modern art of the past 30 or so years) has its origins in those earlier modern art movements where form (appearance/materials) contributes to content (subject and resultant meaning), rather than form being the content (as Modernist critical theory would have it).

Section 2 The neo-avant-garde

In the years following the end of the Second World War, certain forms of modern art were elevated to canonical status largely because they were promoted by Modernist critics, the most influential being Clement Greenberg. Through critical writing and exhibitions, Modernists praised the work of Abstract Expressionist painters such as Jackson Pollock, Willem de Kooning and Mark Rothko for its aesthetic value rather than any meaning it might have in relationship to issues, themes and concerns outside art. Although Pollock spoke about how his drip paintings were statements of the age in which he lived, Modernist critical theory claimed that, while they may well have other meanings, their significance lay in the aesthetic effect generated by their formal characteristics – paint surface, colour, lines, scale and flatness.

Modernist ideas, especially through Greenberg's writing and his close association with several of these artists, were extremely influential in the post-war period. By the early 1960s this was reflected in the critical response to abstract painting and sculpture, with accounts typically privileging form over content and aesthetic effect over meaning or message (such as Figure 1.1). Such critical readings came to dominate galleries, museums, exhibitions and the business of sale rooms.

Insight

Greenberg's ideas had a considerable influence on the way art was viewed and understood in the 1950s and 1960s and Modernism became the pre-eminent critical theory. Therefore, it is not surprising that those artists whose work did not 'conform' to Modernist ideas, or those commentators who did not agree with them, challenged this hegemony. (See Barbara M. Reise, 'Greenberg and The Group: A Retrospective View', originally published in 1968 and reprinted in Frascina and Harris (1992).)

As we have seen, the selectivity of the Modernist position left a good deal of art outside its parameter of taste. The example cited earlier of Man Ray's *Gift* (Figure 1.2) failed to meet Modernist criteria for 'significant' and 'good' art but, in fact, it was with such works that the foundations of contemporary art were laid and not by those works admired and celebrated by Greenberg and his devotees.

But even as early as the 1950s some artists were already challenging the Modernist hegemony (the controlling influence of Modernist ideas). One was the American Robert Rauschenberg (1925–2008), who, in 1954, began to make what he called 'combines', combinations of painting and three-dimensional elements. Not only did these 'combines' contest the Modernist concept of medium-specific art, but because they used everyday materials – glass, electric light fittings, steel wool, magazine clippings, postage stamps, furniture, Coca-Cola bottles, stuffed animals and so on – they were seen as reconnecting art with life. In defence of his work, Rauschenberg noted that there were few things in his daily life that had to do with oil paint, thereby declaring that his art was about life rather more than it was about art. Consequently, some critics saw Rauschenberg and other American artists, such as Jasper Johns, Edward Kienholz and Bruce Connor, as re-establishing art as an avant-garde practice rather than sustaining it as a Modernist one.

Before going any further, you might want to think about the term medium-specific in relation to Modernism and what has been said about Rauschenberg's work.

▶ *Modernist critics, like Greenberg, claimed that quality in art was the consequence of the viewer's response to a work's formal characteristics – its colour, shape, line, etc. But in order for this to operate, the work of art must stay within the limits of its discipline. As Greenberg put it: '[artists should] use the characteristic methods of the discipline to...entrench it more firmly in its area of competence' (quoted in Harrison and Wood (2003), p. 774). The limits of the discipline of painting*

(Contd)

('its area of competence') are shape, colour and the flatness of the canvas.

▶ But a work that includes paint, glass, electric light fittings, steel wool, magazine clippings, postage stamps, etc., like Rauschenberg's 'combines', is neither a painting nor a sculpture; it is not medium-specific and so, if we accept the Modernist principle, it fails to possess aesthetic value or quality.

▶ You might have also thought about how medium-specific art favours conventional forms of art making such as painting, and so perpetuates them, arguably inhibiting change. Furthermore, paint alone could be restrictive to an artist's creative expression – a combination of paint, glass, steel wool and magazine clippings may be a more effective means to express or communicate a subject or idea.

▶ As a result of all this, we might say that Rauschenberg's 'combines' deliberately challenged the constraints of Modernist taste by combining two- and three-dimensional elements drawn from non-artistic sources. In doing so, they developed the idea that contemporary art could be 'hybrid' – made from a variety of media or objects, rather than just one.

If this book had been about an earlier art historical period – the Renaissance, the Baroque, or even the earlier twentieth century – painting would have been the dominant discipline of the visual arts. But if you look at this book's illustrations of art made after 1980, not only are paintings in a minority, thereby indicating that this is no longer the pre-eminent artistic form, but very few of the works illustrated can be categorized as medium-specific. This might suggest that the work of Rauschenberg and a number of his contemporaries made an important contribution to the development of contemporary art.

As in the United States with Jackson Pollock and the Abstract Expressionists, in the two decades following the end of the Second World War, the work of a number of European artists seemed to be judged as Modernist. Matisse's brightly coloured paper collages, the bold, black brushstrokes of Pierre Soulages's abstract paintings, and the welded, bolted and painted sculptures of Anthony Caro

(Figure 1.1), all appeared to endorse medium specifity, the primacy of form over content, and the separation of art from the concerns of everyday life. But, even as early as the mid-1950s, Modernist dogma was being contested. One of the contributions to the 1956 exhibition *This is Tomorrow* at London's Whitechapel Art Gallery, appears anti-Modernist in its form, content and ideas.

Please look at the exhibit for the exhibition *This is Tomorrow* (Plate 2) by Richard Hamilton (b.1922), John McHale (1922–78) and John Voelcker (1927–72). What features would you identify as anti-Modernist?

▶ *If you establish what Modernist means, identifying what might be anti-Modernist should prove straightforward. In the way we have been discussing it, Modernism stresses:*
 ▷ *the importance of form over content to elicit an aesthetic response in the viewer rather than the interpretation of a message*
 ▷ *the separation of art from the experience of everyday life*
 ▷ *a medium-specific art.*
▶ *While there is aesthetic content in this exhibit, the subject matter dominates. Or to put it another way, we are far more aware of the imagery than we are of the things that form the imagery, such as the shapes, colours, textures, etc. Consequently, the exhibit might be seen as a challenge to the first Modernist criterion listed above.*
▶ *You may also have noticed that the imagery is not conventionally that of a work of art, at least not in 1956. It is taken directly from mass communication media, which we would understand to be film, television, mass-circulation magazines, advertising and so on. The illustration of Marilyn Monroe, the over-sized bottle of Guinness, and the robot carrying the woman (which is taken from a poster for the film* Forbidden Planet*) are mass-media images. Only Van Gogh's* Sunflowers, *positioned next to the woman's legs, refers to 'art', but this is, in fact, a postcard reproduction and so a mass-produced version of a unique painting. The various connections to popular culture (in this case, cultural forms created for a mass audience)*
(Contd)

> *signify the* This is Tomorrow *exhibit's close relationship to aspects of everyday life, a stance which is anathema to the Modernist position.*
>
> ▶ *Considering the third Modernist criterion listed above, this exhibit is not medium-specific; there is painting (Monroe, the robot and his unconscious companion), a mechanically printed mass-reproduced postcard (of the Van Gogh painting), a 'sculpture' (the outsize bottle), an 'architectural' structure (through which viewers walk), a microphone (with the 'speak here' label), and more inside the structure that this photograph does not show – a spongy floor, projected film, magazine pages and optical illusion imagery.*

The engagement with popular culture that Plate 2 demonstrates was completely at odds with Greenberg's Modernist beliefs. In 1939 he had written an essay called 'Avant-garde and Kitsch', which claimed the role of the avant-garde was to maintain culture, whereas kitsch, which for him included popular mass culture, was 'the epitome of all that is spurious in the life of our times…[demanding] nothing of its customers except their money – not even their time' (quoted in *Harrison and Wood* (2003), p. 543).

Only a few years after the *This is Tomorrow* exhibition, Pop Art emerged in the United States and Europe, a movement that drew much of its inspiration from popular culture. Epitomized by Roy Lichtenstein's comic book imagery, Peter Blake's paintings of Pop music stars and Mimmo Rotella's torn poster collages, Pop Art challenged Modernism's claims that art was primarily a medium-specific aesthetic experience independent from life. Furthermore, Pop seemed to question the boundary between high and low art – between fine art and kitsch, as Modernists had categorized these apparently different cultural manifestations. But once Pop Art had assimilated mass media and consumer imagery into the arena of fine art, not only did art's appearance change forever but also its ivory tower elitism was called into question. As we shall see later,

popular culture, consumerism and contemporary art are areas between which there is frequent interchange.

In December 1961, the American artist Claes Oldenburg (b.1929) created *The Store* on East Second Street in Manhattan. Renting a shop set among others selling cheap and second-hand items, he named his outlet the 'Ray Gun Manufacturing Company'. The back room functioned as a studio where Oldenburg made crudely modelled replicas of clothes, food and small objects from painted cardboard, plaster and plaster-soaked muslin, which were then displayed on improvised shop fittings and sold. By exhibiting in a shop, albeit one he created, Oldenburg was connecting art with everyday life by asserting its role as a commodity for purchase and display.

What do you think are the principal differences between Oldenburg's *The Store*, as it has been described above, and Caro's sculpture (Figure 1.1)?

▶ *Apart from the clear differences in the materials used – Caro's metal sculpture and Oldenburg's painted plaster objects – the setting for each is quite different.* Early One Morning *is exhibited in a gallery, whereas* The Store *was in a New York shop. In fact, the shop was part of Oldenburg's work and integral to its character, but the gallery, while playing a role in* Early One Morning's *effect on the viewer, was not something created by the artist.*

▶ Early One Morning *is made from a number of metal elements, arranged and painted to form a stylistically interconnected whole;* The Store *was a collection of disparate painted plaster objects and improvised shop fittings.*

▶ *To experience Caro's sculpture, the viewer must walk around it; to experience* The Store, *the viewer had to enter and be part of it.*

In considering the differences between these two works of art, it is also important to know that Caro's sculpture is now part of London's Tate Gallery collection and frequently displayed at

Tate Britain; *The Store* was never permanent. It was dismantled and now exists only in photographs and some of the objects that Oldenburg made for it are in museum collections. You might consider that the temporary nature of *The Store* imitates the transitory nature of commodities and popular mass culture, whereas *Early One Morning* is enduring as a permanent exhibit in a museum's collection of art.

The abstract nature and use of industrial materials in Caro's work might have challenged sculptural conventions of the time, but *The Store* and the *This is Tomorrow* exhibit involved the viewer in ways that *Early One Morning*, and Modernist art in general, could never do. Visitors walked into both exhibits and their experience was multi-sensory: they could see, touch, smell and sometimes hear the work. At the time, such pieces were called 'environments' but, in the terminology of contemporary art, they became installations, a form we shall discuss in Chapter 4, Section 5.

As well as creating environments, Oldenburg and other American artists, such as Allan Kaprow, Red Grooms and Jim Dine, were involved in 'happenings' – part exhibition, part theatrical presentation, usually by the artist. Later re-labelled as performance art (see Chapter 4, Section 4), happenings generally avoided plots, actors, scripts and rehearsals, although they were rarely improvised events. In *Snapshots from the City* (1960), Oldenburg was wrapped in bandages and smeared with dirt in an environment of newspapers and cardboard; in Tokyo, predating happenings in the United States, Kazuo Shiraga of the Gutai group wrestled with a thick pool of mud in *Challenging Mud* (1955); in France, Yves Klein directed two nude female models to sponge themselves with blue paint and imprint markings of their bodies on large sheets of paper (*Anthropometry of the Blue Epoch*, 1960), while Niki de Saint-Phalle fired a rifle at bags of paint attached to a board to create *Fire at Will* paintings (1961).

Environments and happenings were just two of the art practices that confronted Modernist standards of aesthetic value, notably

by engaging with socio-political and economic-cultural concerns and insisting on the supremacy of content over form. Oldenburg summed this up in a text issued at the time of his *Store* show:

I am for an art that embroils itself with the everyday crap & still comes out on top. I am for an art that imitates the human, that is comic, if necessary, or violent, or whatever is necessary. I am for an art that takes its form from the lines of life itself, that twists and extends and accumulates and spits and drips, and is heavy and coarse and blunt and sweet and stupid as life itself.

(Quoted in *Harrison and Wood* (2003), pp. 744–5)

The work of Rauschenberg, Oldenburg, Klein, Shiraga, Saint-Phalle and others, represented the dramatically changed artistic practices of the later 1950s and 1960s, examples which were to influence the work of subsequent artists.

The following three descriptions illustrate examples of radical art made in the 1960s and early 1970s. Please read them and think about the possible intentions or motivations associated with each work.

1 In 1961 Piero Manzoni (1933–63) produced 90 tins each containing 30 grams of his own faeces. Signed, numbered 001 to 090 and labelled 'Artist's Shit' in Italian, French, German and English, he sold them by weight for their equivalent price in gold (see http://www.tate.org.uk – search 'Manzoni shit').

2 In 1966 John Latham (1921–2006) tore out and, with associates, chewed pages from Greenberg's book *Art and Culture*, which was on loan from St Martin's School of Art in London, where he taught. When the library recalled the book, he presented a phial of masticated paper pulp. He later displayed the evidence of his actions – the phials of pulp, chemicals added to the phials, letters from the library, a copy of Greenberg's book, and so on – in a briefcase, calling it *Art and Culture* (see http://search.moma.org – search 'Latham art and culture').

3 In 1971 in a New York gallery, Vito Acconci (b.1940) lay under a specially constructed floor and, while vocalizing his fantasies about the visitors he could hear above him, masturbated. In their turn, visitors heard Acconci beneath the floor. The work was called *Seedbed* (see http://www.dailymotion.com/video/x7ygpc_vito-acconci-seedbed-1972_creation).

You might consider these examples radical, perhaps extreme, but from what we have said so far, it should be possible to identify serious aims and intentions.

▶ *All three works use unconventional materials and processes, and seem to have little or no interest in aesthetic effect. In these ways they challenge both conventional art forms and the medium specific aestheticism associated with Modernism.*

▶ *Manzoni's* Artist's Shit *appears to be making the point that whatever the artist makes is art. This owes something to the ideas of Marcel Duchamp, whose early twentieth-century ready-mades proposed that an artist could confer the status of art on any object. But such art has to be presented appropriately. In Manzoni's case,* Artist's Shit *came in a limited edition of 90, priced in relation to gold, and each tin was signed. You might ask yourself whether Manzoni was conforming to ideas that art should be financially valuable, have specific authorship, and not be mass-produced, or whether he was using these conventions to subvert them.*

▶ *Since Latham chose Greenberg's book, his work seems more clearly an attack on Modernist values. Not only did he destroy the book and, by implication, its ideas, he used unconventional methods to do it. Whether you think this was an artistic act largely depends on what you think art is.*

▶ *Like Manzoni's work, Acconci's may be about what the artist produces, in this case semen. But* Seedbed *was also about involving the public in the work by creating a situation of interchange between artist and visitor (although visitors were not knowingly complicit in what was going on). Moreover, the work was not really visual, but oral and aural.*

Each of these examples involved the artists' bodily functions – defecating, chewing and masturbating. For Manzoni and Latham the work exists independently of the artist, but for Acconci the work existed only at the time of the exhibition (although there are photographs and a video of the event). Seen against the background of momentous social change (about which we will say more in the next chapter), practices such as these signified an expansion in the concept of art.

By the mid-1960s, it had become clear that art wasn't what it used to be. Challenging painting as the pre-eminent form of the visual arts were environments, happenings, photography and the use of the artist's actual body. There was also much experimentation with different materials. In France the Nouvelle Réaliste (new realist) artists used mass-produced products, from crushed cars (César) to shaving brushes inside a transparent mannequin (Arman). In Italy artists associated with Arte Povera (poor or impoverished art) rejected conventional art materials and references to modernity, technology, consumerism and commodity culture, using glass, wood, lead and fabrics (Merz, Anselmo, Fabro, Pistoletto). In Germany Bernd and Hilla Becher took black-and-white photographs of industrial architecture, framing them in sets depicting water towers and blast furnaces, while in the United States Edward Ruscha produced a limited-edition book called *Every Building on the Sunset Strip* (1966), which was exactly that – photographs of every building on Los Angeles's most famous street.

Not only was there an expansion in the use of artistic materials and processes, but art's purposes and intentions were questioned. In the later 1960s the idea, or concept, itself came to be considered as significant, if not more significant, than the physical work. The conceptual artist Joseph Kosuth presented photostat dictionary definitions of words such as 'meaning' and 'nothing', and his colleague Lawrence Weiner sold proposed works of art that, if the buyer wanted, would be realized by the artist.

In the face of all this, Modernists maintained that art should elicit an aesthetic response in the viewer, but along with conceptualists,

Pop and performance artists, so-called Minimalist artists, such as Donald Judd (1928–94), Carl Andre and Robert Morris, were testing Modernism's sacrosanct beliefs.

Please look at Donald Judd's *Untitled* (Figure 2.1). What points of similarity and difference can you identify between it and Caro's *Early One Morning* (Figure 1.1)?

Figure 2.1 Donald Judd, Untitled, 1971–2. Anodized aluminium and Plexiglas. Each unit: 120.7 × 152.1 × 152.1 cm (47.5 × 59.9 × 59.9 in.) St Louis Art Museum, St Louis. Photo: Graham Whitham.

▶ Both sculptures are made from metal and are abstract and angular.
▶ The arrangement of Early One Morning *is relatively complicated, being made up of a number of separate elements – flat pieces, angled sections, rods; some are vertical, some horizontal, some set at an angle, and all arranged asymmetrically.* Untitled *is a repetition of the same unit in a symmetrical arrangement, relatively simple in overall form.*
▶ Space 'flows' in-between the linear and planar forms that make up Early One Morning *and is, arguably, as much part of the work's appearance as the forms themselves; the metal boxes of Judd's work have the effect of enclosed space and it is not a space the viewer can enter physically, as they could with Caro's piece.*

> ▶ *Imagine moving around* Early One Morning; *each time you moved you would see a different sculpture, so to speak; moving around Judd's* Untitled *would only result in a range of similar views.*
> ▶ *Although the photographs do not show it, Caro's work is painted red; Judd's is the colour of the materials used – aluminium and Plexiglas (perspex).*

Minimalists made 'objects', as they called their works, that were simple in form and would not necessarily engage a viewer's attention for very long. However, one of them, Robert Morris, argued that 'simplicity of shape does not necessarily equate with simplicity of experience' (quoted in Harrison and Wood (2003), p. 830), suggesting that the object's uniformity and predictability aimed to encourage the viewer's awareness of their own presence in relation to it and its relationship to the setting. Therefore, he argued that Minimalism's meaning resulted from the interaction of work, viewer and location rather than from merely the work itself (this idea has significance for the development of installations and is discussed in Chapter 4, Section 5).

Although the critic Barbara Rose famously claimed that nobody really liked Minimalism, despite being married at the time to the Minimalist painter Frank Stella, its influence in the later 1960s was considerable. By the end of the decade some artists were developing the possibilities Minimalism had suggested. Robert Smithson (1938–73), whose work had engaged with Minimalist forms and ideas, began to make works that more directly interacted with their setting and, in the process, challenged the monopoly of galleries, museums and exhibitions: a woodshed buried underneath 20 truckloads of earth and a 500-m-long earth spiral projecting into Utah's Great Salt Lake. These were made exclusively for a particular location, which was integral to their meaning. So-called 'site-specific sculpture' or, in the case of Smithson's woodshed and spiral projection in Utah, land art (see Chapter 4, Section 6), was part of a whole range of practices that the critic Rosalind Krauss (b.1941) identified as 'the expanded field of sculpture'. In a highly influential essay she wrote:

*Over the last ten years rather surprising things have come to be
called sculpture: narrow corridors with TV monitors at the ends;
large photographs documenting country hikes; mirrors placed
at strange angles in ordinary rooms; temporary lines cut into the
floor of the desert. Nothing, it would seem, could possibly give
to such a motley effort the right to lay claim to whatever one
might mean by the category of sculpture. Unless, that is, the
category can be made to become almost infinitely malleable.*

(Krauss (1986), p. 277)

What Krauss identified in sculpture was endemic in much artistic
practice in the 1960s and 1970s; there had been a shift from an
established consensus about what art was or should be and a
plethora of hybrid forms that brought this consensus into question.
In other words, art was no longer a relatively clearly defined series
of conventional activities, such as painting and sculpture, but a
diverse and frequently unconventional range of forms, acts and
performances.

While performing a work at the University of Aachen in 1964,
which involved melting fat on a hot plate accompanied by a
recording of a Nazi speech, the German artist Joseph Beuys
(1921–86) was attacked by right-wing students, an event which
he recalled further politicized his work. A performance artist who
exploited the symbolism of materials, gestures and actions, Beuys
was a founder of the German Student Party, which advocated
worldwide disarmament and educational reform, an organizer of
Direct Democracy by Referendum, proposing increased political
power for individuals, instigator of the Free International University,
which emphasized the creative potential in all human beings, and a
founding member of the Green Party.

Although Beuys's work might seem obscure – in *I Like America
and America Likes Me* (1974) he lived for several days with a wild
coyote in a gallery – political and social radicalism was fundamental
to his life and art. Indeed, as it was for pre-war movements such as

Dada, art as an aesthetic activity was anathema to Beuys; he regarded what he did as an artist as inseparable from what he did in his everyday life. Although Peter Bürger had claimed that the neo-avant-garde, of which Beuys must be considered a part, was ineffectual as a means of social criticism, Beuys's example disputes this.

Please read the following claim Beuys made in an interview in 1985:

> **By artists I don't just mean people who produce paintings or sculpture or play the piano, or are composers or writers. For me a nurse is also an artist, or, of course, a doctor or a teacher. A student, too, a young person responsible for his own development. The essence of man is captured in the description 'artist'. All other definitions of this term 'art' end up by saying that there are artists and there are non-artists – people who can do something, and people who can't do anything.**
>
> (Quoted in *Nairne* (1987), p. 93)

How do you think this might relate to ideas about the avant-garde discussed earlier?

▶ *You might feel that broadening the term 'artist' to mean 'the essence of man' [meaning humankind] is excessively liberal and permissive, but this claim does meet two of the original principles of the artistic avant-garde as noted on p. 21: to 'spread new ideas' and to be socially radical.*

▶ *If what a nurse, doctor, teacher, student, or anyone else does is designated as art, and if everyone is an artist, it is conceivable that the canon of 'great art' and cultural hierarchy, together with the system of artists, dealers, patrons, galleries and museums that supports them, would be destabilized and collapse. Therefore, you might see Beuys's claim as a form of critical opposition to the cultural 'establishment', which could be deemed as a primary intention of the avant-garde.*

▶ *On the other hand, you might consider Peter Bürger's argument in* Theory of the Avant-garde *we discussed earlier. He maintained that the 'neo-avant-garde' merely repeated the failed strategies*

(Contd)

> *of the 'historical avant-garde'. If you look again at Man Ray's* Gift
> *(Figure 1.2), which belongs to Bürger's 'historical avant-garde',*
> *its unconventional use of materials and subsequent form could*
> *be understood as opposing the cultural norms of its day and, by*
> *association, its social and political hierarchies. But Bürger argues that,*
> *in the end, such works of art were an ineffective critique of society,*
> *and you may feel that Beuys's claim is no different.*

In the 1960s Beuys was associated with the Fluxus group, whose members believed that banal, everyday actions were as worthy of consideration as artistic events. Together with the Situationist International (SI), whose origins lay in extreme leftist politics and which, throughout the 1960s, advocated a kind of intellectual terrorism in which art would play a role, the ideas and work of Fluxus engaged with social and political radicalism. *The Fluxus Manifesto*, written by George Maciunas in 1963, declared:

> **Purge the world of bourgeois sickness, 'intellectual',**
> **professional and commercialized culture. Purge the world**
> **of dead art, imitation, artificial art, abstract art, illusionistic**
> **art…promote a revolutionary flood and tide in art. Promote**
> **living art, anti-art, promote non art reality to be grasped by all**
> **peoples, not only critics, dilettantes and professionals.**

> (The manifesto is reproduced in a number of publications,
> including Higgins (2002), p. 76)

In their opposition to social and political conventions and control, the work and ideas of Beuys, Fluxus and the SI represent a link with the inter-war avant-garde movements (Bürger's 'historical avant-garde') such as Dada. Compare the extract from the *Fluxus Manifesto* with one from a 1920 Dada article: 'The bourgeois must be deprived of the opportunity to "buy up art for his justification". Art should altogether get a sound thrashing, and Dada stands for the thrashing…' (Quoted in Harrison and Wood (2003), p. 262)

But where does this leave us in respect of art's more recent history? On the one hand, politically and socially critical art has

flourished in the past 30 years, but its objective has not focused on assaulting the standards and conventions of the middle class (the bourgeoisie). Rather it has been a critical exploration of issues that are arguably more pertinent to contemporary life, such as gender and ethnic identity, consumerism and globalization (see Chapter 5). On the other hand, the strategies used by both the pre- and post-war avant-gardes provided paradigms or patterns for many contemporary artists. These amounted to:

▶ *a significant challenge to the idea of art principally as an aesthetic activity*
▶ *the use of new and unconventional materials, processes and techniques, bringing about the breakdown of previously discrete artistic disciplines, such as painting and sculpture (see Chapter 4, Section 1)*
▶ *art becoming increasingly indistinct from other areas of culture – film, television, advertising, science, computer-generated imagery and so on – an idea which is discussed in later chapters.*

Insight

The examples we have given in this section challenge conventional artistic forms and contest aestheticism and medium-specifity as primary criteria for art. Moreover, they propose approaches that appear to inform later, more contemporary art.

Section 3 Reading contemporary art

So far, this chapter has proposed that contemporary art is, to some degree, derived from, and influenced by, previous forms and debates about meaning and purpose. The examples that have been cited illustrate that during the post-war period there was a determined challenge to Modernist dogma, resulting in:

▶ *art as a more permissive concept, verified by the use of diverse ideas, materials, methods and processes*

▶ *a strident questioning of art's autonomy from life*
▶ *an assumption that art developed as part of a dialogue with context, space and the viewer or audience.*

To what extent art had always engaged with life was an issue thrashed out by critics and art historians from the 1960s onwards, but the fact that this was discussed at all suggests opposition to Modernist claims for art's aesthetic independence. In 1985 the American critic and theorist Hal Foster (b.1955) characterized art's changing purpose.

Please read the short extract from Hal Foster's essay 'Subversive Signs':

> **the artist becomes a manipulator of signs more than a producer of art objects, and the viewer an active reader of messages rather than a passive contemplator of the aesthetic...**
>
> (Quoted in *Harrison and Wood* (2003), p. 1038)

Thinking about what we have discussed in the previous sections, how would you interpret what Foster is saying?

▶ *Foster claims that contemporary artists (or at least artists working around the time he wrote the essay) were 'manipulator[s] of signs' more than 'producer[s] of art'. In order to make sense of this we have to understand what he means by 'art' in this context. Since he goes on to say that the viewer is no longer 'a passive contemplator of the aesthetic', it appears he is referring to 'art' in a Modernist sense – an autonomous, aesthetic experience. This suggests that the viewer simply receives what the work of art has to offer, implying it is an aesthetic experience distinct and different from the artist's and viewer's experiences of social, economic, political and cultural conditions, or moral and philosophical imperatives.*

▶ *Claiming that contemporary 'art' provides messages, which the viewer has to 'read' actively by interpreting 'signs' that artists have embedded in their work, he proposes this is the way art has changed.*

It is worth knowing that Foster's essay goes on to say that the change he identifies is not new and, because he references Dada and Pop Art as examples of earlier practices that were 'manipulator(s) of signs more than...producer(s) of art objects', he connects the inter-war avant-garde and the post-war avant-garde (Bürger's 'historical avant-garde' and 'neo-avant-garde') with the evolution of contemporary art.

To illustrate Foster's premise, please look again at Plates 1 and 2. Which work best illustrates Foster's idea of art being an aesthetic object to be contemplated, and which can be understood as a grouping of signs and messages to be actively read?

> ▶ *On one level, this question is very easy. Van Doesburg's* Counter Composition XIII *(Plate 1) seems to fit the first definition and the* This is Tomorrow *exhibit (Plate 2) the second. What messages could we possibly read into an arrangement of yellow, black, red and grey triangles? The imagery of the 1956 installation is much more straightforward as a grouping of signs and possible messages, with its references to fine art and popular culture, to consumerism, and the stereotyping of women.*
>
> ▶ *However, any mark might be a sign and have a message. Van Doesburg claimed that his paintings were images of an aesthetic unity of harmony and equilibrium and the composition of lines, shapes and colours might communicate precisely that to the viewer. Equally, do we necessarily interpret a robot carrying a woman and Marilyn Monroe as examples of gender stereotyping?*

Insight

Foster's claim is not a comprehensive truth about all contemporary art, but a broad estimate that identifies a noticeable shift from an aesthetic-based art with its parallel assumption of a contemplative and passive viewer, to a message-based art with an active and discursive viewer-reader. Just how these messages might be read and interpreted is the subject of the remainder of this book.

Suggestions for further reading

Michael Archer, *Art Since 1960*, Thames and Hudson, 2002

Mark Cheetham, A. *Abstract Art Against Autonomy: Infection, Resistance, and Cure since the 60s*, Cambridge University Press, 2006

Richard Cork, *Everything Seemed Possible: Art in the 1970s*, Yale University Press, 2003

Hal Foster *et al.*, *Art since 1900: Modernism, Antimodernism, Postmodernism*, Thames and Hudson, 2004

Charles Harrison, *Modernism*, Tate Publishing, 1997

David Hopkins, *After Modern Art, 1945–2000*, Oxford University Press, 2000

Grant Pooke and Diana Newall, *Art History: The Basics*, Routledge, 2008

Anne Rorimer, *New Art in the 60s and 70s: Redefining Reality*, Thames and Hudson, 2001

Paul Wood (ed.), *Varieties of Modernism*, Yale University Press, 2004

Paul Wood *et al.*, *Modernism in Dispute*, Yale University Press, 1993

THINGS TO REMEMBER

▸ *In order to understand contemporary art, it is necessary to look at the ideas, themes and interests of the art that preceded it; that is, art from c.1945 until the later 1970s.*

▸ *Depending on your point of view, contemporary art is a continuation of modernist ideas and hence classified as 'late modernism'; a shift in cultural practice responding to historical and cultural circumstances that we might call 'postmodernism'; or a reaction to Modernist critical theory, which emphasized the aesthetic aspects of art, claiming that form over content and medium-specificity were prerequisites of 'good' art.*

▸ *Contemporary art is often seen to evolve from post-1945 avant-garde practice, which itself is a development of inter-war avant-garde art.*

▸ *The post-1945 avant-garde, or neo-avant-garde, challenged Modernist ideas of medium-specificity and the dominance of form over content. Much contemporary art does this and so we might conclude that contemporary art was influenced by the neo-avant-garde.*

▸ *Hal Foster's 1985 text 'Subversive Signs' provides a generalized view of the change from pre-1980 to post-1980 art by emphasizing the active participation of the viewer, rather than the passive contemplation of aesthetic qualities encouraged by Modernist critical theory.*

3

Contexts for contemporary art

In this chapter you will learn:

- *how contemporary art can be interpreted and understood in relation to social, political, economic and philosophical contexts*
- *how social and political circumstances can influence the form and content of contemporary art*
- *why economic conditions play a significant role in the creation, promotion and recognition of contemporary art, and how they affect the public reception and response to art*
- *how contemporary art responds to pervading philosophical concepts and cultural fashions.*

Section 1 The march of history

When Henri Matisse and his fellow artists exhibited their paintings at the Autumn Salon in Paris more than a hundred years ago, they were nicknamed 'wild beasts' (*fauves*). Their bravura brushwork and vivid colour was quite unlike other painting of the time and they started something that became an ever-accelerating and intensified cycle of challenging and unconventional artistic production. Now, at the end of the twenty-first century's first decade, that process has resulted in an almost infinite array of artistic practice.

Among the origins of modern art, with its innovative forms and challenging ideas, were the fauve paintings of 1905. Their exhibition

and display coincided with burgeoning industrialization, urbanization and technological innovation, and with the capitalism associated with developing global markets, but this was no coincidence. While Matisse and his colleagues used brilliant colours and bold brushstrokes, Europe was industrializing and colonizing.

The 'primitive' style of fauve art, together with its subject matter, which often related to nature or a life close to nature, is sometimes seen as a reaction against the materialism that was beginning to characterize the age. It was also a response to the artefacts of colonized peoples, widely imported and housed in ethnographical museums and collections. What this strongly suggests is that art is a product of its time and not created in a cultural vacuum; that historical, social, economic and philosophical contexts influence its emergence, development and reception. If fauve art can be understood as a product of historical conditions in the early twentieth century, then the art of our own time might be seen as a response to the contemporary world.

Insight

The direct relationship between art and its historical contexts is not always straightforward and is sometimes difficult to verify with any certainty, but an understanding and awareness of historical conditions and how they came about will help us to grasp and comprehend contemporary art.

The modern world is significantly different from that which preceded it. Since the 1980s there have been many eventful developments in all areas of human activity, from science, technology and medicine to politics, economics and culture. Thirty years ago the world was divided into opposing political ideologies of capitalism and communism; we knew little about the ozone layer's depletion above Antarctica or of AIDS; there were no personal computers, DVDs, iPods and mobile phones, no such currency as the euro. If art 'mediates' or is a product of its times, how far is it influenced by historical and current events and to what extent is it a response or a reaction to them?

As explored in the previous chapter, the art of our time did not simply appear but had its genesis in previous forms of aesthetic practice and debates concerning meaning and purpose. We might also add that its origins lie in earlier contexts that inform current social, political, economic and philosophical conditions.

As Chapter 2 suggested, the later 1950s and 1960s were a watershed for art with Modernist hegemony disputed by practices and debates variously labelled postmodern, late modern and neo-avant-garde. We suggested that these changes reflected uncertainty and insecurity brought about by significant shifts in social, economic, political and cultural conditions. What were these changes and how are they relevant to the contemporary world and its art?

Please look at the exhibit for the exhibition *This is Tomorrow* (Plate 2) by Richard Hamilton (b.1922), John McHale (1922–78) and John Voelcker (1927–72). Considering that the exhibit was originally made in 1956, what features would you regard as characteristic of its time?

▶ *Specifically, you might have identified Marilyn Monroe, an iconic film star of the period (the image is from the film* The Seven Year Itch, *made in 1955), and Robbie the Robot, a character from the 1956 film* Forbidden Planet. *You may also have noted the giant bottle of Guinness, although this is less date specific than the film references.*

▶ *More generally, you might have considered that the exhibit was characteristic of its era because the images of Monroe and Robbie the Robot were taken from what was known at the time as the mass media (film, television, mass-circulation magazines, etc.) and Guinness, a product and brand, is part of consumer culture. Both the media and the explicit references to consumerism are important features of the modern age, although still in their relative infancy in 1956.*

Insight

History, tradition, convention, intellectual content and vested interests have created a distinction between art and other

visual forms. Art is regarded as unique whereas other forms are generally mass-produced; art is considered culturally and financially more valuable than many other visual forms. We ascribe labels such as 'elite' and 'popular', 'high' and 'low', to define these apparent distinctions. But the differences between art and other visual forms are sometimes not so clear cut.

The development, growth and influence of mass media and consumer culture are particularly significant and ongoing contexts for contemporary art (see Chapter 5, Section 3). This is especially true of television, which has had a profound effect on the way we interpret images, understand information, and generally perceive our world. The medium of television is in our homes and so, for most of us, is part of our daily lives and its influence is pervasive. Since 1971 we have been able to record TV programmes and, more recently, with the arrival of satellite channels, there has been more to watch and more to record. Technological developments have also made TV screens larger, images clearer and sound more 'realistic'. With the addition of 24-hour news channels, others that cater just for the weather, natural history, for younger audiences and so on, and the availability on DVD of virtually any film, TV programme or subject, we might reasonably think we are approaching information overload.

Given this context, we should not be surprised that art, like our everyday lives, has changed. As we noted in Chapter 2, the *This is Tomorrow* exhibit was at odds with prevailing norms in art, not only as a result of its popular culture subject matter, but also because it fell outside conventional artistic forms, being neither painting nor sculpture. Equally, video and film works made by artists are still, for many of us, blurring the boundaries between what we expect to see on a TV or cinema screen and what we encounter in museums and art galleries. Plate 2 is an early example of art responding to the contexts of popular culture, mass media and consumerism; Plate 3 illustrates how that process has become more sophisticated.

Matthew Barney (b.1967) is an American artist who made five films called *Cremaster* between 1994 and 2002. They are unconventional in theme and narrative, having at least two endings and two sets of beginnings, but they are highly original and imaginative. However, they are made in the manner of a Hollywood production, employing editors, make-up artists, costume designers, composers and musicians, choreographers, animators, administrative assistants and actors (including Ursula Andress, the sculptor Richard Serra, the late writer Norman Mailer, a performance artist, a paralympic athlete, and Barney himself). Furthermore, they are screened in art galleries as well as cinemas, in addition to being a part of museum exhibits and film festivals.

Even with their partial description here, how do you think Barney's films might confuse or obscure the boundaries between mass popular culture and the idea of an elite, or high, art?

▶ *You may think that a professional artist, who uses Hollywood production methods, has celebrities and others play character parts, and shows his films in museums as well as cinemas, is both confusing and obscuring the boundaries between art and mass culture. But Barney's films are not made for mass consumption, principally because their narratives, characterizations and symbolism fly in the face of filmic convention, reducing the prospect of their broader cultural popularity. However, aspects do refer to the conventions of popular and more commercial film-making and therefore, if you recall an argument made in Chapter 2, to some degree such productions do engage with life rather than being autonomous aesthetic forms. Put another way, you might not be able to make immediate sense of what's going on in a Cremaster film, but because something is going on in recognizable (if sometimes strange) settings with distinctive characters, you can partly identify with it. This is because it is not wholly unlike everyday experience. This could not be said for the abstract painting illustrated as Plate 1.*

▶ *You might have looked at the question we posed in another way. Film is generally regarded as a medium of mass popular culture; art is more conventionally associated with a smaller and more exclusive audience. Moreover, film is reproduced and universally presented, often at the same time in different places; conventionally, works of art are associated with uniqueness and displayed in one specific location. In addition, film takes place over a period of time (in fact, the length of each* Cremaster *film ranges from just over 40 minutes to more than three hours) and we do not usually expect to watch a three-hour film in an art gallery. Viewing more conventional art – a painting or a sculpture – is typically an experience that in comparison lasts a relatively short time.*

The question of whether Barney's films confuse or obscure boundaries between mass popular, or low, culture and elite, or high, art is important because it draws attention to art's more recent engagement with aspects of culture hitherto regarded as inappropriate (see p. 28 and the reference to Greenberg's essay 'Avant-garde and Kitsch'). More generally, work by artists like Barney also questions what is actually meant by 'high' or 'elite' culture at a time when such qualitative tags are much less evident in other areas of social and economic life. Furthermore, this example suggests that art is intimately related to the social, historical and cultural contexts of its time: in this case an omnipresent industry of mass communications, media and consumer culture.

Perhaps more so than Barney's work, that of the American artist Jeff Koons (b.1955) might be seen as an explicit development of art in the 1950s and 1960s that responded to a burgeoning mass culture and consumerism (see the references to Pop Art on p. 28). Koons's *New Hoover Convertibles, Green, Red, Brown, New Shelton Wet/Dry 10 Gallon Displaced Doubledecker* (Figure 3.1) is a Plexiglas (perspex) case over fluorescent lights with vacuum cleaners displayed inside.

Please look at Figure 3.1. How might you interpret this work?

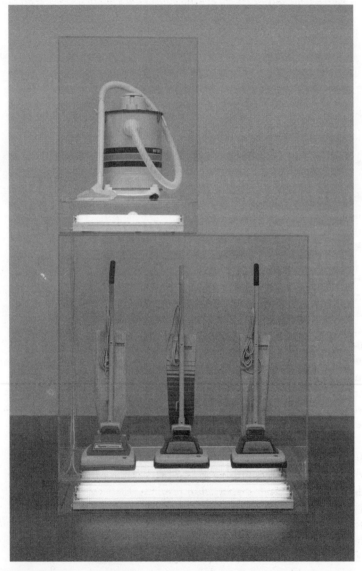

Figure 3.1 Jeff Koons, New Hoover Convertibles, Green, Red, Brown, New Shelton Wet/Dry 10 Gallon Displaced Doubledecker, 1981–87. Vacuum cleaners, Plexiglas and fluorescent lights: 251 × 137 × 71 cm (98.8 × 53.9 × 28 in.). Tate Gallery, London.

> ▶ *Looking at four vacuum cleaners in a transparent case illuminated by lights, you might think of a showroom or shop display. But because* New Hoover Convertibles *is not meant to persuade you to buy the vacuum cleaners – it is, after all, a work of art – it is difficult to determine the artist's intentions. Perhaps Koons is celebrating consumerism; it would seem that the shiny, pristine products in their pure, clean environment make a positive statement about selling and ownership.*
>
> ▶ *Equally, the work may be a celebration of the machine in the postmodern age. Koons once noted that he was a salesman of art and enjoyed making people patrons of the modern.*
>
> ▶ *On the other hand,* New Hoover Convertibles *may be seen as essentially critical of marketing and consumerism. It is conceivable that the work makes an ironic statement about materialist values in contemporary culture, seductive advertising, persuasion, and the manipulation of desire and ownership.*
>
> ▶ *Koons himself noted that there was something of the eternal about his vacuum cleaners; they were brand new and would, in all likelihood, out-survive the viewer. He also said that the cleaners were anthropomorphic, calling them breathing machines and likening them to androgynous figures with 'sexual' openings and apertures.*

Any or all of these interpretations are valid, especially if we understand the role of contemporary art as exploring aspects of our culture in ways that may not be open to us through other means. But precisely because art often presents things in ways that are 'different', it has the capacity to enlighten, excite and enrich us, as well as to confound, confuse and provoke.

You may consider *New Hoover Convertibles* goes beyond what could be regarded as art, perhaps more so than Matthew Barney's films, since the latter display skills and imagination that are conventionally regarded as 'artistic characteristics'. Koons's work is no different than something you might see in a shop; he arranged the objects but did not fashion them, so displaying little or none of the skill or visual creativity many of us would associate with making art. However, *New Hoover Convertibles* does follow an

established tradition in art. At the time of the First World War, the French artist Marcel Duchamp (1887–1968) created what he called 'ready-mades', which were manufactured objects he purchased and displayed as art. Consequently, an object bought in a store, not fashioned by the artist, was given the status of art, which increased its cultural standing and its financial value. Duchamp's ready-mades questioned art's conventional qualities – skill, aesthetic significance, uniqueness and monetary worth – in effect broadening the scope of what could be called art.

In the early 1960s Andy Warhol's silkscreen-printed Brillo boxes and images of soup tins extended Duchamp's concept in response to the period's burgeoning consumerism and advertising. Koons, taking his lead from Duchamp and Warhol, presents actual consumer products as if they are displayed to sell. Since it is exhibited in an art gallery, *New Hoover Convertibles* encourages us to think about the objects and their social, cultural and economic contexts in a different way than we would if coming across them in an electrical store or shopping mall.

Insight

The apparent distinctions between so-called 'high' and 'low' art are brought into question by the examples we have given. While they might beg the question what is art, it is probably more useful to ask, what is the purpose of art? As we have suggested, a Matthew Barney film offers an experience distinct from that provided by a Hollywood movie, and vacuum cleaners in an art gallery evoke different thoughts and invite different responses from seeing them in a shop.

So far we have discussed something of the impact of mass media and consumerism on contemporary art, noting that traditional divisions between elite, high or mass culture seem to have become less clearly defined, resulting in fine art more readily drawing upon the imagery and processes of popular art. The growth of mass communication and consumerism is significant, but it is just part of an array of social, political and cultural contexts that have had an effect on the way art has evolved in the past 40 years.

Among other things, the Western world has seen concerns over pollution, ecological damage and sustainability, greater liberalism in sexual behaviour, determined efforts to secure gender equality, a burgeoning youth culture, and drives towards internationalism while, at the same time, paradoxically accommodating national and regional interests.

These things affect us all to some extent, but art can reflect, comment and respond to them in ways that are often interesting and enlightening. Consequently, if we, as viewers, want to experience this, we require some awareness, knowledge and understanding of those social and political circumstances with which art engages, as well as an aptitude to read and interpret the 'language' that artists use to mediate some of these issues.

An important and established mode of artistic communication is iconography – the employment of visual symbols that can reveal meaning of art and its social and historical circumstances and attitudes.

Please look at Romuald Hazoumé's *Dream* (Plate 4). In order to make a contextual interpretation of this work, we require some background information on the circumstances of its production. We would call this a **pre-iconographical** analysis (literally one which is undertaken 'before the image').

Hazoumé (b.1962) is an artist from the Republic of Benin in West Africa, an economically poor country. His work is often concerned with African identity and traditions and how they are threatened by Western influences. He frequently uses discarded mass-produced objects which, in *Dream*, are plastic oil containers.

Armed with this pre-iconographical information, we can now attempt **iconographical** and **iconological** analyses. The first examines possible symbolic, or 'concealed', meanings of the subject matter, objects or 'motifs' in the work. The second connects this symbolism (the iconography) with broader historical circumstances, realities and interpretation (iconology).

How do you think issues of national identity and criticism of the cultural values of the Western world might be themes of *Dream*?

▶ *There is no obvious message about national identity and criticism of Europe and the USA in Hazoumé's work, but because the boat is made from oil containers and other discarded materials, this may be important to its meaning. While being an ingenious use of 'found' materials that continues African traditions of making artefacts from unwanted mass-manufactured objects, a construction made of such things and set against a photograph of an idyllic beach scene might refer to industrial debris encroaching on nature, or the broader impact of the industrialized world on Africa and its indigenous peoples, or it may represent the issue of oil's influence on the modern world.*

▶ *However, there is another important context for Hazoumé's use of these materials. In Benin, such canisters are a widely used utensil, often employed to transport smuggled fuel. Furthermore, in order to seek out a better life, many people flee Benin by making improvised boats from whatever they can find. Knowing this adds another dimension to the way we might interpret* Dream.

▶ *On the other hand, you may regard* Dream *as having no meaningful message about issues of national identity or criticism of the Western world. You may see it as a celebration of the so-called undeveloped world (and of the artist himself) to create something remarkable and, you might think, beautiful from discarded materials, that particular beauty being set against the natural beauty represented in the background photograph.*

Insight

From this analysis, it should be clear that understanding works of art is a matter of interpretation based upon looking and knowing. If you did not know that Hazoumé was an African artist, that he nearly always uses discarded manufactured objects in his work, or that he was concerned about the negative influence of the West on his country, your interpretation would be different since it would miss an issue of central relevance to the work's intended meaning.

Please look at Plate 5 and read the following information.

Poppy Field was created by Sanja Iveković (b.1949), a Croatian artist interested in the political and social situation in Afghanistan as well as being committed to women's civil rights. Iveković's installation was accompanied by recordings played on loudspeakers of Afghan women singing.

Afghanistan produces about 90 per cent of the world's opium, which is its main agricultural product and principal export. Opium requires little looking after, does not spoil, so no refrigeration is needed, and is bought directly from the farmers for cash, so a road system for delivery is unnecessary. Since the US-led war against the Taliban, opium production has increased, but Allied eradication policies on growing, together with the continuing conflict, have forced farmers into selling crops before they are grown and at a discount. If the crop fails, the buyers demand repayment, which sometimes takes the form of the farmers' daughters.

Given this information, how might you interpret Iveković's *Poppy Field* (Plate 5)?

▶ *As with Hazoumé's work, Iveković's has no obvious reference to social and political contexts. It is, after all, just a field of poppies. But the poppy has symbolic meanings in Western culture of sleep and death and since the First World War it has been associated with remembrance of the dead. Given Iveković's concerns for the situation in Afghanistan, the theme of death is apposite.*

▶ *Opium is extracted from the poppy but the beauty of* Poppy Field *seems at odds with both the war and the treatment of women in Afghanistan.*

▶ *Women, who had little or no civil rights in Afghanistan under the Taliban – they were not allowed to work, wash clothes in streams, take a taxi without a close male relative in attendance, wear clothing regarded as sexually stimulating, and so on – are once again victims, a partial consequence of Allied policies on growing opium.*

You may feel that a field of poppies planted in a town in central Germany cannot convey meanings like those listed above. But when we view art we give it our attention in a way that we do not necessarily do with other things in our life. Moreover, we expect a return, but sometimes we have to contribute more than just our interest in order to receive and appreciate this. *Poppy Field* seems to be an example of this. Together with the recording of Afghan women singing and the artist's own pronouncements, Iveković's installation makes us more responsive to things in a different and, arguably, more evocative way than could a news story.

Please look at Marina Abramović's *Balkan Baroque* (Figure 3.2). This is a photograph taken at a performance in which the artist sat on a pile of bloody animal bones rubbing the last shreds of flesh from them and singing mournful songs. Three copper bath–like containers filled with water surrounded the pile of bones while images of her mother, father and the artist herself flickered on surrounding video screens.

Abramović was born in 1946 in Belgrade, in what was then Yugoslavia. Her parents were Yugoslav partisans during the Second World War. Her father was acclaimed as a national hero and her mother, a major in the army, later became director of the Museum of Art and the Revolution. In 1991 the Socialist Federal Republic of Yugoslavia disintegrated into a vicious civil war that was characterized by political, religious and inter-ethnic conflict.

How can we interpret *Balkan Baroque* in the light of Yugoslavia's recent history and Abramović's family background?

▶ *The pile of bones on which Abramović sat (six hours a day for five days when the work was performed at the Venice Biennale in 1997), seems to symbolize the result of the conflict in her country. She said that the work was an attempt to deal with her own emotions about the war, about which she felt ashamed. While the bones may represent the*

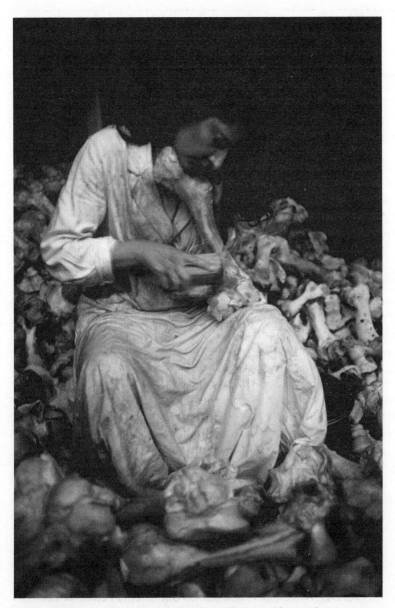

Figure 3.2 Marina Abramović, Balkan Baroque, 1997. Dimensions variable. Photograph from its performance.
Sean Kelly Gallery.

> *dead of Serbia, Montenegro, Croatia and the other Balkan nations,*
> *or even the death of Yugoslavia itself, rubbing the flesh from them and*
> *the mournful songs seem to be expressions of grief.*
> ▶ *The copper containers filled with water were interpreted by some*
> *commentators as symbols of both therapeutic cleansing and healing.*
> ▶ *Abramović's parents had fought for and served Yugoslavia's*
> *communist ideals which were abruptly swept away in 1991, although*
> *the consequence was bitter inter-ethnic conflict. The video images*
> *of her parents seem to resonate with this ironic legacy while also*
> *representing something far more personal for Abramović as an artist.*

Balkan Baroque, originally created as a performance (see Chapter 4, Section 4), was made into a film in 1998 and is as discontinuous and fragmentary as Barney's *Cremaster* series, although lacking the allusions to popular culture. It is a response to political circumstances, a theme which has a long pedigree in art, encompassing, for example, Lorenzetti's mid-fourteenth-century Sienese frescoes *Good and Bad Government*, Rubens's 1630 canvas *Peace and War*, Goya's *Third of May, 1808*, Picasso's *Guernica*, and the 1960s and 70s paintings and drawings protesting against American involvement in Vietnam by Leon Golub and his wife, Nancy Spero. One way in which these examples differ from Abramović's *Balkan Baroque* is that they are identifiable as 'art' because they conform to established conventions of media and presentation; performance and film are newer and relatively unestablished artistic forms. Furthermore, performance has associations with theatre, and film with popular entertainment, which for some of us makes their presence in an art exhibition or gallery difficult to reconcile.

In *Balkan Baroque* the artist is the performer and the work is staged, acted and presented, so lying somewhere between visual art and theatre. This is not the case with a work such as *The Battle of Orgreave*. In 2002 the British artist Jeremy Deller (b.1966), the film director Mike Figgis, and historical re-enactment expert Howard Giles, made an hour-long film about the violent confrontation between miners and police at the village of Orgreave, near Sheffield, during the 1984 British coal miners' strike (see http://www.channel4.com/fourdocs/archive/battle_of_orgreave.html).

Using photographic stills of the original events, interviews with participants, and a shockingly authentic re-enactment, the film, shown in art galleries, on television, and available to buy as a DVD, seems to be at odds with any customary perception of a work of art. Unlike Abramović's *Balkan Baroque*, which was a subjective, symbolic and emotive political statement, *The Battle of Orgreave* used conventional documentary means and the techniques of reportage to tease out what was claimed to be the actuality of the events.

Given the above information, do you think *The Battle of Orgreave* can be classified as an art work?

▶ *Even if you accept film as an art medium, you might consider that one which uses interviews, photographic stills, and a re-enactment that purports to record historical events, is a documentary and not an art work, even more so if it is directed by a film director, broadcast on television and sold as a DVD. However, the artist Jeremy Deller did conceive and instigate the work, which begs the question: does the involvement of an artist make the result a work of art?*

▶ *However, if you think* The Battle of Orgreave *is not a work of art, it may be that your understanding of art is relatively conventional. As we saw in Chapter 2, the past 40 years have seen increasingly unconventional forms of art, requiring us to adjust our previous understanding of the term. Consequently, Deller's film could be encompassed within a broader definition of the term. But at what point does something stop being art and become something else?*

▶ *Putting aside its visual impact and social and moral messages, Deller's film offers an example of the way some contemporary art so directly engages with life it becomes indistinguishable from it. Think back to Joseph Beuys's claims referenced in Chapter 2 (pp. 36–38) that everyone is an artist and, by implication, anything that anyone does is art. You may consider this too permissive and that art needs to be located as something distinct and essentially different from everyday life. But you may also think that art can and should be more than an experience confined to a gallery or museum. That view is certainly one taken by Deller and you might relate it to the Institutional Theory of Art we discussed in Chapter 1.*

In discussing the other examples used in this chapter so far, we have employed iconography and iconology, relating the works to a broader context as a basis for establishing their possible meaning. This is not the case with Deller's film because it is, in effect, a documentary and its context and meaning are unequivocal. You might be correct in thinking that this example is all about context.

Insight

Arguably the most important point to be taken so far from this chapter is that an informed viewer might more fully interpret works of art than an uninformed one. This is not to say that without contextual knowledge it would be impossible to understand, interpret and appreciate works of art; there are always levels of meaning embodied in any work. But in general, contemporary art's concern with content makes a strong case for the informed viewer being the most rewarded viewer.

Section 2 Money makes the art go around

In October 2007 BBC news reported that, according to a study of auction sales around the world, the financial value of contemporary art had risen by 55 per cent in a year. The report cited British artist Damien Hirst's (b.1965) diamond-encrusted skull called *For the Love of God*, which sold for £50 million, and a spray paint on steel work called *Space Girl and Bird* by the guerrilla graffiti artist Banksy (probably b.1974), which was bought for £288,000. For many onlookers, the price of art is sometimes difficult to reconcile, especially when one considers the cost of the materials and manufacture of *For the Love of God* was between £8 and £10 million and those used in Banksy's spray painting were far less, both resulting in substantial profits for the artists and their dealers.

The issue of art's worth is not a contemporary one. In an infamous libel case in 1878, the American artist James McNeil Whistler was asked whether the two days it took him to finish a painting

was worth the £210 asking price, to which he replied, 'No. I ask it for the knowledge I have gained in the work of a lifetime.' If we accept Whistler's claim that the monetary value of art is to be equated with the artist's skills and experience (for this is surely what Whistler meant by knowledge), can this argument be applied to all art?

What reasons do you think might justify art's price tag?

▶ Whistler's argument was that the price of art cannot be equated with the time spent making it. What he asked payment for was the 'knowledge' that went into the making. If this is skill and experience, you might think that a work such as Jeff Koons's New Hoover Convertibles *(Figure 3.1)* fails to display skill in any conventional artistic sense. However, there may be a stronger case if the price of art is determined by the artist's experience.

▶ Since the price of a work of art is not determined by a theory of value based on labour, other reasons must exist. One of these might be art's uniqueness: there is only one Venus de Milo *and one Sistine Chapel ceiling and, even when there is more than one version of a work, such as Caravaggio's* Supper at Emmaus *or Edvard Munch's* The Scream, *they are essentially different and so each remains unique. We value exclusivity and often put a high price on it, although in recent times, even art's uniqueness has been challenged. In 1974 the British artist Victor Burgin (b.1941) produced* What does possession mean to you? *(Figure 3.3), posting 500 copies on street billboards in Newcastle upon Tyne. Not only did this challenge the idea of art as something unique, it took it out of the gallery and made it a part of everyday life (an idea we discussed in Chapter 2). A different assault on art's uniqueness was made by the American artist Sherrie Levine (b.1947), who re-photographed Edward Weston's photographs and reproductions of Van Gogh paintings in books, presenting her work as original (for which the term 'appropriation' was used. See http://www.tate.org.uk/collections/ glossary/definition.jsp?entryId=23). If art's value is thought to be contingent on uniqueness, then Burgin's posters and Levine's appropriation of others' work brings this into question.*

(Contd)

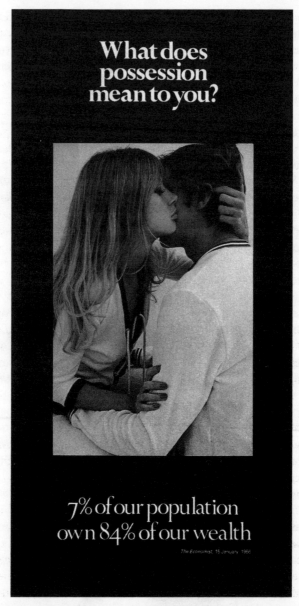

Figure 3.3 Victor Burgin, What does possession mean to you?, 1976. Photolithographic print poster, edition of 500: 124 × 84 cm (48.8 × 33.1 in.).

▶ *If uniqueness is no longer necessarily a criterion for the high price we put on art, then you may think that creativity contributes to it. A buyer may be willing to pay a lot of money for something thought to be imaginative and inspired. Creativity is often associated with the concept of genius; Michelangelo and Picasso are seen in this way. However, in recent times this concept has been questioned, in part because it has been so freely used and conferred on so many artists. But even if genius has become devalued, a buyer might pay for something, or someone, she or he regards as special or different.*

▶ *Art can serve as a 'fashion statement' or a symbol of status and power, for which people will pay a high price. This is by no means new. The Medici court in Florence recognized the ownership of art as a means of conveying social and cultural status; ruling monarchs in seventeenth- and eighteenth-century Europe commissioned art that conveyed their authority; and Hermann Goering obsessively collected because it promoted his cultural aspirations, as well as fulfilling a desire to own art objects, although he rarely paid for them.*

In the end, art's value may simply be dependent on what people are willing to pay. But two things distinguish the present situation and its impact on contemporary art's worth: the emergence of an investment and speculative market in art and the increasingly indistinct boundaries between art, media and celebrity. These things have had an effect on contemporary art practice and theory.

Insight

As viewers we should be aware that art's commodity status and the roles of artists, dealers, collectors, critics, curators, speculators and media are important contexts for our awareness and understanding.

Art and the economy have always been linked but in the past 40 or so years they have become much closer. The cycle of financial booms and recessions since the 1970s and insecurity about the world economy resulted in art becoming a means of investment in much the way gold has been. In the 1980s, for example, middle-class Americans enjoyed a sustained period of prosperity and many invested in art. Between 1983 and 1985 more than a hundred new

galleries opened in New York and sales in 1984 exceeded $1 billion. By the end of the decade individual works were selling for ten to twenty times more than they had at the beginning. In the 1960s art collectors had been regarded as shrewd benefactors; by the 1980s they were seen as opportunist speculators. The 1989 stock market crash and other subsequent financial crises meant that the spectacular returns of the 1980s were never to be repeated, but contemporary art has continued to sell profitably, as the examples of Damien Hirst and Banksy given above illustrate.

However, the financial success of contemporary art is not just a consequence of desirable objects, eager buyers and astute dealers. Fashion, celebrity, publicity hype and business play their part in the commodification of art.

Irving Stone's 1934 biographical novel *Lust for Life* and Vincente Minnelli's 1956 Hollywood adaptation made Vincent van Gogh a celebrity artist, as did the 1950s photographs of Picasso on the French Riviera and Jackson Pollock in the act of painting. These are early examples of art and media rubbing shoulders to create celebrity; in recent years this has become the norm rather than the exception for many artists. The Italian painter Francesco Clemente modelled clothes on the catwalk, as well as acting in a Hollywood film; Jeff Koons (see Figure 3.1) infamously married the porn star Ilona Staller and produced a series of works illustrating their sexual relationship; the 2001 Turner Prize (see pp. 248–249) was presented by 'pop icon' Madonna; and, as we have seen, Matthew Barney's *Cremaster* films (see Plate 3) 'star', among others, an actress and a writer.

The celebrity status of some contemporary art is further enhanced by so-called superstars collecting it: Brad Pitt was reported to have spent $50,000 at the 2008 Art Basel in Switzerland (see p. 246). Sting, Paul McCartney and Madonna are the UK's top pop star art spenders, and it was reported that Elton John was to rebuild part of his home as an art gallery to house his collection. This included a series of Nan Goldin photographs, which the singer loaned to the Baltic Centre (Figure 6.1) in 2007 for an exhibition called 'Thanksgiving'. A day before the opening, it was decided that

one of the pictures might breach pornography legislation, the police were called in and the picture was removed. Nine days later, Elton John decided to remove all the photographs. These events might have been detrimental to the artist, gallery and owner, but in the end it gave all of them a higher profile, proving the adage that all publicity is good publicity.

As well as celebrities collecting art, a few also create art: Paul McCartney, Bob Dylan, Tony Bennett, the late Dennis Hopper, Tony Curtis and David Bowie have all had exhibitions of their work, making connections between art and celebrity even stronger and more durable. As we have seen, art has become more obviously commodified in recent times, and its ownership can influence our approach and reaction to it. On one level, a work of art in London's Tate Modern or Los Angeles's Museum of Contemporary Art has the kudos of the institution behind it and, consequently, we may pay it more attention, grant it greater reverence and believe it to be particularly important. We might not feel quite the same way about art that is in private ownership.

In 2008 Chelsea Football Club owner Roman Abramovich bought paintings by Lucian Freud and Francis Bacon for record-breaking prices. How do you think information such as this might affect our reception of art?

▶ *It is possible that some people would moralize about this information as a man with too much money indulging himself or simply making a shrewd investment.*

▶ *On another level, we may admire or dislike a particular art collector, as far as we know them, leading us to associate them with their taste in art, and so colouring our view of that art.*

▶ *Clearly, artistic or cultural value cannot necessarily be measured by financial value; if it could, Abramovich's purchases would make the Bacon picture, at £34 million, a 'greater' work than the Freud, at a more modest £17 million. But as we have seen, art and money are often closely associated and the paintings bought by Abramovich might now be given more attention than previously because of their connection with this high-profile businessman.*

While Abramovich may not have gone out of his way to publicize his purchases, sometimes art and publicity are very knowingly united. It is now standard practice for business companies to sponsor major art exhibitions and even form partnerships with museums for the mutual benefit of each other. Of course, advertising and promotion are realities of twenty-first-century life, but when the Royal Academy, the Museum of Modern Art, and other august institutions first courted corporate sponsorship more than 30 years ago, it shattered the belief for some that art was above all that. Nevertheless, there were benefits for both art and business.

In what ways do you think business sponsors might benefit from supporting art?

> ▶ *You might perceive corporate sponsors of art exhibitions and museums, art festivals, fairs and so on as charitable benefactors. This would be a positive image for a sponsor, perhaps encouraging their business to be seen as more than simply a profit-making organization.*
> ▶ *Furthermore, sponsors themselves could believe that their association with the arts raises their 'cultural profile', elevating them above associations with 'mere' business.*
> ▶ *By sponsoring art, a business might hope to tap into a new market. Demographically, audiences for art tend to be better educated and wealthier, providing fresh 'business potential' for companies.*

In what ways do you think art museums and organizers of art fairs and festivals might benefit from business sponsorship?

> ▶ *The financial benefits for the arts from private sponsorship, at a time when State funding is being reduced, must be attractive to museums and other art organizations desperate for money.*
> ▶ *The established marketing infrastructure and business acumen of commercial corporations which sponsor the arts could be readily mobilized to the benefit of art institutions and organizations.*
> ▶ *Private sponsorship can offer museums and art organizations support that is free from State intervention, controls, restrictions and party political influence.*

Although the partnership of art and business has been successful, as many examples prove, there are some drawbacks.

How might corporate sponsorship restrict art institutions and organizations?

▶ Because 'they who hold the purse strings' are generally in control, we might be concerned about the possibility of sponsors vetoing something that is judged inconsistent with the image they want to promote. At the most extreme level, this could result in the insistence that certain exhibits are inappropriate, a particular project unacceptable, or the views of a particular artist unwelcome.

▶ Equally, corporations that provide money to the arts may involve themselves in more than just a financial capacity. Decisions about displaying art or promoting an exhibition or event could be taken out of the hands of curators and organizers in order to best suit the sponsor's ambitions. But in defence of corporate sponsorship, there is no reason to think that State-funded art institutions and organizations are any less vulnerable to such hegemony and particular agendas.

Type 'art exhibition sponsorship' into any search engine and there are hundreds of museum and festival websites offering corporate sponsorship opportunities. Sponsors range from insurance and computer software companies to car manufacturers and fashion houses; there seem to be no limits for partnerships between art and business. However, in some cases sponsorship has been controversial. An infamous example was the oil company Mobil's financial support for an exhibition of African art when that company's subsidiaries, or so the artist Hans Haacke (b.1936) claimed in his 1985 work *MetroMobilitan*, were selling to the apartheid regime in South Africa.

As viewers, we must understand that the relationship between art and money is closer now than ever before. Art objects may enlighten, elevate and entertain us, but we cannot forget their increasing role as commodities, a context of which we should be aware when viewing them.

Section 3 Reality isn't what it used to be

So far in this chapter we have examined how contemporary art has responded to social, political and economic changes, such as a burgeoning media, increased mass production, widespread consumerism and a commodity culture, ecological concerns, war, the search for ethnic, national and individual identity, and corporate business practices. While much contemporary art is an expression of these tangible manifestations of change, it is also underpinned by new philosophical discourses that endeavour to understand the reality of the world which we have created in the past 40 or so years. In this section we want to look at the ways in which contemporary art can be understood as a response to new frameworks of ideas that permeated Western philosophy after the late 1960s. In other words, we shall examine the philosophical contexts of contemporary art.

In the late 1960s, through the writing of a number of French intellectuals, new ideas were being promoted about a whole array of cultural practices and experiences, from literature, philosophy and art to sociology, science and religion. On the whole, these ideas were sceptical of existing beliefs and consequently challenged established thinking. Central to this ethos was Jacques Derrida (1930–2004), whose notion of 'deconstruction' proposed that texts – be they words or images – have many meanings, none of them absolute. Arguing that we understand things in relation to the forms of knowledge in which we categorize them, for instance, science, history, common sense, logic and so on, he suggested that this limits the meanings of the things themselves.

For example, the term 'art' assumes a single thing to which the word corresponds; we think of things as 'art' or 'not art', and so we ask 'what is art?' rather than 'what does the *word* art mean?' Put another way, a word's meaning does not have its origin in what it describes – it does not mirror reality and as such we know only what the word allows us to know. Derrida tried to show how once trusted relationships between language and the world it claimed to describe are inclined to falsify or misrepresent. Through deconstructing meaning, we can come to our own understanding of

things and not one necessarily based on established and frequently unquestioned assumptions and conventions.

Please read the discussion of Jeremy Deller's film *The Battle of Orgreave* on pp. 58–60 in the light of what we have said about Derrida's ideas.

▶ You will see that one strand of the discussion was concerned with whether Deller's film could be classified as art and we even posed the question 'At what point does something stop being art and become something else?' From a deconstructionist position, there is no fixed meaning of the word 'art'; its very existence sets up an opposition with what is 'not art', which serves to limit and even suppress meaning.

▶ Derrida's ideas seem to propose that the names we use for things play a significant part in the way we understand them and, as a result, our language consistently misleads us. In the discussion of Deller's film, we noted Joseph Beuys's claims (pp. 36–37) that everyone is an artist and, by implication, anything that anyone does is art. This appears to be as accommodating a position as Derrida's. You may find all this too permissive and consider that we need categories, names and definitions to help us locate things in relation to each other and, ultimately, to understand them. But Derrida's views do suggest that we should question received assumptions because they make us think and respond in a particular way.

It is relevant that Derrida's ideas originated in the later 1960s, a period of confrontation and change when the Vietnam War and opposition to it reached new heights; workers and students rioted against De Gaulle's government on the streets of Paris, and the so-called counter-culture challenged what it perceived as social repression in Europe and the United States.

These and other events had significant repercussions and about ten years later the philosopher Jean-François Lyotard (1924–98) published *The Postmodern Condition: A Report on Knowledge* in which he too responded to social, political and cultural change by challenging received opinion. Not unlike Derrida, he argued that knowledge is limited by the disciplines and institutions in which it is created. For example, we hold science to be a superior form of knowledge

that is 'truthful', objective and progressive, but Lyotard argued that, like all fields of knowledge, science works only within the protocols of its own discipline; it is restricted not only by the procedures and language it uses – and the questions which it decides to address – but also by a belief in its role as seeker of objective truth and the progress of humankind. Science's claim to objectivity, truth and progress is an example of what Lyotard called a 'metanarrative', by which he meant a universally accepted account that explained and legitimized a discipline or practice. Metanarratives would include religion and its claims for truth (Plate 7, *La Nona Ora* by Maurizio Cattelan (b.1960), might be seen as a tongue-in-cheek critique of this), history seen as an account of advancement and improvement (Figure 3.2, Abramović's *Balkan Baroque*, challenges this), or the belief that knowledge can liberate us (Figure 3.3, Burgin, *What does possession mean to you?*, brings this into question). In 1992 Lyotard also exhorted artists to question Modernism, which he saw as a metanarrative.

Please look at Caro's *Early One Morning* (Figure 1.1) and Koons's *New Hoover Convertibles, Green, Red, Brown, New Shelton Wet/Dry 10 Gallon Displaced Doubledecker* (Figure 3.1). Which of these works would you think Lyotard regarded as representative of a Modernist metanarrative and why?

▶ As we saw in Chapter 2, Caro's sculpture can be seen as exemplifying Modernist principles by privileging form over content and valuing aesthetic effect over meaning or message. This interpretation of Modernism is, in Lyotard's terms, a metanarrative.

▶ Koons's New Hoover Convertibles does not easily read as favouring form over content and it is difficult to consider the work as aesthetic in any conventional artistic sense. Therefore, it seems to operate outside the metanarrative of Modernist art. If we accept Lyotard's ideas:

 ▷ Koons's work seems to challenge the metanarrative by operating outside its conventions

 ▷ it is both fine art and consumer commodity culture, cultural categories that had hitherto been separated

 ▷ it employs ready-made objects and so demonstrates no conventional artistic skills

 ▷ it seems to convey no explicit meaning about aesthetic value nor does it appear to have social meaning.

Much contemporary art attempts to look at things differently and a good deal of it engages with questions about identity and shared practices that have been socially and culturally marginalized, which brings us to particular aspects of work by the cultural theorist Michel Foucault (1926–84).

Foucault argued that society is controlled by various 'institutions of power', for example the law, medicine, politics, academia and even art. The language used by those within the 'institutions' endorses their authority but also subordinates or excludes those outside the 'institution'. For example, a discussion between artists about art will draw on forms of language and debate – 'insider' knowledge – from which those 'untrained' in the language and methodologies of the activity will be marginalized. Foucault's focus was on 'institutions' such as the law, the penal system and medicine, and what he called their discourses of power, that is the institutions themselves and the language they use, both of which impose a particular kind of identity on those within the institutions. However, this is more than simply fitting into a particular role and doing what is expected. For Foucault, we do not merely play these roles; more exactly, they shape our identity and form the way we perceive ourselves and are perceived by others.

For example, as a businessman or woman, a mother, a student, an artist, an immigrant, or a member of the local darts team, the way we think about ourselves and the way others see us is respectively circumscribed in part by our job, the way we look after our children, what we study, what we make, which country we are from, or how accurately we throw darts. Although we may not think of motherhood or the local darts team as 'institutions of power', they are discourses that control how we are seen – they put us in our place and, in effect, make human identity a form of constructed fiction by locating and 'normalizing' our position

in society. But in doing this they also exclude and alienate those who are not a part of the discourse and who do not have sufficient power to control the formation of knowledge. For contemporary artists this idea has held a special appeal, not least because it drew attention to identities marginalized by discourses, such as the experience of women and the values of non-Western cultures.

Bearing in mind Foucault's ideas, please look at *Rebellious Silence* (Figure 3.4) by Shirin Neshat (b.1957) and consider how you would understand themes of gender and ethnic difference in this image.

▶ *The model in this photograph is the artist herself, an Iranian who works in the West. She is wearing a chador and her face is covered in Arabic script that 'replaces' the veil. She stares directly at the viewer with a rifle in front of her. Everything we see makes reference to a specific ethnicity and gender, although religious belief and implied violence may also be inferred. But thinking about Foucault's ideas, it may have occurred to you that the way we understand these things is always in relation to our own discourses and experience.*

▶ *For many Western viewers, perceived gender roles in the Islamic world might suggest an interpretation of female oppression and submission, while the gun and its possible implication of terrorism could throw up stereotypes of radical Islamic fundamentalism. But are these readings dependent on a Eurocentric discourse reinforced by the press, politics, literature, advertising and language?*

▶ *In fact, Neshat's image both supports and confuses these readings. The Arabic script serves as an indicator of Islam for a Western audience but is in fact Iranian feminist poetry that offers different views on wearing the chador. Equally, the stereotypical Western view of the garment is as a signifier of female obedience and coercion established by the 'institutions of power' – men and religion. But within those 'institutions' it allows women freedom; without it, for example, they cannot enter the public world. Given the feminist discourse that has been suggested, the gun may be a feminist symbol of assertion against a patriarchal 'institution of power' rather than a sign of radical Islamic fundamentalism.*

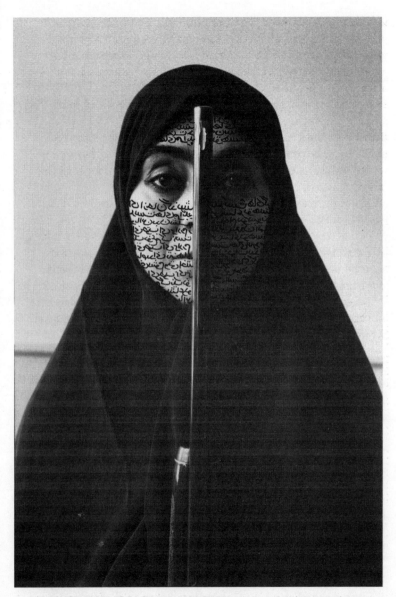

Figure 3.4 Shirin Neshat, *Rebellious Silence*, 1994. *Black & white photograph: 27.5 × 35 cm (10.8 × 13.8 in.).*

In our discussion of Neshat's photograph, we suggested that interpretation and understanding typically occur in relation to our own discourses. For instance, a Western viewer would, in all likelihood, interpret the image in a dissimilar way to an Arabic viewer, or a man might understand it differently to a woman. But is this what the artist herself intended? We might imagine that the artist's interpretation is paramount here, but the French intellectual Roland Barthes (1915–80) robustly disagreed. Exploding the metanarrative of the artist/author as the principal authority, he proposed that a written text or a work of art is not an empty vessel into which the artist has poured meaning but, because it exists at different times, in different places and is seen by different audiences, it gathers meaning.

For example, a twenty-first-century viewer will not necessarily identify the specific references to mid-twentieth-century popular culture in Plate 2 and so understanding and meaning might change. In effect, Barthes argued, it is not the author who stands before us but their work, so they cannot control the various interpretations which we or others might subsequently attribute to it.

Barthes also noted that works of art are created with conscious or subconscious references to other works of art. He called this 'intertextuality', arguing that artists get their ideas from somewhere, so, however original an idea might appear to be, it is created to a greater or lesser degree by the knowledge and experience of other art. This is as true for the viewer as it is for the artist, because the viewer can 'read' the work only in the light of what they have seen previously. While it is the condition of all works of art, intertextuality can be conscious and explicit, such as in Figure 3.3, where Burgin refers to glossy magazine advertising, and Figure 4.1, where Paul McCarthy parodies a fun fair ride and a Hollywood film.

Having challenged accepted ideas of authorship and originality, Barthes went on to propose that ideas are not autonomous of the language an artist uses. He suggested that they are essentially formed and mediated by the language available. For example, the

idea of Banksy's *Yellow Line Flower* (Figure 4.2) is a result of the existing language/symbol of double yellow no parking lines, while the meaning of Hazoumé's *Dream* (Plate 4) is largely determined by the materials it uses. In effect, the ideas these and all other works of art convey cannot exist independently of the form they take.

Barthes's theories were proposed in an influential essay called *The Death of the Author*, published in 1968 and translated into English nine years later. But can we really accept that the author of a work is not its principal authority? To be fair, Barthes is asking us to reconsider the importance and ranking we place on authorship rather than wholly dismiss its contribution and influence.

Please look at *Your Golden Hair, Margarete* (Plate 8) by Anselm Kiefer (b.1945). If you have never seen this painting before and know nothing about the artist, examine it and make a note of what you think it's about and how you respond to it.

▶ *As Barthes notes, the viewer brings meaning to the painting. Some would argue that what you think it is about is what it is about. The artist can only direct your interpretation insofar as particular materials, colours, forms, textures are arranged in order to represent a subject, issue or idea. They cannot replace those responses and thoughts which are determined by your own knowledge and experiences.*

Now read the following information.

Kiefer is a German artist born just before the end of the Second World War. Until the 1990s and the reunification of Germany, much of his work addressed themes from the Nazi period.

Your Golden Hair, Margarete was inspired by Paul Celan's 1945 poem 'Death Fugue', a metaphoric description of Auschwitz that pairs and contrasts Shulamith, a Jewish woman, with Margarete, an idealized German woman.

How does this information change your response to the painting?

▶ Whatever you thought before must have now have been altered to an extent by discovering something of the work's context, which we should suppose was what Kiefer intended to convey. Despite what we think the painting represents or means, once we know what the artist intended we can never 'un-know' it, as it were.

▶ If this is the case, you might think that the author is not dead, as Barthes claims, since knowledge of his sources and the context of his work informs our interpretation.

▶ On the other hand, you might think that Barthes has a point, because whatever we discover about Kiefer and his painting is understood in the light of our own knowledge and experience, making us the ultimate arbiters of meaning.

At the beginning of this chapter we noted how the contemporary world has changed as a result of new technology and media. One consequence of this is a plethora of images, from television, cinema and computer screens to magazines, newspapers, packaging, billboards, T-shirts, and the photographs and moving images we take on our mobile phones and digital cameras. But to what extent does all this imagery influence and even replace our first-hand experience of reality?

The question is important in relation to the way we look at things, including art, and it is a major concern of Jean Baudrillard's writing. Just as Barthes argued for 'intertextuality', so Baudrillard (1929–2007) asked how we can experience reality independently when what we see is always shaped by preconceptions and expectations established through a pervasive culture of images. For instance, visiting a hospital cannot be completely disassociated from our experience of watching television hospital dramas; wearing Calvin Klein perfume makes us like the character in the advertising campaign; or being at a sports event seems to lack something if we cannot see the action replay. In the accepted scheme of things, we consider images and other forms of representation to be inferior to reality, but Baudrillard argued that this was no longer the case. Using the term 'simulation', which is usually defined as imitation or counterfeit, he proposed that

the imagery of film, television, advertising, the 'virtual reality' of computer games, and so on, create a situation where reality is no longer a fixed concept.

So what does this mean for art? Baudrillard himself was sceptical about art, regarding it as a naive attempt to refresh ways of seeing in order to understand the world. For him, it was like everything else – a set of signs that reinforced the slippage between reality and simulacra – a copy of something which is lost or no longer present. For example, the logic of art is to create a simulation of the world as the artist sees it, feels it, comments on and responds to it. We give art a special place in our culture, seeing it as a sign of authenticity and individuality guaranteed by its uniqueness and the artist's signature.

But in fact, it too slides into what Baudrillard called hyperreality – the proliferation of second-hand authenticity and the creation of things that in a world of simulation assure us of their, and our, reality. Examples of this would be video and Wii games, reality-TV shows, interactive TV, Facebook, publications, CDs and DVDs that claim to help you find your inner self and release the 'real you'. For Baudrillard, art enters into successive stages of simulation, each of which becomes even more remote from the actuality that it seeks to depict.

Please look at Jeff Koons's *New Hoover Convertibles* (Figure 3.1) again and think about how this work can be interpreted in relation to Baudrillard's ideas.

▶ New Hoover Convertibles *confuses the distinctions between art and reality by presenting vacuum cleaners as art. The artist has created a simulation of the world – a work of art – but has used real objects to do this.*

▶ *However, the vacuum cleaners are no longer 'real', in the sense that they cannot be used to perform their intended function; they exist only as art displayed in a museum.*

(Contd)

> ▶ *The work of art is unique and individual – there is only one* New Hoover Convertibles *but at the same time it is the product of mass production and replication, which further confuses and problematizes our understanding.*
>
> ▶ *If art is a sign of authenticity and individuality,* New Hoover Convertibles *might be seen as a paradigm of the slippage between reality and simulation. Equally, this may also apply if it is seen as a sign of wealth – the price of vacuum cleaners dramatically increases when they are arranged, illuminated and encased in Plexiglas (perspex), and have the status of art conferred upon them.*

For the past 40 or so years, many artists have drawn on the ideas of Derrida, Lyotard, Foucault, Barthes, Baudrillard and others, and required their viewers to be aware of these contexts. Some would argue that such philosophical discourses are imported in an attempt to support inconsequential creations. For instance, is Iveković's *Poppy Field* (Plate 5) something to be conceptually deconstructed, regarded as a discourse, or seen as a manifestation of hyperreality or, conversely, is it just a field of poppies? Of course, it is all of these things and more, suggesting that if art is in the eye of the beholder, as is often claimed, then so is its meaning. But, as we have seen, meaning is dependent to a significant extent on knowledge and understanding. The contexts in which these develop – personal, social, experiential, cultural and so on – are frequently as varied as the actual art being encountered.

More recently, theorists such as Nicolas Bourriaud and Claire Bishop have suggested that much contemporary art practice has become increasingly 'relational'; that is, it seems more open to some of the discursive and subjective encounters, responses and readings which have been broadly discussed here. So, having looked at the origins of contemporary art in Chapter 2 and some of its contexts in this one, the following two chapters will examine contemporary art in relation to the variety of forms it takes and some of the themes with which it engages.

Suggestions for further reading

Claire Bishop, *Participation*, MIT Press, 2006

Nicolas Bourriaud, *Relational Aesthetics*, Les Presses du Réel, 2002

Christopher Butler, *Postmodernism: A Very Short Introduction*, Oxford University Press, 2002

Jonathan Harris, *Art History: The Key Concepts*, Routledge, 2006

Eric Hobsbawm, *Age of Extremes. The Short Twentieth Century, 1914–1991*, Michael Joseph, 1994

Amelia Jones (ed.), *A Companion to Contemporary Art since 1945*, Blackwell, 2006

Arthur Marwick, *The Arts in the West since 1945*, Oxford University Press, 2002

Jean Robertson and Craig McDaniel, *Themes of Contemporary Art: Visual Art after 1980*, Oxford University Press, 2005

Julian Stallabrass, *Art Incorporated: The Story of Contemporary Art*, Oxford University Press, 2004

Glenn Ward, *Teach Yourself Postmodernism*, Hodder Headline 2004

Paul Wood, 'Commodity', in Robert Nelson and Richard Shiff (eds), *Critical Terms for Art History*, University of Chicago Press 2003

THINGS TO REMEMBER

▶ *Artists do not work in a vacuum; their art is a product of its time, influenced in varying degrees by historical, social, economic and philosophical contexts and circumstances. The contemporary world is characterized by innovation and change and contemporary art reflects this.*

▶ *The growth of electronic media and consumerism has both challenged and contributed to contemporary art, making distinctions between so-called elite, or high art and mass popular culture more difficult to discern.*

▶ *Interpreting visual symbols in contemporary art (iconography) and their relationship to broader historical circumstances (iconology) can lead to meaningful interpretation, although employing this methodology requires the viewer to have contextual knowledge.*

▶ *While art of the past has often been connected to wealth, power and fashion, contemporary art seems more intimately connected with these things. Investment and speculation markets of the later twentieth century recognized art's commodity value and, as viewers, we should be aware of this.*

▶ *The close relationship between much contemporary art and fashion, celebrity, publicity and business can influence both the creation and reception of works of art.*

▶ *Any meaningful understanding of contemporary art must take into account some of the philosophical discourses of the past half-century. These are generally characterized by scepticism about existing beliefs and inherited assumptions.*

▶ *A number of philosophers and cultural theorists working since the Second World War proposed different interpretations of truth and knowledge; much contemporary art can be understood as responding to these.*

4

Forms of contemporary art

In this chapter you will learn:

- **to recognize the principal forms that contemporary art assumes**
- **about the range and variety of media, techniques and processes employed to create these forms**
- **how and why different mediums are used by artists to communicate ideas, issues and themes**
- **how different mediums might be approached, interpreted and understood by the viewer.**

Introduction

There was a time when art was relatively easy to recognize. Although there were exceptions, art tended to be framed and hung on a wall or it was carved from stone or cast in bronze. More recently it has become increasingly difficult to identify something as art merely on the basis of the form it takes or the medium it uses. For instance, painting has been displaced as the pre-eminent artistic discipline by a variety of other practices, apparent when one considers that among the 36 nominees for the Tate Gallery's prestigious Turner Prize between 2000 and 2008, only four could be considered painters – and none of them won the competition.

Equally, sculpture is no longer clearly defined as a modelled, carved or constructed object. A significant number of contemporary practitioners who work in 'the expanded field of sculpture' (see pp. 35–36) use real objects, combine three-dimensional pieces with other media such as film and video, or create tangible spaces that the viewer can enter. Additionally, what were once cultural disciplines or activities distinct from art as it was displayed in galleries, such as photography, film and theatre, are now embraced by contemporary artists (see Figure 3.4, Plate 3 and Figure 3.2 respectively), along with an array of wholly unconventional materials and techniques, some more associated with non-artistic activities such as horticulture (Plate 5), biology (Plate 9) and housework (Figure 3.1).

All this goes to make a visit to contemporary art galleries such as Lyon's Musée d'Art Contemporain or New York's PS1 a distinctly different experience from one to the Louvre in Paris or Washington, DC's National Gallery. We are relatively comfortable with pictures hanging on a wall because the conventions of how to look at them have been long established, but the plethora of approaches in art over the past 30 or so years confronts those expectations. Sometimes it is even difficult to recognize what actually is art despite it being displayed in a gallery, as was the case in 2001 when British artist Mike Nelson (b.1967) created a room, perplexingly titled *The Cosmic Legend of the Uroboros Serpent,* that had some visitors wondering if they had wandered out of the galleries and into a storage area (see http://www.303gallery.com/detail.php?workid=11290 for its installation in New York City).

Given the variety of contemporary art practice and the difficulties this poses for many viewers, as illustrated by Mike Nelson's room, this chapter examines some of the media, techniques and processes artists have used and the forms they have taken. We have identified six significant areas but, as will become clear, these, although important, are just indicative. Since a characteristic of contemporary art is its inclination to hybridize practice – that is, the mixing of what had conventionally and previously been regarded as separate and autonomous areas – our classifications are sometimes a little artificial. Examples of this include Marina

Abramović's *Balkan Baroque* (Figure 3.2), which comprised live performance, objects and video projections and was later expanded into a 63-minute film by the director Pierre Coulibeuf, and *Golden Ghosts* (Figure 5.1) by Grayson Perry (b.1960), a work that blurs the boundaries between art and craft, drawing and decoration. Therefore, while the sections in this chapter identify six relatively specific forms or genres of contemporary art it should be evident that these are not as fixed and distinct as the ordering implies.

THINGS TO REMEMBER

▶ *Contemporary art embraces a range of media and disciplines, many of which would have been beyond the scope of earlier art. Furthermore, these are not necessarily used as a discrete form, as some works of contemporary art employ a hybrid practice where different media and artistic disciplines are combined.*

▶ *Such hybridity challenges some of the distinct boundaries which previously defined identifiable artistic genres and practices.*

Section 1 Painting, mixed media and sculpture

PAINTING AND MIXED MEDIA

How does one move beyond the perception that all serious painting is merely a footnote to the endgame of abstraction.

(Stapleton (2004), p. 15)

The above quote is not an untypical response to one episode in painting's recent history and, at least in the developed world, its ambiguous cultural status. Painting is probably the oldest example of artistic mark making and, in many respects, remains the most immediately recognizable and possibly most conventional art form.

As a genre it has experienced the extremes of cultural fashion and critical fortune. Despite annual predictions of its demise as a contemporary artistic medium, painting has remained central to the history of modern art – and has continued to make a robust contribution to contemporary practice.

So what do we mean by painting? How might we approach figurative and abstract examples of the genre, and why does it remain such a durable art form within contemporary practice? In this section we will explore:

▶ *aspects of terminology*
▶ *some of the critical ideas and theories associated with modern painting*
▶ *examples of subject matter, issues and concerns which have been explored using the medium*
▶ *some of the reasons for its continuing popularity within contemporary culture.*

Please look at Plate 8, which is a photographic reproduction of a canvas by the German painter Anselm Kiefer (b.1945). How would you describe the surface and its appearance?

▶ *The medium (oil paint and emulsion) has been thickly and expressively applied to the canvas.*
▶ *You will have also noticed the drift of straw, which has been applied to the canvas surface giving the effect of a lopsided arch or that of a partial silhouette. This may be a literal reference to the painting's title (the straw can be understood as Margarete's golden hair) as well as a means of making emphatic and actual the landscape, which is Kiefer's apparent subject matter (since it is straw, the dried stalk of a cereal plant that grows in the landscape).*
▶ *Kiefer has used a palette (choice of colours) dominated by greys, off-whites and black to paint direction lines that give a plunging diagonal perspective (the illusion of space on a flat surface) which angles to a high horizon line on the far left of the painting.*
▶ *The painting's tone (the contrast between light and shade) is echoed through the juxtaposition of the limited colour range with the*

> arid-yellow of the straw. The horizon line is a mere slash of mid-grey paint, which gives the open expanse of painted surface an ominous and brooding presence.
> ▶ Kiefer's painting style is expressive and quite stylized – that is, atmospheric effects and motifs are suggested and implied, rather than depicted in minute, figurative detail. We might guess that this painting references an open landscape with harsh plough or track lines, but this is suggested rather than made explicit, as might be the case in a highly figurative painting or a photograph.

You may have recorded other impressions in thinking about this example, but we might note the following as general effects of the genre:

▶ *The medium has been used to both conceal and reveal the actuality of the flat surface on which the image is painted; we know that the canvas is flat but we suspend our disbelief for the purposes of reading or interpreting a subject, story or narrative.*

▶ *Pigment is used to create colour, form, contrast texture, scale and tone.*

▶ *Paintings may be medium-specific (they use one medium – such as oil, acrylic or watercolour), or they may 'mix media', combining various pigments or, as with Kiefer's example, use and apply other materials in order to enhance either the pictorial effect or to reference the image's subject or narrative focus.*

▶ *Stylistically, paintings range across a spectrum, from the figurative (attempting to simulate in every detail something we might encounter in life) to the entirely abstract (an image which does not obviously refer to nature or to objects in the visible world), with every possible variation in between.*

In the developed world, at least since the fifteenth century, the main paint media have been tempera (pigment mixed with egg yolk and diluted with water), oil (pigment mixed with vegetable oil and diluted with turpentine and oil), watercolour (pigment mixed

with gum arabic and diluted with water) and acrylic (pigment suspended in a polymer emulsion). All of these paints have three components:

▶ *pigment (the actual colour either in a powdered or granulated form)*
▶ *the medium that binds the pigment*
▶ *the thinner, which dilutes the paint so that it can be applied to the support, traditionally canvas or wood, although in one of the examples used in this book (Plate 12), an aluminium support has been used.*

Since the 1950s forms of acrylic paint have become widely manufactured, although oil, enamel, gloss and emulsion-based paints continue to be widely used and combined. So, for example, Kiefer's canvas, in addition to straw, uses both oils and emulsion in order to achieve a depth of colour and a translucent effect across parts of the picture surface. Tonal variations (shifts from light to dark) can be achieved in oils by thinning or thickening the pigment or by using glazes.

Up until the mid-nineteenth century painting practice in the West was widely regulated by academies (see Pooke and Whitham, *Teach Yourself Art History*), but by the early twentieth century, this system had largely broken down and lost relevance, particularly for the newly emerging avant-garde artists. But one of the legacies of the academies for modern art generally, and painting in particular, was the prevalence of canons.

In art history the word canon (deriving from the Greek word for a carpenter's measuring stick) refers to a benchmark of quality. So, for example, to suggest that a particular painting or work was included within the Western canon was to imply a positive judgement concerning its value, recognition or status. For modern art (made between c.1860 and c.1960 – see Chapter 2), and for art history, particularly since the start of the twentieth century, the term began to be used more flexibly.

To illustrate this, please look at Plate 1, an abstract painting called *Counter Composition XIII*, 1925–26, by the Dutch artist Theo van Doesburg (1883–1931). How would you characterize this painting?

▶ Counter Composition XIII *is a fully abstract and geometric composition. Unlike the Kiefer example, it does not use painterly or expressive effects, but is highly linear and the painted surface is flat in appearance. In other words, there is no attempt to suggest dimensions of space through the use of perspective.*

▶ *Only if original canvases by van Doesburg are looked at closely is it possible to see the subtle brushstrokes which he typically used to build up the layers of colour.*

▶ *The surface of the composition is defined by an asymmetrical arrangement of geometric shapes, but these are not used to frame or delimit the picture space or composition. Instead, the changing spatial intervals (and distances) between each shape is created by changes of colour and seems to suggest something akin to the cadences of a rhythm or sound which has been given visual form.*

Insight

In a literal sense, *Counter Composition XIII* does not illustrate a narrative nor are its meaning or subject immediately apparent. As an abstract painting it does not resemble anything in particular, although it may be understood to represent (or re-present) a variety of thoughts, ideas, beliefs and associations.

From the time of the First World War until his death in 1931, van Doesburg was the guiding figure of an art movement called De Stijl (The Style) and his non-representational paintings, like those of his colleague Piet Mondrian have been classified, in Dutch, as *nieuwe beelding* (new image creation; sometimes translated as neo-plasticism). As such, his particular kind of art became associated with what was termed an abstract, Modernist canon.

Please look again at the painting. What aspects do you think were particularly valued by van Doesburg and De Stijl and, by association, this canon?

▶ *van Doesburg and his De Stijl colleagues excluded natural form from their art because they believed it 'blocks pure aesthetic expression, the ultimate consequence of all concepts of art' (quoted in Harrison and Wood (2003), p. 281). Therefore,* Counter Composition XIII *was accorded status because of its emphasis on the formal qualities of painting only – colour, shape and surface. Unlike the earlier, stylized example by Kiefer, there is no attempt to construct a believable depth of space; no attempt is made to conceal the flatness of the painting's surface, or indeed to suggest a narrative or story.*

It was for these reasons that De Stijl's flat, geometric paintings were highly rated by some critics and art historians in the mid-twentieth century, notably the American Clement Greenberg (1909–94). Some of the basic assumptions behind these ideas were mentioned in Chapter 2 and van Doesburg's painting illustrates the characteristics of the distinct critical tradition of Modernism that we listed on pp. 16–17 and which Greenburg espoused. Modernism was an approach to avant-garde visual culture that was particularly influential on both sides of the Atlantic from the 1940s through to the late 1950s and early 1960s, establishing the idea that the most innovative and progressive avant-garde art of the past 100 years had been, or had become, increasingly abstract. According to Greenberg, the abstract art produced by the avant-garde was characterized by the increasing extent to which it made the medium explicit within the work, a development which was borne out by the flattening of the picture surface and a refusal of illusionism.

Looking back in 1960 at what he understood to be the logic of avant-garde art's supposed development over the previous century, and its distinctness from the narrative and naturalistic painting which had preceded it, Greenberg observed:

*The limitations that constitute the medium of painting –
the flat surface, the shape of the support, the properties of
pigment – were treated by the Old Masters as negative factors
that could be acknowledged only implicitly or indirectly.
Modernist painting has come to regard these same limitations as
positive factors to be acknowledged openly.*

(Quoted in *Harrison and Wood* (2003), p. 775)

Greenberg's commitment to the virtues of abstract art arose
from a conviction that it was only when avant-garde art was
able to emphasize those qualities which made it different and
distinct from other genres like sculpture or from earlier forms of
naturalistic art that it achieved its true status as a progressive,
Modernist canon. Those included in the (highly selective) list
of 'great' Modernist painters were Manet, the Impressionists,
Cézanne, Picasso, Braque, Matisse, Kandinsky, Mondrian, Miró,
Pollock, Rothko, Newman and later examples of so-called 'Post
Painterly Abstraction' by Helen Frankenthaler, Kenneth Noland
and Morris Louis. According to Greenberg, Modernist art
developed through a cumulative process of self-purification or
'self-criticism', which adapted and improved the best from previous
avant-garde art. Some of Greenberg's contemporaries, such as the art
critic and author Michael Fried (noted in Chapter 2 and Section 5
of this chapter), developed complementary ideas that were applied
to robustly three-dimensional work by neo-avant-garde artists
and which were to form part of the eventual swing against
Modernism.

You may wonder how and why Greenberg's ideas are relevant to
contemporary painting. Although it is fair to say that his ideas
dropped out of fashion in the 1960s (for some of the reasons
see Chapter 2, Sections 2 and 3), he played an influential part in
developing art criticism and writing about art as a serious and
demanding creative activity, principally in relation to painting but
also, later on, to abstract sculpture. Although earlier writers like
Roger Fry and Desmond MacCarthy, and peers such as Harold
Rosenberg and Meyer Schapiro, had also played an important

part in promoting abstract art as such, Greenberg attempted to develop and popularize ideas which explained and accounted for the prominence, importance and direction of abstract art in the twentieth century.

One of the prevalent features of painting, particularly since the 1950s, has been the willingness of practitioners to incorporate other media into and as part of the painted surface. As mentioned earlier, the flexibility offered by acrylic paint has played a part in this, but we can see much earlier precedents. For example, in 1912 Picasso incorporated fragments of oil cloth with printed chair caning onto the surface of one of his still life paintings. A rope was improvised as a frame, further underlining the idea of the painting as a physical object, or as a synthesis of actual objects, rather than simulated ones (see http://www.artchive.com/artchive/P/picasso/chaircan.jpg.html). This was followed up with the regular inclusion of collaged fragments – tram tickets, newspapers and shop flyers by both Braque and Picasso within their Cubist compositions during what became known as the period of 'Synthetic Cubism' (1912–14).

Looking back to this period in 1958, Greenberg interpreted this 'paper pasted' innovation as a major revolution within Modernist painting. Although Greenberg emphasized the use of collaged materials because they drew attention to the reality of the flat painted surface, other artists incorporated mixed-media with painted compositions for very different reasons.

With this in mind, please look at Plate 2, a work by Richard Hamilton (b.1922), John McHale (1922–78) and John Voelcker (1927–72) made for the exhibition *This is Tomorrow*. This was made from wood, paint, foam rubber, fibreglass and collage, and included film projection and microphones.

What do you think the wide-ranging media suggest about the collective intention or aim behind the piece?

> ▶ This work not only used a range of materials not usually associated with art, it also emphasized contemporary technologies and new media. With this in mind, we might reasonably ask if this work is primarily a painting, an installation, a film or projection-based piece, or whether, given its size, it might be described as an architectural construction. Of course, it is all of these things – what might be termed a hybrid, mixed-media work.
>
> ▶ Given the exhibition's multidisciplinary use of materials, this is how Roger Coleman, a friend and colleague of the artists, described the exhibit's ethos: 'Everything is eclectic, there is no culture, it's what we receive, what we decide, what we choose, and it's our responsibility to choose.' (Roger Coleman, quoted in http:/www.thisistomorrow2.com)

You may have been struck by this statement; it is strident, assertive and confident, with culture defined as consumer based – what is directly experienced and decided upon by a new generation, rather than ideas and values that are passively received and accepted. As you read this, you might wish to compare its tone and content to some of Greenberg's Modernist ideas on painting we quoted above, as emblematic of a particular and somewhat different form of cultural value.

Insight

Rather than an inward and pictorially abstract exploration of medium and pigment, the *This is Tomorrow* exhibit, which prefigured Pop Art, was expansive, figurative and arguably more socially accessible.

You may well have noticed something else about the creation of the *This is Tomorrow* exhibit – it was collectively created and made. In fact, the entire exhibition was a collaborative curatorial event with 12 separate teams creating work. Originally, each team was to include artists and architects (although this did not quite work out in practice for every team); this division was consistent with the interdisciplinary understanding of what contemporary culture was believed to be.

Although this is a slight generalization, because there had inevitably always been artistic partnerships and collaborations, one of the recurrent aspects of Modernist painting and Greenberg's theory was the emphasis on the creative and solitary individual, often mythologized as the tortured genius. To some extent, the tragic fortunes of Arshile Gorky, Jackson Pollock and Mark Rothko gave sad credence to this emphasis, but it also created a view of artistic creativity for which a subsequent generation of Pop Art painters had little time, temperament or respect.

Group 2's *This is Tomorrow* exhibit is emblematic of a particular kind of post-war hybrid painting and we might make the following observations:

▶ *Such work played an important part in making the subject matter of figurative painting more accessible and fashionable.*
▶ *Painters adapted images from consumer culture, advertising and contemporary technology – things which have influenced a subsequent generation of artists (see Chapter 5, Section 3).*
▶ *Pop Art, which the* This is Tomorrow *exhibit informed, used painting as a basis for composite, mixed-media works, spanning installations, prints, posters and collaged environments.*
▶ *Pop Art gave emphasis to a process of making as a more collective, communal and inclusive activity than had been the case with Modernism.*
▶ *It identified particular subject matter within figurative practice as relevant Postmodern or late modern art forms, ensuring the ongoing significance of painting as a contemporary genre.*

More recently, a younger generation of artists, who grew up with the examples of Pop Art and the object-based, installation work of the neo-avant-gardes, have begun to re-explore some of the ideas associated with not just the theory of Modernism, but with the more socially engaged and observant subject matter related to some of the older historic avant-gardes: Cecily Brown, Glenn Brown, Gillian Carnegie, Gary Hume, Marcus Harvey, Angus Pryor, Fiona Rae, Martin Maloney and Jenny Saville are just a few of the artists who have melded innovative and expressive painterly effects with wider concerns and subjects.

With some of the issues we have discussed in mind, please look at Plate 14, *Night Vision* by Fiona Rae (b.1963).

Rae might be described as a member of a 'post-conceptual' generation of artists – that is, those who have come after the neo-avant-gardes of the 1960s and 1970s, and who are familiar with many of the critical ideas and debates which have been briefly discussed in this and other chapters. Rae studied at Croydon and Goldsmiths colleges in the UK and was among those artists whose work was exhibited at the first *Freeze* show of 1988 (see p. 238), curated by Damien Hirst. Shortlisted for the Turner Prize (see pp. 248–249) in 1991, her work has been widely exhibited both nationally and internationally.

How would you describe the use of paint and the resulting style of *Night Vision*?

▶ *The painting is one of a series in which Rae has explored the textured and visual effects of different and blended painting media.*

▶ *Black acrylic paint has been put on with a roller, giving the base covering. Oil paint has then been applied on top – with differing colours used to portray both organic-looking and more geometric shapes.*

▶ *Paint has been dragged, blended and applied in depth (impasto) to give a compendium of effects, motifs and forms.*

▶ *The style is abstract, a juxtaposition of geometric with freer, more fluid, organic forms.*

Is there an easily identifiable subject matter?

▶ *While certain forms may remind you of things – a flying bird, a horizon line and so on, and while there is illusionistic depth in the painting created by overlapping, variations in colour, and a figure-ground arrangement – the painting has no identifiable subject.*

▶ *In looking at Rae's canvas, you may have been reminded of some of the technical and pigment-based concerns associated with Modernism, and her use of matt-colour backgrounds recalls work by earlier avant-garde artists such as André Masson and Joan Miró.*

Noting Rae's referencing of earlier styles and idioms, the art critic Louisa Buck has described her as making 'painting about paintings' and the experience of looking at Rae's canvases as akin to 'being taken on a ram-raid through art history' (Buck (1998), p. 58).

Insight

Buck seems to be acknowledging Rae's sense of self-consciousness as a painter; someone who, aware of the histories of painting, is also concerned to explore its technical possibilities – and the ambivalence which still attaches to the medium.

If Rae's canvas can be said to have a subject, it is the exploration of painting as a medium, in a way reminiscent of some of her Modernist predecessors. In describing her own fascination with the medium, Rae has observed: 'The appeal of painting is that there is no solution. It always eludes you, you can't solve it or quantify it. It's a process with no possibility of arrival, a long and engaging attempt to conquer something unconquerable.' (quoted in Kent (1994), p. 79).

Other contemporary painters have taken the versatility offered by painting in a different direction. Angus Pryor (b.1966), a graduate of Wimbledon School of Art and the Kent Institute of Art & Design in the UK, describes his highly tactile and expressive canvases as 'disguised or layered narratives' which reference traditions of both abstraction and figuration. The style of *The Deluge* (Plate 15) is typical of some of Pryor's earlier paintings; based on a visit to Venice, its iconography references scenes from the apocalyptic motif and biblical narrative of Noah and the Ark.

The painting employs a strong palette of crimsons and reds; colours such as these were used by the Venetian painters Tiepolo and Veronese and are recurrent influences in Pryor's work, as is the abstract, gestural work of the American painter and printmaker Philip Guston and the Abstract Expressionist Willem de Kooning.

How would you describe the visual characteristics of Pryor's *The Deluge* (Plate 15)?

- ▶ The paint surface is saturated in multiple layers and skeins of paint, which comprises household undercoat mixed with oil paint.
- ▶ Caustic builder's caulk has been added to the mixture which raises the surface (impasto) to ridges and buttons of pigment.
- ▶ No single motif or focus dominates the composition; the 'all-over', or polyphonic effect of the painted surface results in a mosaic, encouraging our gaze to wander across the entire image.
- ▶ Looking at the canvas, there is a sense of colliding narratives; motifs are obsessively worked and then reworked. The canvas combines gestural painting with an all-over approach which seems to cover every inch of space. This is what Pryor says about the context to his paintings: 'Everyone grew up being told stories; linear narratives are part of our everyday consciousness. My paintings are real narratives. They exist in settings where a multitude of experiences are happening at once. Like the hieroglyph in archaeology, everything has a meaning' (Interview with Grant Pooke, July 2008).

The use and innovation of the media and the base remain an ongoing concern for contemporary painters. For example, Gary Hume (b.1962), one of the yBas (Young British Artists) generation of artists, came to prominence with his series of painted gloss and emulsion hospital doors which used aluminium, rather than canvas, as a base and support. More recently, he has obliquely referenced some of these earlier techniques with *Hermaphrodite Polar Bear* (Plate 12). Also completed on aluminium, it uses enamel paints to create a stylized but amusing fish-eye view of the Arctic carnivore.

Please look at Hume's *Hermaphrodite Polar Bear* (Plate 12). In describing the image and the way it is painted, what interpretations might you form?

- ▶ The paint is applied flatly; there is little tonal modelling (light and shade), no textures to indicate fur or paws, no naturalistic detail.
- ▶ The colours are simplified, although they describe the parts of the animal being depicted.
- ▶ The shape of the polar bear fills the rectangular aluminium support.

(Contd)

> ▶ The overall style of the painting is reminiscent of animated cartoons, a result of flat colour and outlines, or a child's toy.
> ▶ The only features that indicate the subject are the overall shape of the animal, its paws and its genitals. The latter, a hybrid of male and female, are referred to in the title, the result of a trip Hume made to the Arctic (see pp. 211–212).

Another contemporary and widely exhibited figurative painter is Peter Doig (b.1959).

Please look at *The Architect's Home in the Ravine* (Plate 11). How does this image depart from, or challenge, conventional expectations of what a painting should be?

> ▶ The house, the apparent subject of Doig's painting, is almost entirely obscured by a thick lattice of underbrush. Although we know we are meant to be looking through branches and twigs, the effect is also of an irregular pattern of lines on the surface of the canvas (which it is) that seems to emphasize the two-dimensional plane.
> ▶ Doig's technique suggests ambiguity. Despite the painting's apparent subject – the house, which is convincingly situated using perspectival depth, we are drawn to compositional technique – the process and means of depiction which emphasize the flatness of the painted surface.
> ▶ In this example, Doig balances subject matter and technique, leaving us with a composition, the meaning of which is unresolved and open.

Finally, we should like to consider *The Pyramid Art* (Plate 16), a painting by Mark Dolamore (b.1956). What do you find most immediately striking about its appearance?

> ▶ Perhaps it is that the artist has used the distinctive shape of an isosceles triangle, rather than the conventional rectangular format associated with the genre of painting, whether figurative or abstract. This certainly helps to make the painting distinctive and different.

How would you describe the painting?

> ▶ *'Hieroglyphic' imprints cover the painted bas-relief to suggest an ancient language, re-assembling an ancient stone tablet, perhaps like the Rosetta Stone.*
>
> ▶ *The surface has been painted to suggest evidence of fractures, evoking the patina associated with age and history.*
>
> ▶ *A striking blue has been used to evoke the presence of the spiritual or the transcendent. In the Renaissance, the semi-precious mineral lapis lazuli was crushed to create a distinctive blue pigment for paint. It was known as ultramarine (literally 'beyond the sea' because lapis was, at that time, available only from mines in Afghanistan) and was so precious that it was reserved for special features in pictures, particularly the drapery of the Virgin Mary in altarpieces.*

Mark Dolamore is a British artist with a particular interest in the phenomenon of 'synchronicity' – that is, events in life that appear to be related because they suggest a fundamental reality yet have no logical or causal connection. The term was coined by the psychologist Carl Jung, who believed that 'meaningful coincidences' are designed to enlighten us into unconscious unifying principles. For Jung, this idea supported his belief in psychological archetypes – certain universally held concepts which situate the human condition as a product of recurrent behavioural traits. Referring to Jung's innovation of the term, Dolamore writes: 'His writings indicated that synchronicity appears at moments of religious insight to clarify the mystery of why we are here' (ecva.org/exhibition/Gifts2009/Dolamore.htm).

The symbols in *The Pyramid Art* are a discovered language, which the artist has described as an invitation to share in an important secret. Although this image suggests a very personal take on a relatively uncommon perceptual phenomenon, it demonstrates the expansive versatility of painting as a medium of expression. In this case, Dolamore has used it to fix a personal understanding of the unconscious 'underworld' or hinterland we might all share, through symbolism derived from a mathematical system. Underpinning this image is the artist's conviction that his

connection to an unconscious force of nature holds the prospect that it might be shared with others who contemplate the painting.

We can close this section by making some general observations about the genre of painting:

- *Forms of painting have been associated with various canons and schools, from the abstract through to the figurative.*
- *From having been the dominant genre for much of the nineteenth and early twentieth centuries, painting has increasingly shared cultural space with other ways of making and thinking about art.*
- *Aspects of Modernism (the critical theory which emphasized the abstract, flat qualities of the medium) continue to exert some influence on more recent painting practice.*
- *Pop Art in the 1960s gave an impetus to figurative painting and printmaking, as well as to the idea of mixed-media hybrid paintings that explored aspects of mass culture and contemporary technology.*
- *Painting, whether abstract or figurative, continues to be popular, not least because it can be used to register both a distinctness from, and engagement with, the idea of the contemporary.*

SCULPTURE

As with painting, the character of sculpture has changed in recent times. Until the early years of the twentieth century, sculpture was created by carving and modelling, but in the years immediately before the First World War, Pablo Picasso began making sculptures that were constructed; that is, they comprised separate pieces which were fixed together. From this followed a plethora of forms that were categorized as sculpture, from the welded metal creations of Julio González to the wire and perspex (Plexiglas) works of Naum Gabo, the hanging, moving sculptures of Alexander Calder (known as mobiles), and the ready-mades of Marcel Duchamp (see p. 52). But it was in the three decades after the end of the Second World War that the avant-garde really challenged established sculptural conventions. As we saw in

Chapter 2, the critic Rosalind Krauss identified what she saw as an 'expanded field of sculpture', citing 'narrow corridors with TV monitors at the ends; large photographs documenting country hikes; mirrors placed at strange angles in ordinary rooms; temporary lines cut into the floor of the desert' (Krauss (1986), p. 277).

Please look at the *This is Tomorrow* exhibit by Richard Hamilton, John McHale and John Voelcker (Plate 2). In the previous section, we considered this work in relation to painting. Now, please think about it as sculpture.

In what ways might you categorize this as sculpture?

▶ It is a three-dimensional constructed work, a series of forms that exist in space.
▶ The large bottle of Guinness that stands on the floor can be viewed through 360 degrees, like a conventional free-standing sculpture.

In what ways might you think that this is not sculpture? How does it depart from some of the typical conventions we might associate with the genre?

▶ Because viewers walked through the exhibit (see p. 30), you might think it is closer to architecture, or better categorized as an installation – a form we will look at in Section 5 of this chapter.
▶ You might consider the giant bottle of Guinness more a model or replica than a sculpture in any conventional sense.
▶ The flat surfaces of the structure are painted and collaged, which further confuse its status as sculpture.

If you look back to what was said about this example on pp. 92–94 and 98, you will see that we suggested it illustrated a hybrid form of art; that is, it is a mixture of painting, sculpture, installation, architecture and so on, and impossible to classify as a particular artistic form. What all this demonstrates is that sculpture, along with painting, has become an artistic form which is increasingly difficult to define in the terms with which it was once understood.

You might ask why every artistic three-dimensional creation
is not simply defined as sculpture? Or conversely, why we
do not call it all art and do away with a variety of types,
such as painting, installation and sculpture? This permissive
strategy is, arguably, what Marcel Duchamp did when he
created his ready-mades; he conferred the status of art on a
snow shovel, a bottle drying rack, a urinal and other objects
he bought and signed. Its generosity also seems to correspond
with Joseph Beuys's subsequent view that everyone is an artist
(see pp. 36–37). If you think back to some of the
philosophical arguments we outlined in Section 3 of Chapter
3, you may recognize resonances of the ideas of Derrida,
Dickie and Lyotard in all this.

Please look at *Early One Morning* (Figure 1.1) by Anthony Caro
(b.1924) and *Untitled* (Figure 2.1) by Donald Judd (1928–94). We
discussed the differences and similarities between these examples
on pp. 34–35, noting that Caro's work retained the formal
and aesthetic conventions of sculpture, while Judd's challenged
them; Judd even denied the term 'sculpture', calling his creations
'objects'. Despite *Early One Morning* and *Untitled* each being
free-standing, three-dimensional forms around which the viewer
can move, and despite each using 'modern' materials and processes
of construction, the intended purpose and subsequent effect and
meaning of the works is very different.

While Caro's seems to be about the relative complexity of forms
in juxtaposition and the resultant aesthetic engagement of the
viewer, Judd's is about simplicity, repetition and a purity of forms
that consciously denies the viewer the kind of aesthetic connection
encouraged by Caro's example. As we will see in Section 5 of
this chapter, so-called Minimalist work like Judd's *Untitled* was
to contribute to a form that came to be called installation art.
However, this development does not follow a direct line from
Minimalism; installation art also has its origins in the *This is*

Tomorrow exhibit (Plate 2), Oldenburg's *The Store* (pp. 29–30), and other manifestations of the neo-avant-garde. But the point here is that its evolution not only demonstrates ways in which sculpture has become more than carved, modelled and constructed forms around which the viewer moves, but also that it is no longer a clearly defined category of artistic activity. All this said, there remain many examples of contemporary art that we would classify as sculpture.

Please look at *Great Deeds Against the Dead* (Figure 5.2) by Jake (b.1966) and Dinos (b.1962) Chapman and *La Nona Ora* (Plate 7) by Maurizio Cattelan (b.1960). Which of these works would you classify as sculpture?

▶ *In one sense, they are both sculptures. Each is three-dimensional and each modelled – Cattelan's in wax, the Chapman brothers' in fibreglass.*

▶ *In a general sense, the subject matter of each is the traditional subject of sculpture – the human figure.*

▶ *However, the figure in* La Nona Ora *is part of a larger 'environment' which the viewer is invited to enter; the walls, red carpet and the broken skylight are all part of the work. On the other hand,* Great Deeds Against the Dead *is a discrete form; its environmental setting is not part of the work.*

▶ *While the Chapmans' work is more conventionally sculptural in its form and setting, Cattelan's might be regarded as installation (which is how we have considered it in Section 5 of this chapter).*

Despite all this apparent uncertainty about categorizing various forms of art, some works remain more sculpture than anything else. *Great Deeds Against the Dead* is one example illustrated in this book, along with arguably, Jeff Koons's *New Hoover Convertibles* (Figure 3.1) and *Angel of the North* (Figure 4.4) by Antony Gormley (b.1950). We want to close this section by looking at another example you might regard as sculpture, *Self* (Plate 6) by Marc Quinn (b.1964).

Why might you consider this work as sculpture?

▶ Like some of the other examples we have noted, Quinn's work is a free-standing, three-dimensional piece around which the viewer can move.

▶ The head is modelled – in fact, it is made from a cast of the artist's head; casting is a relatively conventional processes used in sculpture.

▶ The subject is traditionally sculptural – a portrait bust.

▶ The head appears to be on a plinth, a conventional way of displaying sculpture.

Despite all these points, it would be unreasonable to conclude that *Self* is a traditional sculpture. If you have read the caption, you will see that the work is made from stainless steel, perspex (Plexiglas), refrigeration equipment and blood. By any stretch of the imagination, these are not conventional sculptural materials.

Why do you think Quinn has used these materials?

▶ The head is made from nine pints of the artist's own blood, poured into a cast and frozen. You may have considered that this material is part of the artist himself and so the self portrait is actually him, rather than a mimetic rendering in a material that has no physical relationship to the subject.

▶ The plinth is a freezer unit encased in stainless steel and is necessary to keep the blood frozen and solid. Moreover, its height is that of the artist himself so that the sculpture is literally life-size.

▶ The perspex (Plexiglas) cover keeps the cold in and the head solid. But it also gives the work the appearance of a museum exhibit, like a specimen in a glass case, as well as a parody of the way some smaller sculptures are displayed in art galleries.

As with a number of the examples we referenced in the previous section on painting and mixed-media, Quinn's work illustrates that sculpture has not wholly disappeared, although the materials it uses and the forms it takes may have changed. While it would be true to say that this genre of contemporary art is different from that which preceded it, it should be seen more as a development from, and innovation of, previous art practices.

Suggestions for further reading

Mary Acton, *Learning to Look at Paintings*, Routledge, London and New York, 1997

Julian Bell, *What is Painting? Representation and Modern Art*, Thames and Hudson, 1999

Mikkel Bogh *et al.* (eds), *Contemporary Painting in Context*, Museum Tusculanum Press, 2009

Martha Buskirk, *The Contingent Object of Contemporary Art*, MIT Press, 2005

Judith Collins, *Sculpture Today*, Phaidon, 2007

Frances Colpitt, *Abstract Art in the Late Twentieth Century*, Cambridge University Press, 2002

Jason Gaiger, *Aesthetics & Painting*, Continuum, 2008

Glenn Halper and Twylene Moyer, *Conversations on Sculpture*, University of Washington Press, 2008

Glenn Halper *et al.* (eds), *A Sculpture Reader: Contemporary Sculpture since 1980*, University of Washington Press, 2006

Jonathan Harris (ed.), *Critical Perspectives on Contemporary Painting: Hybridity, Hegemony, Historicism*, Tate Liverpool and Liverpool University Press, 2003

Charles Harrison, *Modernism* (Movements in Modern Art Series), Tate Publications, 1997

Martin Herbert *et al.*, *The Painting of Modern Life: 1960s to Now*, Hayward Publishing, 2007

Thomas McEvilley, *Sculpture in the Age of Doubt*, Allworth Press, 1999

Grant Pooke and Graham Whitham, *Teach Yourself Art History*, Hodder, 2003

Paul Wood, Jonathan Harris, Francis Frascina and Charles Harrison, *Modernism in Dispute: Art since the Forties*, Yale and Open University, 1993

THINGS TO REMEMBER

▸ *While abstract painting represented a new direction in modern art, its interpretation by Modernist critics such as Clement Greenberg was challenged by the neo-avant-garde and subsequent contemporary artists. One result of this was the incorporation of other media into painting.*

▸ *Far from rejecting Modernist concerns for the integrity of the painted surface, some contemporary artists have further exploited this.*

▸ *Like painting, sculpture is no longer a clearly defined artistic category but, probably more so than painting, any definition of sculpture in contemporary art must be a particularly expansive one.*

Section 2 Photography

Given the number of photographs on display in galleries and exhibitions of contemporary art, it would not be unreasonable to ask when is a photograph art? There are a number of terms in use that attempt to address this question, from 'photographic art', which suggests that photography is a category of art, to 'art that uses photography', which implies photography is one of the means used to produce something called 'art', to simply 'photography', which seems to indicate it is something different from 'art'. What all this tells us is that there is no universal consensus about

photography's status as art or as a medium or discipline related to, but essentially independent of, art. One of the reasons that this situation exists is the ubiquity of photographs, especially since the advent of commercially available digital cameras from the 1990s onwards. The ease with which we take photographs, particularly since this involves relatively little skill when, say, compared to making a drawing or a painting, make it problematic for some of us to accept photography as an art form. Moreover, the history of photography reinforces this view.

In all probability, photography was originally developed as an aid for artists, so that they could have a permanent image to take away, study and copy rather than the impermanent reflected image provided by a camera obscura, which they had been using since at least the sixteenth century. In the nineteenth century, when photography became a relatively common form of reproducing a fixed image of the real world, artists sometimes used it as an aid for their work. Édouard Manet and Edgar Degas were just two of the artists who employed photography in this way, and, since it functioned as a means to an end, this underlined its status as secondary to painting. However, in the first decades of the twentieth century, photography was being practised by artists such as Laszlo Moholy-Nagy, Marcel Duchamp and Man Ray (see Figure 1.2) as a creative activity parallel and equal to painting. By the same token, a number of photographers and critics promoted the medium as an art form in its own right. However, while all this served to elevate photography's status, it also exacerbated the rivalry with painting.

As we saw in Chapter 2, it was the neo-avant-garde that provided the inspiration and impetus for much of today's contemporary art, and their use of photography, whether in its own right, as in Edward Ruscha's book *Every Building on the Sunset Strip* (1966), or as part of mixed-media work, such as Robert Rauschenberg's 'combines', helped to contest the belief that photography was a supplementary genre to painting or 'real art'. By the end of the 1980s, photographs were appearing in displays and exhibitions of contemporary art and by the twenty-first century photography was, for many artists, the preferred medium.

Please look at *Untitled (No.224)* (Plate 10) by Cindy Sherman (b.1954). This is a photograph made in an edition of six. Each print measures 111.8 × 137.2 cm (44 × 54 in.) and is signed, dated and numbered. What similarities and differences can you identify between this work and a painting?

▶ There are a number of similarities between Sherman's photograph and a painting, not least the scale of her work, which is more the size we are accustomed to for a painting than a photograph. Furthermore, the photographs are signed and dated, a convention that we usually associate with paintings.

▶ The subject matter is a portrait, a conventional genre in photography and painting. Moreover, the subject is posed and the background plain, to put focus on the sitter, which is reminiscent of studio photographs and portrait paintings.

▶ You may also have thought that the detail and strong colour of Sherman's photograph evokes a carefully rendered, smooth-surfaced oil painting. In fact, Sherman's photograph is a pastiche of Caravaggio's late-sixteenth-century painting in the Borghese Gallery, Rome, which is smaller than the photograph, measuring just 66 × 52 cm (28.3 × 26 in.), just over half the photograph's size (see http://www.caravaggio-foundation.org).

▶ Other than these similarities, and, of course, Sherman's photograph and a painting being considered works of art, there are a couple of significant differences. A painting is hand-made; the photograph created by a machine – the camera.

▶ Generally, a painting is unique – there is just one version – whereas, in this instance, there are six identical photographs, albeit with different edition numbers added.

Comparing and contrasting Sherman's photograph with a painting is a useful exercise because it reveals a number of things about the medium of photography that are relevant to understanding it as a contemporary art practice. We might see photography as a form that is in competition with painting because both can represent the three-dimensional on a two-dimensional surface, and because photographs can now be made at a large scale, something which

painting has always had the capacity to do. Equally, the question of uniqueness arises because photographs are easily duplicated. That Sherman limits the number of prints to six and signs, dates and numbers them tells us something about her attitude to the idea of art as a unique object.

The apparent veracity of photography seems to have given it a special place as a means of creating images. Much contemporary art engages with the themes and issues of the individual, groups and society, and photography has become an effective and direct means of exploring and expressing these. For instance, Andreas Gursky's (b.1955) photograph of the Arirang Festival in North Korea, which is held in honour of the communist leader Kim Il Sung, is both a record of a visually striking event and, arguably, a comment on the political control such an event illustrates. The photograph gives us a truthful representation of the festival, albeit Gursky's interpretation, because it is seen through the lens of his camera; if there was a painting of the same scene, it would be perceived as less 'truthful' because photography is regarded as more impersonal and objective than painting.

However, the objectivity of a photograph is something of a misconception, although it is difficult to shake this off, surrounded as we are by images that seem to deny it, from photographs in newspapers to our own family snapshots. But since photographs are inherently representational, we tend to regard them as accurate and objective depictions of the world. On the other hand, paintings are more generally considered as interpretations by an artist and therefore subjective. After all, painting is a form of cultural production which involves time. If it draws upon the visible world for its subject, the manipulation of paint on a flat surface is an approximation of what the artist sees, let alone its transformation as a result of the artist's temperament, context and point of view. The photograph is considered to be an accurate depiction of the visible world, independent of the artist's character or beliefs because its creation is both immediate (through the click of a camera's shutter) and impersonal (the artist merely points the camera).

Please consider how accurate it is to claim that photography is an objective representation of the world, while painting is a personal and therefore subjective representation.

▶ Because paintings are hand-made objects and photographs machine-made, it would be reasonable to believe that the former are subjective and the latter objective. You might have thought of the cliché 'the camera never lies' and, in one sense, this is true. A photograph is an accurate depiction, but it can never be an objective one. This is because everything we do is subjective and so there are degrees of subjectivity, some of which may come close to objectivity, but can never achieve it. We are, after all, individuals with our own thoughts, opinions, judgements, beliefs and so on, and as such nothing we say, think, do, sense or interpret can ever be wholly objective. What the artist decides to photograph, the point at which the shutter release is pressed, the position and viewpoint adopted, the degree to which a scene is cropped by the viewing frame, and so on, are all subjective decisions that determine the way a photograph will look. Moreover, the image can be altered during the stage between taking the photograph and printing it, something that digital photography and computer programs have normalized.

Look again at Cindy Sherman's *Untitled (No.224)* (Plate 10). This is a posed studio figure (Sherman herself), carefully made-up, clothed, lit, and seated amongst meticulously positioned props. Whilst the photograph is an accurate copy of that reality, it is a reality the artist wants the viewer to see and so, in its way, is subjective rather than objective. The same is true for *Rebellious Silence* (Figure 3.4) by Shirin Neshat and Joel-Peter Witkin's *Three Graces* (http://www.art-forum.org/z_Witkin/Ip/JPW_graces.htm).

Insight
Thinking about photographs in this way might encourage us to regard them as creative and unique as paintings, and not just records of a reality we see and at which a camera has simply been pointed and the shutter release pressed.

Since the 1980s, photography has become an important medium for many artists. Where painting was once the dominant 'high' art form,

it now exists as simply another artistic mode and has been surpassed, some have argued, by photography as the pre-eminent form of two-dimensional art. To some extent, the rise of photography as 'high' art was dependent on the development of new artistic forms. For example, in the 1960s and 1970s photography was the principal means of documenting performance art (see Section 4 of this chapter), a form that was transient and therefore required a way of making it more permanent, albeit an incomplete one. We know the appearance of some of the early performances mentioned in Chapter 2, such as Kazuo Shiraga's *Challenging Mud* and Oldenburg's *Snapshots from the City*, only through photographs. This was similar for land art and also for recording the relative impermanence of forms of graffiti (see Section 6 of this chapter), where often inaccessible locations, the image's large scale, or the relative transience of the work made it difficult for most people to see it other than in photographs. But as time has gone on, photography has taken a more prominent role as an artistic medium in its own right.

There are a number of reasons why this has occurred, not least developments in technology that have encouraged artists to extend their ways of working. Cindy Sherman's *Untitled (No.224)* (Plate 10) is a large-scale photograph by normal standards, but it is relatively small compared to works by some other contemporary artist-photographers. For example, Andreas Gursky's 2007 photograph of the Arirang Festival mentioned above, is 4.22 m (13.85 ft) wide. Such pictures would not be possible without the technology that allows photographs to be printed to this scale or cameras capable of depicting fine detail. Photographs like this seem to rival academic paintings from previous centuries in their scale and representation of minute detail, and we might consider them as the contemporary equivalents of canvases by Charles LeBrun, Jacques-Louis David and Theodore Géricault.

The large photograph presented as a work of art is an important development, partly because its scale challenges painting for attention in a museum or gallery. Artists such as Gursky, Wolfgang Tilmans and Thomas Struth have exploited this, and the Canadian artist Jeff Wall has taken it further by presenting his work as large back-lit transparencies. The detail, colour saturation and precision

of large photographs, especially Wall's illuminated pictures, engage us in a different way than would a painting.

Please look again at Plate 10, Cindy Sherman's *Untitled (No.224)*, and also at Plate 11, Peter Doig's *The Architect's Home in the Ravine*. Although you are looking at photographic reproductions of a photograph and a painting, how do you respond to the way each has been made?

> ▶ *While they are completely different subjects, both works of art represent in a realistic, or naturalistic, style. Consequently, your response might have been to think of Sherman's picture as a truthful copy of reality and Doig's as a more subjective interpretation of reality, albeit one that is still convincing as an authentic reproduction of an actual place seen from that angle and position. But, as we have seen, they are both examples of artifice: Sherman's is a staged scene and Doig's a painted view of what we would assume is an actual location, although we cannot be certain of this.*
>
> ▶ *Since* The Architect's Home in the Ravine *has been made by applying paint to canvas, you might be interested in the way he has achieved such a naturalistic effect or, put another way, how the illusion of reality has been created. In a museum or gallery you may want to take a closer look at the painting's surface in order to see how such a realistic effect has been achieved. Unfortunately, the photographic reproduction in this book does not allow you to do this and there is an irony here because we would suggest that you, or any other viewer, would be less interested in the surface of a photograph. If you went close to Sherman's picture it would not, in all likelihood, be to observe the surface of the work in order to see how it was made.*
>
> ▶ *You may also have considered the question we have posed in a broader way. Your response to the two images may have been predicated on the fact that one is a painting and the other a photograph. For many of us, paintings still have a higher artistic status than photographs. There are many reasons for this, not least that painting has a longer history than photography and has always been a practice that we associate with art; that paintings are objects we might think display skill in a way that photography cannot; or that painting is a more appropriate and sympathetic medium for exhibiting creativity and*

personal expression than is photography. Moreover, our judgements may be influenced by the way we perceive the roles and purposes of photography. On the whole, it visually records reality; it is a principal means of documenting, whether in newspapers and magazines as something we consider newsworthy, or as something more personal, such as family events recorded in our own snapshots. We regard it as evidence, for example in a legal trial, or a record of finds on an archaeological dig; it is a means of recording a location, as on a postcard or in a travel brochure; a verification of a person's appearance, as in a passport photograph; or documentation of meteorological phenomena, as in photographs taken from space of hurricanes. When we look at photographs in an art gallery, we might think of all this as photography's 'baggage', the 'meanings' that it carries which can interfere with our understanding and appreciation of it as art.

Insight

Photography as art has been an important aspect of our culture for at least a century and a half, but because it has so many other roles and purposes, as we have illustrated above, we might still find it challenging and difficult as an art form, especially since in more recent times it has become far more ubiquitous in this role.

Despite technological developments that have allowed artists to create larger photographs, manipulate images, accurately replicate colour, and produce a high finish in which every detail is visible, for many of us photography still remains painting's poor relation. In comparing and contrasting photography with painting, we have suggested reasons why this might be, but if we look at some examples of photography that are regarded as art, we should be able to better clarify the medium's artistic status.

Although *What does possession mean to you?* (Figure 3.3) by Victor Burgin (b.1941) was made in the 1970s, it is the sort of work that has informed aspects of contemporary art. What is important to our discussion here is that it is an example of a particular type of photography being taken out of its original context, which results in a changed meaning.

First of all, the artist did not take the photograph. It was a stock image from a picture agency selected because it communicated what the artist wanted. Secondly, it was printed as 500 posters and pasted around the streets of Newcastle upon Tyne in north-east England at the time Burgin's photoworks were being exhibited in a gallery there. On both counts, therefore, *What does possession mean to you?* is not a unique work of art, nor is it hand-made by the artist. Equally, it could be regarded as a way of advertising the exhibition, but it was also intended as a work of art in its own right, which, for it to be effective, was displayed in the street as though it was an advertisement. *What does possession mean to you?* addresses issues of gender, class and wealth, which will be discussed in Chapter 5, Section 1, but what concerns us here is the use of photography in this work.

Please think about the type of photograph used in *What does possession mean to you?* and its possible role in communicating meaning.

▶ *The photograph is a part of the work and it would not be particularly useful to consider it independently of the text and layout. The arrangement of text and image seems to be straight from the page of a glossy magazine, but what makes Burgin's poster different is what the text says. A question is asked, information given, and nothing is being sold. The photograph itself is fairly neutral until associated with the text. The woman's arm on the man's and her hand around the back of his head might be taken as the 'possession' in the headline above; their apparent affluence, perhaps indicated by their clothes and grooming, could be an interpretation prompted by the information below the picture.*

▶ *In this work, differentiating between photography as art and photography as a means of advertising is not easy. Leaving aside the possibility that it was made to promote Burgin's exhibition, similar images of young and affectionate couples can be found in numerous magazine advertisements for perfume, clothes, chocolates and so on. In fact, since this is a stock picture from a photo agency, it may well have been used for such a purpose. But what Burgin has done is purposely*

> *used the pictorial language of advertising in order to subvert it and make a point about the unequal division of wealth.*
>
> ▶ *The photograph in* What does possession mean to you? *fails to meet the criteria many of us would require for something to be art. It is not original; it was not taken by the artist and so does not display his skill; and it is not unique. But perhaps we should ask ourselves about Burgin's purpose.* What does possession mean to you? *conveys a message which, some would argue, is an important one. In order for that message to reach a wide audience and be effective, Burgin appropriated the well-established language of advertising, part of which was a photograph that, like so many others, carried meaning through its association with 'luxury products'. In other words, the photograph has to be a stock or clichéd image for it to communicate the intended meaning.*

The example of *What does possession mean to you?* illustrates that the way a photograph might look, or the type of photograph it is, can contribute to its meaning, and artists frequently exploit this. In the late nineteenth century photographers such as Jacob Riis and Lewis Hine in the United States recorded the often unpleasant and unhealthy living and working conditions of the urban proletariat. Dorothea Lange, Walker Evans and Arthur Rothenstein took similar photographs in the Midwest during the 1930s Depression. The convention that many of these pictures adopted was that of the subject posed in their living or working environment, often looking dispassionately and inexpressively at the camera. Through the work of 'social' photographers like those noted above, this form became established to the extent that we now recognize such poses, lack of expression and particular locations as signifying serious, socially conscious documents. Establishing a meaning using motifs and devices in a metaphorical or symbolic way is known as a **trope**.

During the early 2000s Adam Broomberg (b.1970) and Oliver Chanarin (b.1971) photographed refugees, prison inmates and gypsies using a similar form. A photograph taken in a maximum security prison in Cape Town, South Africa, in 2002 called *Timmy, Peter and Frederick. Pollsmoor Prison*

(http://www.paradiserow.com/browse/_,Adam%20Broomberg%20%20Oliver%20Chanarin,1/), shows three bare-chested inmates staring expressionlessly at the camera in a small cell with barred window, basin, toilet and stained walls. Broomberg and Chanarin used the trope established by earlier photographers – the staring, expressionless faces, poses, setting, the position of the camera, and lighting – so that the purpose and meaning of their photograph would be recognized as serious and socially conscious.

Burgin's *What does possession mean to you?* uses the trope created by sophisticated magazine advertising but, unlike Broomberg and Chanarin, he adapts it to undermine photographic conventions rather than to reinforce them. The photographs of Joel-Peter Witkin (b.1939) also reference a trope, but in a different way again.

Witkin's photograph *The Three Graces*, which you can find online at http://www.art-forum.org/z_Witkin/Ip/JPW_graces.htm, is black and white and the clarity of image is not as sharp as in, for instance, Cindy Sherman's *Untitled (No.224)* (Plate 10). The surface of the picture is stained and marked with wax. The corners of the photograph are cut, giving the appearance of having been stuck in an album using photo mounting corners, or attached in a frame so the image can be projected.

The trope here is that Witkin's photograph has the characteristics of age and, like Burgin's *What does possession mean to you?* and Sherman's *Untitled (No.224)* (Plate 10), *The Three Graces* uses a trope to 'misdirect' the viewer. Burgin gives us a glossy advertisement that is not one, Sherman a Caravaggio painting of a boy that is neither a painting nor a boy, and Witkin a photograph that looks as though it comes from the nineteenth century but was made in 1988. In photographs, like all works of art, form and content cannot be divorced; they complement each other in order to convey meaning. In *The Three Graces*, the hermaphrodites are posed, as the title tells us, like the Three Graces in a painting, but the aged appearance of the image seems to contradict this high art

analogy, suggesting that the figures are part of some nineteenth century circus or freak show, their unusual appearance recorded by the photographer for the interest of voyeurs.

More ubiquitous than ever in art exhibitions and collections, photography no longer comes second best to painting, but the genre's uncertain cultural status since its invention in the 1820s still dogs it as a universally accepted art form. It is more straightforward for us to regard works such as Sherman's *Untitled (No.224)* (Plate 10) and Witkin's *The Three Graces* as 'art' because they were created in the studio, unlike the work of Gursky, Broomberg and Chanarin, which is so closely associated with photojournalism that for some of us it cannot be art.

In the contemporary world, however, the term art is no longer a confined or fixed one. It may not be possible to establish a less fluid and imprecise classification of art, but it is interesting to look at how photography has addressed the question of its own status. Taking advantage of technological developments, we might think that many photographers create large-scale work in order to compete with painting, while others make direct reference to specific paintings (Plate 10). On the other hand, contemporary artist-photographers, such as Gursky, Broomberg and Chanarin, exploit established and recognizable photographic motifs and devices (tropes), and in so doing further assimilate the medium as an art form.

Suggestions for further reading

Susan Bright, *Art Photography Now*, Thames and Hudson, 2006

David Campany (ed.), *Art and Photography*, Phaidon, 2003

Charlotte Cotton, *The Contemporary Photograph as Art*, Thames and Hudson, 2004

Michael Fried, *Why Photography Matters as Art as Never Before*, Yale University Press, 2008

Uta Grosenick and Thomas Seelig (eds), *Photo Art: The New World of Photography*, Thames and Hudson, 2008

THINGS TO REMEMBER

▶ *Although in the past photography might have been regarded as an activity separate from art, it is an accepted and widely employed medium of contemporary art.*

▶ *Photography has become an effective and direct means for artists to engage with themes, issues and ideas that were once the monopoly of painting.*

▶ *Despite their apparent objectivity, photographs are, in their own way, as subjective as paintings.*

▶ *Appreciating photography as an art form may be difficult because we associate it with other roles and purposes, principally as a means of documenting and recording.*

▶ *Because photographic images are so ubiquitous, forms of representation have been established and artist-photographers exploit these to convey meaning.*

Section 3 Film, video and digital media

FILM AND VIDEO

In the first three decades of the twentieth century a number of European and American artists, including Hans Richter, Viking Eggeling, Man Ray (see Figure 1.2), Laszlo Moholy-Nagy, Salvador Dalí, and Marcel Duchamp, extended their artistic practice by experimenting with film. It is not surprising, given the prehistory of contemporary art we have sketched, that these artists belonged to the avant-garde and that many of them were

associated with those movements critically engaging with the concerns of everyday life. In the early twentieth century, film was a relatively new medium employed primarily as a form of entertainment, information and news. Using it to create art was radical, not only because this crossed the boundaries between fine art, information communication and popular culture, but also because it offered artists a different range of possibilities for expressing and conveying their ideas in a way that more traditional forms, such as painting and sculpture, could not.

Conversely, just as some artists were developing their work through film, some film-makers began to exploit the potential of the medium as something more than a form of entertainment and information. In the first half of the twentieth century Len Lye, Norman McLaren and Harry Smith hand-painted and scratched on celluloid film and projected the results; directors such as Walter Ruttmann, Germaine Dulac and Dziga Vertov used film's potential to create dissolve, fade, superimposed and split-screen shots; Mary Ellen Bute experimented with electronic visual effects to accompany music; and Douglas Crockwell filmed wax and paint manipulated on glass.

This blurring of boundaries between art and popular culture continued into the second half of the century as artists and film-makers associated with the neo-avant-garde (see Chapter 2, Section 2), such as Stan Brakhage, John Cassavetes, Joan Jonas and Andy Warhol, looked for new possibilities of experimentation and expression. As a result, although film was associated principally with popular entertainment, it was often considered as a medium that had the potential to be 'art', and artists such as Matthew Barney (b.1967) have exploited this. While Barney's *Cremaster* films (Plate 3 and pp. 48–49) use actors and employ Hollywood production techniques, their unusual themes and narratives, esoteric symbolism, and unconventional time shifts and locations, establish them as a form of fine art rather than popular culture.

In contrast to film, the other dominant screen-based medium of the later twentieth century is television which, until relatively recently, remained firmly in the domain of popular entertainment. The rise of television has been spectacular. By 1967 nine in ten

British households had television sets, a figure that had been reached seven years previously in the United States and surpassed in the early 1990s when 99 per cent of households had at least one TV set. The medium's ubiquity is staggering: not only does television broadcast in our homes but also in our public spaces, from airport lounges to hospital waiting rooms. In the early 1960s some artists were paying attention to television. Wolf Vostell (1932–98) and Nam June Paik (1932–2006), artists associated with the neo-avant-garde Fluxus group (see p. 38), respectively wrapped a television set in barbed wire and buried it and distorted television pictures with a magnet.

Given the critical position of neo-avant-garde artists in general and Fluxus in particular, how would you interpret the actions of Vostell and Paik?

▶ *You might think that these actions were intended to challenge the hegemony of more conventional forms of art, which was certainly a strategy employed by the neo-avant-garde in general and Fluxus especially. But George Maciunas's* Fluxus Manifesto, *part of which we quoted on p. 38, called for artists to eliminate 'bourgeois sickness, "intellectual", professional and commercialized culture'. In light of this, you may consider that wrapping a TV set in barbed wire, burying it and distorting its picture were symbolic actions. The TV set might signify the broadcasting companies and the businesses and manufacturers who advertised through them, which Fluxus regarded with contempt as elements of the controlling capitalism of Western society.*

Artists such as Vostell and Paik looked upon television as a medium where the spectator is a passive receiver of a broadcaster's insidious, capitalist 'message'. Consequently, they promoted a more active viewer engagement and, in the 1960s, Paik developed *Participation TV*, where viewers could modify the electronic image using a microphone. In this way, he believed that the viewer was empowered and not merely the submissive recipient of a controlling broadcast.

Of course, viewer participation has developed commercially with the relatively recent and rapid increase in television channels and

the development of cable and digital TV. Pressing buttons on the TV's remote control or telephone voting for talent shows provides a modicum of viewer participation but, on the whole, programmes are still controlled by corporate broadcasters. However, that hegemony was significantly challenged in the mid-1960s when the electronics company Sony marketed the first portable video recorder, making it possible to record more directly, easily and cheaply than with film. In the early 1970s the portable colour video recorder was invented and video cassettes were standardized; by mid-decade, it was possible to record TV broadcasts on video tape, and at the end of the 1970s the camcorder appeared, which could record and play.

Video liberated film from corporate control and allowed anyone to record anything, something that appealed to the critical and permissive spirit of the neo-avant-garde. Paik and Warhol were making and showing their video films as early as 1965; the first book about video art was published in 1970; Gerry Schum, a mediator between television and artists, opened a video gallery in Düsseldorf in 1971; in 1975 video art was displayed in major exhibitions in Brussels, Copenhagen, Paris and London; and in 1977 the Centre Georges Pompidou in Paris bought about 50 video art works for their newly created photo/film/video department. The development of digital technology in the 1990s not only allowed the integration of material in different formats, such as magnetic tapes and 35-mm film, but also produced high-resolution images.

Since its inception as an art medium in the 1960s, video has proved to be a difficult art form for many viewers, not least because it is a familiar medium but frequently used in unfamiliar ways. For example, 24 Hour Psycho (1993), made by the Scottish artist Douglas Gordon (b.1966), is Alfred Hitchcock's 1960 film slowed down so that the running time is a whole day, as the title indicates (see http://www.mediaartnet.org/works/24-hour-psycho). Watching it from start to finish would be unrealistic, if not impossible when shown in a gallery. As a result, it seems that, while the work appropriates a popular entertainment film, it confounds the original's filmic conventions of narrative, tempo and cinematic artistry, thereby subverting our expectations.

In a similar way, the South African video artist Candice Breitz (b.1972) selected segments from Hollywood films, such as *Kramer vs Kramer* and *Postcards from the Edge*, for her 2005 video installation *Mother and Father* (see http://www.candicebreitz.net). The 'mothers' – actresses Diane Keaton, Julia Roberts, Faye Dunaway, Shirley MacLaine, Susan Sarandon and Meryl Streep – and 'fathers' – actors Harvey Keitel, Donald Sutherland, Tony Danza, Steve Martin, Dustin Hoffman and John Voight – are each shown on 12 television monitors acting out their roles. However, Breitz edited the film clips so that the actors appear in front of plain, uniformly dark backgrounds, divorced from the context of the films' narratives and settings. The viewer listens to each speech, edited so they follow a sequence, and is constantly looking from one screen to another as an actor speaks or moves; at times a screen goes blank while others repeat the image and dialogue sequence. Like Gordon, Breitz appropriates Hollywood imagery but presents it in a way that challenges the stereotypes and visual conventions of popular film.

Please think about the way 24 *Hour Psycho* and *Mother and Father* differ from popular entertainment films or television programmes.

▶ *No doubt you recognized that, while both examples use popular films, neither presents them in a conventional way. Gordon's* Psycho *not only runs for 24 hours but the slow motion causes image changes to be almost imperceptible and sound cannot be identified, both of which restrict a narrative reading. Equally, Breitz's work uses excerpts from different films and not only disassociates them from the original stories by removing narrative contexts, but also organizes them so they create a new, if not wholly comprehensible, narrative.*

▶ *Despite using popular entertainment films as their source material, neither Gordon's nor Breitz's videos allow for the conventions of such films. Narrative and character development, action and drama, typical of most popular productions, are denied.*

> ▶ *You may also have identified that although displayed on a screen or, in Breitz's case, screens, these videos are not shown in cinemas or at home; they are created for art galleries and viewers are not provided with comfortable seats and popcorn.*

Insight

What should be clear is that works of video art, like those described above, are not comparable with popular entertainment films, television and even home videos, although they might appropriate these other forms. Consequently, we have to evaluate them using different criteria to those that operate for a television game show, a period drama, or a James Bond movie.

While there is no set of conventions characteristic of all video art, we might add to the absence of dramatic action, narrative and character roles, which we have already identified, a banality of content, a lack of sophisticated camera techniques and editing, and unconventional attitudes to time by using slow motion and sections of film played on a loop, which allows a sequence to be replayed as many times as required.

Please read the description of *Threshold to the Kingdom*, an 11-minute video projection made in 2000 by Mark Wallinger (b.1959).

Filmed in slow motion to the accompaniment of Gregorio Allegri's seventeenth-century choral piece *Miserere mei, Deus* (Have mercy on me, O God), a static camera films the automatic double doors into the international arrival lounge of London's City Airport, which are flanked by potted plants and an airport or customs employee who sits behind a high desk to one side watching arriving travellers. Sometimes singly, sometimes in small groups, all with bags, suitcases, or airport trolleys, a variety of passengers emerge. Their attitudes vary from solemn to curious, weary to relieved,

apprehensive to nonchalant; they wave at those there to meet them, embrace friends and relatives; they look around and walk slowly and seemingly weightlessly towards the camera and then pass out of shot; at one point a security guard hurries after someone but we never know who as the image fades into darkness. The camera does not zoom in or out; there are no cuts or dissolves, no tracking shots or camera movements, no sound other than Allegri's music (see http://theartblog.org/ 2009/07/weekly-update-mark-wallingers-slow-motion-ode-to-life-loss-and-transience).

▶ *From this description, a number of things we have claimed as generally characteristic of art videos can be identified:*
 ▷ *an absence of dramatic action, narrative and, other than what we can glean from the travellers' clothes, gestures, expressions and general demeanour, characterization.*
▶ *relatively banal content – people arriving at an airport.*
▶ *no exploitation of film's expressive potential – the camera remains still and wholly focused on the arrivals, although the sequences are edited.*
▶ *slow-motion filming, so the concept of real time is challenged.*

The conventional film genres closest to Wallinger's *Threshold to the Kingdom* are news footage and documentary, but the film fails to present 'information' worthy of such labels. Therefore, we might ask, what is the purpose or point of Wallinger's film?

A significant characteristic of Wallinger's film, as with Gordon's *24 Hour Psycho* and Breitz's *Mother and Father*, is a resistance to the conventions of popular entertainment and documentary. We have suggested that any meaningful evaluation of such works has to employ alternative interpretations to those we would normally apply to other films.

Please re-read the description of Wallinger's *Threshold to the Kingdom* given above and, also considering the title and any other information we have provided, think about possible meanings of this work.

▶ *The mundane content and manner of presentation seem to offer little meaning: people coming through automatic doors into an airport lounge is so ordinary as to be tedious. However, our anticipation in waiting for the next traveller to emerge and their actions and expressions might hold our attention. On this level, Wallinger's film could be about people-watching and, in that sense, is documentary.*

▶ *However, the film has a title, music and is in slow motion, all of which suggest that there is meaning over and above simply watching people arrive at an airport.*

▶ *If we know that the airport is London City, the title may refer to the United Kingdom of Great Britain and Northern Ireland, because the automatic doors represent the threshold to a sovereign state. But with the addition of Allegri's religious choral music, the airport becomes a symbol for the Kingdom of Heaven, and the slow-motion filming enhances a feeling of 'otherworldliness'. A number of commentators saw the film as an allegory for people passing through the Gates of Heaven and the airport or customs employee sitting at his desk as the equivalent of St Peter. Wallinger himself noted:*

> **It just struck me that the passage from air site to land site and the rigmarole that the State puts one through, particularly Passport Control and Customs, were a kind of secular equivalent of the confessional and absolution... I thought if we shot this very symmetrically and used slow motion, people's gestures would assume a kind of gravitas and become almost like Renaissance paintings... Obviously using Le Miserere helps; even the words seem to suit this appeal to a merciful God. These people arrive, tired and disoriented and one catches them at that first point, trying to find their bearings.**

> (www.tate.org.uk)

In both form and content, Wallinger's *Threshold to the Kingdom* resists the filmic conventions of popular entertainment and so compels us to look for alternative ways to construct meaning.

Video is a timed-based medium which creates effects that forms of static art, such as painting, sculpture and photography, are unable to provide. Watching a video can elicit expectation and anticipation of things to come seen in the context of things past. With this in mind, we will now look at an example that seems less divorced from other forms of film because it uses more recognizable cinematic conventions, but which exploits the medium's intrinsic time-based characteristics.

Emergence (2002) by Bill Viola (b.1951) is a high-definition video played on a 2 m × 2 m (6 ft 6 in. × 6 ft 6 in.) back projection screen, the whole film running in slow motion for almost 12 minutes (see http://www.getty. edu/art/exhibitions/viola/emergence.html). In a featureless setting, two women sit either side of a carved rectangular stone block, a cross between a wellhead and an ancient sarcophagus. Slowly, a pallid, naked male youth, his eyes closed, emerges vertically from the block as water pours from it. The women stand as he gradually rises, the younger woman kisses his hand and then, with great effort, they lift him from the water and out of the block, laying him on the ground and covering him with a white sheet.

Unlike Wallinger's *Threshold to the Kingdom*, Gordon's *24 Hour Psycho* and Breitz's *Mother and Father*, Viola's players are actors filmed performing a carefully directed script in a studio setting (in fact, *Emergence* was made in the Santa Monica studios where movies and TV shows are filmed).

Although *Emergence* is scripted, uses actors, make-up and costumes, and is shot in a film studio, how do you think it differs from popular entertainment films and television productions?

▶ *You may say that* Emergence *has a narrative, but it is basic and simple – two women lift a youth out of a wellhead/sarcophagus from which water flows. Moreover, this action unfolds over a period of almost 12 minutes and in slow motion. Consequently, compared to cinema or television films, Viola's video is minimal in plot. It is extremely limited in characterization, has little in the way of action to hold our attention, has no dialogue, runs for a relatively short time, and is obviously staged and not convincing as a real-life situation. Perhaps you also recognized that* Emergence *was not made to be shown in a cinema or on television but in an art gallery or a setting equivalent to a gallery (Viola has shown his films in churches, for example).*

▶ *You might have considered that the objectives and purposes of* Emergence *are different from those of popular films and television productions. Arguably, Viola's video is not concerned with entertainment in a conventional sense; after all, its nominal plot, lack of dialogue and slow motion do not match up with the pleasures and delights of popular cinematic productions.*

The differences between cinema and television films and art videos such as Gordon's, Breitz's, Wallinger's and Viola's are significant. Not only do art videos frequently refuse the conventions of popular productions, even when they appropriate such productions (as in *Mother and Father* and *24 Hour Psycho*), they offer us experiences unavailable to a cinema or television audience. For example, *Emergence* is one of a series of videos Viola calls *The Passions*, which explore human emotions through silent slow-motion film. They often make reference to Eastern religion and philosophy, notably Sufi mysticism (which Viola studies); to water as a symbol of birth (amniotic fluid), rebirth (baptism), and death (drowning); and to past art (*Emergence* recalls the entombment, resurrection and pietà images of Christian art, notably Masolino's 1424 painting *Pietà* on which *Emergence* is based).

While it is not beyond the realms of possibility that popular film and television might engage with such themes and make similar symbolic references, their conventions and audience expectations do not allow the focus given them by Viola. All this brings us back to the fact that video art is different from its popular culture relatives, cinema and television, and so has to be viewed for what it is, making comparison between them essentially pointless.

All the examples given so far illustrate video's application as a discrete mode where the film plays and the viewer's attention is directed at the screen. But video art's potential is not limited to such a singular, medium-specific practice. As we have seen, *Balkan Baroque* (Figure 3.2 and pp. 57–59) by Marina Abramović (b.1946) uses video as part of a performance, while *Caribbean Pirates* (Figure 4.1) by Paul McCarthy (b.1945), uses it in conjunction with an installation. McCarthy's work was prompted by the Disneyland attraction *Pirates of the Caribbean*, which subsequently inspired a trilogy of Hollywood films of the same name.

In *Caribbean Pirates* videos play on the walls around a stage set installation of boats, carbon-fibre sculptures and mechanical figures. One of the videos, called *Pirate Party*, was filmed in McCarthy's studio over a period of more than a month using eight cameras and 30 actors, including McCarthy himself. With some of the actors wearing oversize carnival heads and others wielding huge knives, they simulate an attack on a village, a rape, mutilation, the public sale of women, and an assortment of other forms of sexual depravity, violence and brutality. The video was wholly improvised, each actor developing his character during the filming which, in effect, made it a performance, albeit one that was practised, re-shot and ultimately edited. However, unlike the work of Gordon, Breitz, Wallinger and Viola, the intention is to view *Pirate Party* as part of the installation. As a result, the viewer perceives and interprets the film in relation to the environment that was the setting for the video, and which even contained many of the props used in the filming. This

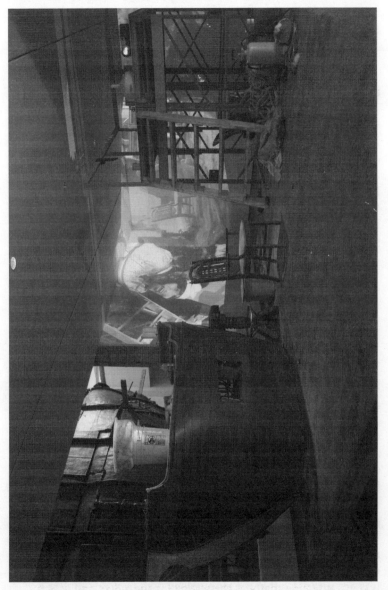

Figure 4.1 Paul McCarthy, Caribbean Pirates (Captain Morgan), 2001–05. Dimensions variable. Multimedia installation. Installation view.

contextualizes the video in an unusual way by displaying the stage set and props while the film in which they were used is playing (see http://www.redcat.org/season/0809/fv/pirates.php).

A different way of contextualizing is used by the American artist Tony Oursler (b.1957), who projects films of faces onto sculpted, curved screens positioned as heads on puppet-like bodies (see http://tonyoursler.com/tonyourslerv2/main.html). These 'talking heads' scream, watch, argue and plead; a tiny figure, its head pinned under an upturned chair absorbs the viewer in its predicament, elicits concern and sympathy, and then venomously asks, 'What the fuck are you looking at?' Because the video projection resembles a living being and 'talks' to the viewer, viewer–art work empathy is created that engages us in quite a different way than a flat-screen projection. In 2008 Oursler further extended his use of the medium away from the flat projection screen to giant video projections on landscapes. The effect of a skull, an eyeball, a tangle of snakes, and women that crawl, sit and float, projected onto hills, mudflats, trees and the sky, not only creates distinctly different imagery to that of a flat screen in a darkened room, but also a distinctive and unusual viewer experience.

DIGITAL MEDIA

The term video, from the Latin *videre*, meaning to see, is used to denote time-based electronic imaging that has all but replaced celluloid film and, more recently, magnetic tape. Digital media have become the norm and their proliferation has been a defining characteristic of recent times. Not only have technological developments created a wider range of visual communication, but also the hardware and software have become more refined and affordable. In art, the term video is still applied to works that project images onto a screen, but other terms are increasingly being used, such as digital art, multimedia art, new media art, and so on. In a period of transition and change, where visual communication media are continually being invented and refined, it is not surprising that the terminology used by artists to define their practice is equally fluid.

Because video, digital, multimedia or new media art presents us with a gallery experience quite different to that with which most of us are familiar, for many of us it is not necessarily easy to assimilate it as art. Suffice to say that different times create different art or, as the German playwright Bertolt Brecht wrote in 1938, 'Reality changes; in order to represent it, modes of representation must also change' (Quoted in Harrison and Wood (2003), p. 501). Given that our 'reality' has changed (see Chapter 3), we should not be surprised that artists respond to this.

Please read the following description of *The Visitor: Living by Numbers*, a 2001 work by the Canadian artist Luc Courchesne (b.1952).

> Suspended from a frame in the gallery is a polished metal hemisphere, like a large teacup. Through a hole in the base of this hemisphere, the viewer positions her/his head so that the 360-degrees curved wall encircles it and a moving video image of a landscape is projected from above. The viewer (who perhaps we should call the visitor) can turn the full 360 degrees and view the panorama of landscape as if she/he is moving through it. However, by calling out numbers between one and twelve, the visitor can change the route she/he is 'travelling' and navigate the landscape, along paths, down a ramp, through corridors, into an office with a woman at a desk, and to a table with other people with whom the visitor can communicate, again by using numbers (see http://www.fondation-langlois.org/html/e/page.php?NumPage=129).

How do you think Courchesne's work differs from the other film and video examples we have given?

▶ *You may have identified that* The Visitor: Living by Numbers *is an interactive work; that is, the viewer is no longer a passive receiver but can determine through voice recognition the appearance of the work, or at least what parts of the film are shown. More than this, once other people appear, voice recognition is used again to simulate a form of socialization.*

(Contd)


▶ *The other difference is that the viewer is completely surrounded by the projected film and, unaware of the gallery environment and what is going on in it, is, in effect, existing in a world of virtual reality.*


Interactive works of art like Courchesne's are, in one sense, the result of a marriage between technological development and an artist's vision, a process that began with Nam June Paik's *Participation TV* in the 1960s. As viewers of such works, we might be reminded of interactive video games played at home using consoles such as PlayStation and Wii and so question what makes Courchesne's *The Visitor: Living by Numbers* different from them. The similarities between works of interactive video art and video games are explored in *Spectropia* (1999–2002), a film by the New York-based artist Toni Dove (b.1946). She calls the work 'part video game, part feature film and part VJ mashing' (www.tonidove.com), interestingly omitting to label it 'art'. Using sensor pads on the floor and voice recognition to trigger digital video segments, viewers, or we might call them players, navigate their way through a time-travel story projected onto screens. *Spectropia* is an example of video art that, like Gordon's *24 Hour Psycho* and McCarthy's *Pirate Party*, confuses the once defined boundaries between art and popular culture. That *Spectropia* is planned for release as a series of DVDs further obscures those boundaries (see http://www.fondation-langlois.org/html/e/ page.php?NumPage=225).

Film, video and digital art are time-based media and as such share common ground with performance art (Section 4 of this chapter). One way in which they all differ from more conventional forms such as painting, is that they engage viewers in a multi-sensory experience, rather than calling on them to simply look in a relatively passive way. This is also the case for installation art, the subject of Section 5 of this chapter, and it is not a coincidence that performance, video and installation often appear together in a single work, such as McCarthy's *Caribbean Pirates* (Figure 4.1) and Abramović's *Balkan Baroque* (Figure 3.2).

Suggestions for further reading

Catherine Elwes, *Video Art: A Guided Tour*, I.B. Taurus, 2005

Doug Hall and Sally Jo Fifer (eds), *Illuminating Video: An Essential Guide to Video Art*, Aperture, 2005

Tanya Leighton (ed.), *Art and the Moving Image: A Critical Reader*, Tate Publishing in association with Afterall, 2008

Christiane Paul, *Digital Art*, Thames and Hudson, 2003

Gill Perry and Paul Wood (eds), *Themes in Contemporary Art*, Yale University Press, 2004

A.L. Rees, *A History of Experimental Film and Video*, British Film Institute, 1999

Michael Rush, *New Media in Art*, Thames and Hudson, 2005

Edward A. Shanken, *Art and Electronic Media*, Phaidon, 2009

Kristine Stiles, 'I/Oculus: Performance, Installation and Video', in Gill Perry and Bruce Wands, *Art of the Digital Age*, Thames and Hudson, 2007

THINGS TO REMEMBER

▶ *As with photographs, screen-based media were regarded as autonomous from art until relatively recently, but they are now an important aspect of contemporary art.*
▶ *The use of film, video and digital media in art is a sign of its reaction to the context of new technology and*
(Contd)

> *communication. In this way, contemporary art does what art has always done – respond to prevailing circumstances.*
> ▶ *Films and videos made as art frequently avoid or resist filmic conventions, forcing the viewer to find different ways to interpret meaning.*
> ▶ *When viewing and evaluating film and video made as works of art, alternative criteria have to be applied to those used for viewing entertainment and popular culture, or those made to inform and document, such as for news and education.*
> ▶ *Developments in digital media have allowed artists to create works that depend upon viewer participation for their effect, thereby giving tangible meaning to Hal Foster's claim that 'the viewer [becomes] an active reader of messages rather than a passive contemplator of the aesthetic'.*

Section 4 Performance

Conventionally, works of art are static objects made by artists to be viewed independently of their maker and frequently in the exclusive setting of an art gallery. Forms such as painting, drawing, photography and sculpture, in most of their manifestations, conform to this definition. But performance art breaks with these long-standing practices, most significantly because it exists in time and space, with the human body and its actions becoming the work of art.

Please read the following account of a 2006 performance called *inthewrongplaceness* by the British-based artist Kira O'Reilly (b.1967).

Viewers were led one at a time from a gallery shop, where they had gathered to see the performance, to a disused building. There they were equipped with latex gloves and told that they

could touch both animal and human flesh. One at a time over a period of four hours, each viewer entered a dimly lit room where the naked artist Kira O'Reilly lay on the carpet, her arms and legs wrapped around the carcass of a pig. She rolled across the floor, lifted the dead animal, embraced and caressed it, all done with care and reverence. Totally absorbed in her actions, the artist seemed unaware of each viewer entering the room, standing a few feet away and watching the performance (see http://www.tract-liveart.co.uk/Kira%20O'Reilly/Kira%20 O'Reilly.html).

Leaving aside for a moment the question of this work's meaning, please think about how its form differs from more conventional art practice, such as painting and sculpture.

> ▶ *As we noted above, performance art is concerned with two things alien to more conventional artistic forms:*
> > ▷ *its use of time and space*
> > ▷ *the human body and its actions as the work of art.*
> ▶ *However, this example also highlights some other features that distinguish performance from painting and sculpture:*
> > ▷ *The work of art was displayed, or rather acted out, in a 'non-art' setting – a disused building as opposed to an art gallery.*
> ▶ *The viewing of the performance was controlled with only one person at a time observing the action (in fact, each viewer was allocated just ten minutes in the room); generally, there are no such restrictions on viewers of paintings and sculptures.*
> ▶ *As well as being in a relatively small space and close to the performance, viewers wore latex gloves and were told they could touch. This intimacy implied their physical 'involvement' in the work, which is outside the experience of looking at a painting or sculpture.*
> ▶ *Furthermore, the physicality of performance engaged a range of the viewer's senses in a way that looking at painting and sculpture cannot. An account of Kira O'Reilly's inthewrongplaceness noted, 'There was a faint smell of blood, and no sound except that of traffic, and of Friday night-pub goers who would not have been aware of her presence in the room only a few yards away from them...' (http://www.tract-liveart.co.uk).*

The differences between performance and conventional art forms are striking; it is important to think about why an artist uses a particular genre or form.

Why create a performance rather than a painting or a sculpture?

▶ *The artist's intentions are paramount and, one supposes, an artist creates a performance rather than any other form of art because it best realizes those intentions.* inthewrongplaceness *developed from O'Reilly's experiences of taking biopsies of a pig at SymbioticA, an art–science collaborative research laboratory at the University of Western Australia. She wrote:*

> **Taking a cutting of 'something' that felt like someone dying and keeping a little bit of it living and proliferating – like a plant… The work left me with an undercurrent of pigginess, unexpected fantasies of mergence and interspecies metamorphoses began to flicker into my consciousness. Strange dreams of porcine/ human flesh manifestations that I realized I wanted to realize…**
>
> (http://www.tract-liveart.co.uk).

▶ *It is clear from this brief and incomplete rationale that the ideas underpinning* inthewrongplaceness *are personal, complex and challenging, and we must assume that O'Reilly believed the performance was the best and, perhaps, only way to convey them.*

▶ *In addition, performance can engage a range of senses in a way that is beyond the capacity of painting and sculpture. In the case of* inthewrongplaceness, *the viewer experiences the piece through sight, touch, smell and sound.*

▶ *The immediacy and transience of performances elicit a different set of expectations and experiences than do more enduring art forms, such as painting and sculpture, where the viewer is encouraged to look rather than be physically engaged.* inthewrongplaceness, *for example, puts the viewer alone in an unfamiliar room with a naked woman and a dead pig for ten minutes, and not in the more relaxed environment of an art gallery with unlimited time to contemplate.*

The example of Kira O'Reilly's work highlights a number of other aspects that characterize performance art, not least that it blurs the boundaries between traditional forms of visual art and theatre. Since we can neither view the work as we would a painting or a sculpture, nor see it as theatre in any accustomed sense because it usually has no conventional plot, characters, costumes and scenery, let alone that it is not performed on a stage, it is clear that performance art challenges many preconceived ideas.

On the one hand, because it conflates different artistic forms, it is the antithesis of Modernism, where the value and meaning of art is determined by how effectively it exploits its specific medium (see Chapter 2). However, on the other hand, its hybrid character can liberalize viewer response and interpretation from the expectations encoded in more conventional artistic practices. Both these characteristics are implicit in earlier avant-garde art and the evolution of performance in the past 40 or so years derives from this ancestry.

Not only can the multi-form character of performance art be traced back to activities of artists associated with early-twentieth-century avant-garde movements such as Futurism, Dada and Surrealism, but also its intentions and purposes can be associated with them. The nature of these early avant-garde movements was to challenge prevailing artistic conventions that privileged form over content or, put another way, aesthetic effect over the subject and its possible meanings, and this seems also to be the spirit of performance art.

We saw in Chapter 2 (pp. 22–23) that the theorist Peter Bürger re-established the term avant-garde as defining art that attempted to critically engage with the concerns of everyday life, meaning such things as social, economic, political, moral, philosophical and cultural circumstances, as opposed to that perceived as separating itself from life to establish a wholly aesthetic experience for the viewer.

Considering this interpretation of the avant-garde, think about the ways performance art might be regarded as avant-garde.

> ▶ *If you look back at Chapter 2, you will see that we characterized Bürger's ideas about the avant-garde as art that used 'unconventional materials to confront accepted artistic conventions' and noted how it 'attempted to intervene in aspects of…everyday life with the purpose of bringing about change'. Undoubtedly, performance uses 'unconventional materials' – the human body itself is not a usual medium for a work of art – and in doing this it confronts the 'accepted artistic conventions' of painting, drawing, sculpture and so on. A work of art where the human body is the medium, and which consists of actions, gestures, speech and other sounds, touch and smell, and is set outside the gallery, such as the disused building employed in O'Reilly's* inthewrongplaceness, *certainly seems to relate in a very general way more to the experiences of everyday life than to those conventionally associated with an art gallery, but how far it 'intervenes in aspects of the social, political, economic, moral, philosophical and cultural order of everyday life' to 'bring about change' is open to question.*

Bürger himself noted that the avant-garde and its progeny, the neo-avant-garde, failed to achieve intervention and bring about socio-political change because the strategy of being unconventional was ineffectual as a form of criticism. But even so, avant-garde and neo-avant-garde practices did provide a platform for critical engagement with socio-political ideas, and accordingly performance art has deservedly acquired a reputation for being subversive, shocking and politicized. In order to examine why and how performance art is used to communicate ideas about a variety of issues and themes, and how we might approach, interpret and understand this form of art, we need to look at examples from its past as well as its present.

In Chapter 2 we noted some mid-twentieth-century examples of neo-avant-garde performance that were labelled as 'happenings', such as Kazuo Shiraga's *Challenging Mud*, Oldenburg's *Snapshots from the City*, and Vito Acconci's *Seedbed*. We may perhaps understand how wrestling with mud, or being wrapped in bandages and smeared with dirt, or lying under a gallery floor and masturbating are activities that 'confront accepted artistic conventions', but we might reasonably ask how they can be connected with socio-political issues in order to

bring about change? There is no definitive answer to this question since such performances seemed aimed at what might be called the limitations of medium-specific art rather than having explicit socio-political motives.

Shiraga's *Challenging Mud* is usually characterized as broadening the act of painting into something more physical, given that he was, in effect, creating a two-dimensional painting with mud. Equally, Oldenburg claimed that his *Snapshots from the City* was an attempt to extend traditional painting from its restricted two-dimensional space, while Acconci's *Seedbed* challenged the idea of a viewer, a central component of all previous art and especially of Modernist art, because the person in the gallery was not viewing anything but instead listening to the artist's responses at the sound of their presence.

However, although we might see these examples only as challenges to artistic conventions in general and Modernist hegemony in particular, those conventions and that hegemony are generated, supported and controlled by wider social, political and economic institutions. In other words, art is regulated by controlling authorities, such as galleries, dealers, patrons, buyers, critics, curators and so on, themselves shaped by conventional social customs and practices that reflect the taste, standards and opinions of a controlling establishment.

Insight

If we accept that art reflects the taste, standards and opinions of a controlling establishment, we will understand that art tends to become regularized and conformist. Therefore, by confronting conventional art forms, the avant-garde also contests the values of the conformist establishment that holds sway over them. In this way, we might see performance art as critical of the socio-political order.

While the examples of Shiraga, Oldenburg and Acconci can be seen to illustrate performance art's implicit critique of conventional and conformist norms, the work of some other artists illustrates a more explicit attack. For example, from the 1970s onwards, the role and

status of women in Western society was questioned, challenged, and re-assessed by the women's movement, with artists responding in a variety of ways and performance becoming a principal form used by feminist artists.

Please read the following descriptions of three performances that addressed feminist issues.

1 *The American artist Carolee Schneemann (b.1939) first performed* Interior Scroll *at the exhibition* Women Here and Now *held in East Hampton, New York State in 1975. To an audience of mainly women artists, Schneemann, naked, smeared with brushstrokes of paint, and adopting conventional life model poses, read from her book* Cézanne, She Was A Great Painter. *Then, putting the book down, she slowly removed a narrow scroll of paper from her vagina and read it aloud (see http://www.caroleeschneemann.com/interiorscroll.html). Taken from the script of a film she had begun three years earlier and related to her research into the symbolism of snakes and their connection to earth goddesses in ancient cultures, the text examined feminist ideas. She had discovered that the traditionally phallic symbolism of the serpent was associated with female genitalia and through a series of connections she concluded:*

> **I saw the vagina as a translucent chamber of which the serpent was an outward model: enlivened by its passage from the visible to the invisible, a spiralled coil ringed with the shape of desire and generative mysteries, attributes of both female and male sexual powers. This source of 'interior knowledge' would be symbolized as the primary index unifying spirit and flesh in Goddess worship.**
>
> (Schneemann (2002), p. 153)

2 *In the same year as* Interior Scroll, *the American artist Hannah Wilke (1940–93) performed* Hello Boys *to a small audience at the Gallery Gerald Piltzer in Paris. Standing nude behind a large glass aquarium filled with water, fish, stones*

and plants, she made fish-like movements and gesticulated erotically to the sound of rock music. Like the fish in the glass tank, Wilke was on display and, moreover, her nudity and fish-like movements suggested a mermaid, a creature that has sexual allure and yet is incapable of sexual union. Hello Boys, as the title suggests, is about the way women were perceived and subsequently represented in art, the media, fashion and so on, as attractive and alluring objects for, as it is known, the male gaze (see http://www.eai.org/eai/title.htm?id=1149).

3 In 1990 the French artist Orlan (b.1947) undertook the first of nine 'surgery performances'. In operating theatres decorated with colourful draperies, conscious but under local anaesthetic, and sometimes wearing costumes by haute couture designers such as Paco Rabanne and Issey Miyake, she underwent cosmetic surgery to the sound of poetry and music. The seventh of these performances, called Omnipresence, took place in New York City and was broadcast by satellite to 15 sites worldwide. Dr Marjorie Cramer, a feminist plastic surgeon, remoulded the artist's face by inserting implants (see http://www.film-orlan-carnal-art.com/Synopsis+.eng.html). Apparently, Orlan's aim was to acquire a face that epitomized female beauty as represented by men: the Mona Lisa's forehead, the chin of Botticelli's Venus and so on. She remarked: 'My work is not a stand against cosmetic surgery, but against the standards of beauty, against the dictates of a dominant ideology that impresses itself more and more on feminine...flesh' (quoted in O'Bryan (2005), p. 19).

Now consider how these artists use performance to address feminist issues?

▶ Each of these performances uses the female body as a medium to address feminist issues. Schneemann and Wilke performed naked, while Orlan had her body physically transformed by plastic surgery.
▶ Each performance must have been challenging to watch, not least because it fails to conform to conventional expectations of art.

(Contd)

But however choreographed and scripted the performances were, the tangible presence of the artist as the work of art, with all the movements, gestures, expressions and sounds, provides a multi-sensory experience which must have made an impact on viewers and, arguably, directly and immediately communicated the feminist 'message'.

▶ *That 'message' is not at all straightforward, as you will no doubt have understood when reading the descriptions of these performances. Each work of art presents the viewer with a complex tangle of symbols, signifying serious feminist comment but with elements of voyeurism and theatre, and, in* Interior Scroll *and* Hello Boys, *eroticism. The nudity of Schneemann and Wilke is important because it may be taken as a sign of their gendered and sexual liberation, something that was central to the women's movement in the 1970s. Equally, removing a scroll of paper from a vagina (Schneemann) and erotic gesticulations (Wilke) are gestures that signal meaning in wholly different ways to that which might be achieved in painting, sculpture, photography or any other medium.*

▶ *Orlan's 'surgery performances' present us with a somewhat different but related experience. For* Interior Scroll *and* Hello Boys *an audience was present in a gallery but for* Omnipresence, *the performance was broadcast. As a result, the audience was physically separate from the performance and the experience was more like watching a television programme. Nevertheless, the content must have been uncomfortable for the viewers, a point that Orlan probably wanted to make since she, the person undergoing a visually disturbing medical procedure, was anaesthetized and not in the least uncomfortable.*

▶ *Since performance involves real people (the artist and, often, the audience) moving and speaking in real space, it is more akin to our experience of everyday life than looking at a painting or sculpture, although what is being done and said in a performance may be quite unlike our daily experiences. This feature of performance art connects with the idea we discussed previously that avant-garde art, and especially performance art, critically engages with the concerns of everyday life and, in the case of our three examples, issues about the social and cultural perception of women.*

From the 1960s onwards, performance artists created a variety of complex allegories of social, economic, cultural, moral and political themes, of which feminism was one. In their *Singing Sculpture*, first performed in 1969, the artists Gilbert and George (b.1943 and 1942 respectively), made reference to popular culture and class (they sang *Underneath the Arches*, an old music hall song that describes the pleasure of tramps sleeping rough). Joseph Beuys (1921–86) regarded his performances, such as *I Like America and America Likes Me*, as catalysts for social transformation. The activities of the Situationist International and the Fluxus group (see p. 00) made political comment, as did Marina Abramović in her performance *Balkan Baroque* (see Figure 3.2, pp. 57–59).

In *My Boston*, performed in the grounds of the Museum of Fine Arts, Boston, in 2005, the Chinese artist Zhang Huan (b.1965) suggested a critique of American military aggression at odds with a democracy supposedly committed to learning and knowledge. He stood semi-naked with his head through a book worn as a yoke, lay under a mountainous pile of books as though being crushed by them, and climbed a flag pole flying the American flag trailing a line of books behind him (see http://www.zhanghuan.com/ShowWorkContent.asp?id=7& iParentID=7&mid=1).

In her *Catalysis Series* performances of 1970–71, the African-American artist Adrian Piper (b.1948) walked along New York streets, got on buses, shopped and so on with the words 'wet paint' daubed across her sweatshirt or a cloth stuffed in her mouth. Confronting passers-by with what appeared to be an abnormality and which they saw as something to be avoided, the performances were allegories for racial difference and how it was treated in public (see http://www.brooklynmuseum.org/eascfa/feminist_art_base/gallery/adrian_piper.php?i=1305).

Between 2000 and 2004 the Scottish artist Roddy Hunter (b.1970), visited central city squares in Belfast, Los Angeles, Minsk, Tel Aviv, Budapest and other cities, always between the hours of sunset and sunrise, and engaged passers-by in

discussions about topics related to these municipal locations: alienation, identity, utopia, architecture, change and so on. Called *Civil Twilight*, this ongoing series of performances was in effect a form of social research about the urban environment, albeit one that was carried out through artistic practice (see http://www.cca.org.il/blur4/roddy.htm).

These examples illustrate performance art's commitment to a critique of established norms via the themes and ideas with which it engages, but, as we have seen, performance itself is an unconventional artistic form that carries an implicit challenge to those norms. One of these is the idea of art as a commodity that can be bought and sold.

Please think about how performance might question its 'commodity' status, and therefore how it can be regarded as anti-commercial.

> ▶ *Performance art is a transient form; once the performance has taken place it no longer exists and so, in theory, cannot be bought, sold, owned or seen again. You might have thought that, once performed, it is gone and no longer exists.*
>
> ▶ *Even if a performance is repeated, some may involve the audience as part of the work; Piper's* Catalysis *and Hunter's* Civil Twilight *are examples of this. Since a different audience would be involved in a repeat performance, the work itself would not be the same. People might respond differently to Piper's abnormal behaviour and Hunter's interviewees would, in all likelihood, engage in a different discussion.*

However, despite performance art's apparently unique and transient character, individual works are sometimes repeated. Kira O'Reilly is listed on the British Council's website as an artist who 'makes and re-makes work' (www.britishcouncil.org), while Schneemann's *Interior Scroll* and Gilbert and George's *Singing Sculpture* have been performed on more than one occasion.

In some cases performances are documented by the written or spoken word, and in many cases they are recorded by photography, film, video, and DVD.

Performance art is a live and transient form but now consider the advantages and disadvantages of experiencing it as a recording rather than seeing it live?

▶ You may think that watching a live performance, or being part of one (as you could be in those of Adrian Piper and Roddy Hunter), is to experience something real, while you might think that watching a performance on a screen is a second-hand experience.

▶ However, you may also have considered that performances are not always presented in a museum, gallery or necessarily easily accessible locations. O'Reilly's inthewrongplaceness, Orlan's Omnipresence, Piper's Catalysis Series, and Hunter's Civil Twilight illustrate this and such works are labelled site specific. Seeing them is, therefore, not always straightforward. For example, Hunter's took place in different cities throughout the world and O'Reilly's was limited to a four-hour period with one person watching for ten minutes, making a total of 24 possible viewers. While film, video, DVD and photographs may not necessarily communicate the immediacy of the performance, nor engage the viewer's capability to touch, taste and smell, they do allow access to something that otherwise would only reach a small audience.

▶ Some performances last a few minutes, others a few days, and in some cases they are a series of separate actions taking place over a long period; Hunter's Civil Twilight was performed over four years. It would be difficult to experience every one of these performances but possible if they were recorded on film, video or DVD.

▶ Some performances are created specifically to be screened rather than watched live. For example, the public was not present at Orlan's Omnipresence but it was broadcast live on television.

Whether live or viewed on screen, performance makes challenging demands on the viewer. Its anti-conventional form is evident in works such as Orlan's televised surgical procedures and Abramović's five-day vigil sitting on a pile of bones; its radical character is expressed in Zhang Huan's *My Boston* and the conscious anonymity and collective actions of a group of international performance artists based in Estonia called Non Grata. Its content is frequently symbolic and allegorical, as in Schneemann's *Interior Scroll*, O'Reilly's *inthewrongplaceness*, and

Non Grata's performances *Peripherian Narratives*, *Ghettomarathons* and *The Screaming Pighead of Edvard Munch*.

> **Insight**
>
> However much performances such as those noted above might appear to some as gratuitous, trite or offensive, we should understand that they all are intended to have meaning and to represent something that the artist believes to be significant and consequential.

How far performances can communicate their intended meanings to an audience depends on an array of circumstances, including the artist's conception and skill in expressing those meanings, the receptiveness of the audience, and how far the wider socio-political contexts are appropriate and sympathetic to the particular performance. In Paul McCarthy's *Caribbean Pirates* (Figure 4.1) there may be aspects that are repellent, brutal and even obscene, but the work is a serious critique of glamour, commercial entertainment and simulated experience and, on a symbolic level, it has been interpreted as a comment on the abuse of prisoners in Iraq. Since it is a performance, albeit on video and screened as part of an installation, the impact of (staged) scenes of mutilation, rape and torture is immediate. The viewer's experience vacillates between fascination, shock and repulsion as the work unfolds, an effect different from that when viewing a static work of art.

> **Insight**
>
> As with all forms, but perhaps more so with performance, the means of presentation are important in conveying content. The immediacy and tangibility of performance art, its duration over a period of time, its relationship to our everyday experience, as opposed to being a 'special' object that we contemplate, and consequently its capacity to convey ideas, issues and themes in a way that other kinds of art may not be able to do, make it an important contemporary art form.

Suggestions for further reading

RoseLee Goldberg, *Performance Art: From Futurism to the Present*, Thames and Hudson, revised edn, 2001

RoseLee Goldberg, *Performance: Live Art since 1960*, Thames and Hudson, 1998

Jens Hoffmann and Joan Jonas, *Performance (Art Works)*, Thames and Hudson, 2005

Kristine Stiles, 'Performance', in Robert S. Nelson and Richard Schiff (eds), *Critical Terms for Art History*, University of Chicago Press, 2003

Kristine Stiles, 'I/Oculus: Performance, Installation and Video', in Gill Perry and Paul Wood (eds), *Themes in Contemporary Art*, Yale University Press, 2004

Tracey Warr (ed.), *The Artist's Body*, Phaidon, 2006

THINGS TO REMEMBER

▸ *Unlike other forms of visual art, performance art employs and exploits the human body in time and space, and so can elicit a multi-sensory response in the viewer.*

▸ *Performance art is regarded as critical of established art practice and, by extension, critical of those institutions that support and reinforce that practice.*

▸ *The transient nature of performance art denies its capacity to be bought, sold or owned, unless the work is recorded on video or digitally, in which case the viewer loses the multi-sensory experience of live action.*

Section 5 Installation

My work is conceived as a mental space...it wants to create the conditions for the activity of thinking. I want my work to walk into the mind of the spectator...to create...a dialogue or a confrontation in the mind of the other person.

(Thomas Hirschhorn quoted in Luckett (2009), no pagination)

The above statement is by the Swiss-born artist Thomas Hirschhorn (b.1957). It accompanied his installation work *Cavemanman*, one of ten 'sculptural environments', each submitted by an international artist for London's Hayward Gallery exhibition *Walking in My Mind* in 2009, which addressed themes of artistic imagination, making and perception.

Cavemanman transformed one of the Hayward's galleries into a complex of four main caves and tunnels meticulously constructed from cardboard and parcel tape. Hirschhorn's stated aim was for each of the four chambers to correspond to the major lobes of the human brain's cerebral cortex. The walls and floors were littered with objects, from simulated rocks and boulders, to disposable drink cans, pin-up posters, and photocopies of philosophical works, extracts from which were either pinned to the walls, or stacked in piles within the complex. Describing the chambers' interior tableaux, Helen Luckett wrote: 'Here and there are bundles of fake dynamite; some attached to books and some to bodies, giving the impression that the whole cave system is – or was – the lair of some reclusive and paranoid philosopher who has left it booby-trapped' (Luckett (2009), no pagination). Images of paintings from the Lascaux caves were played on a continuous video loop, providing viewers with a link back from the contemporary imagination to the Paleolithic era (see http://blogs. walkerart.org/visualarts/2006/10/12/installing-cavemanman).

All the ten exhibits in *Walking in My Mind* were 'immersive installations', that is, they simulated total environments or

constructed landscapes through and within which exhibition visitors could wander at leisure. Each example used and adapted a range of materials, objects and media, other than, or in addition to, those typically associated with more traditional genres of art.

Walking in My Mind underscored just how pervasive and widespread installation art has become within contemporary visual culture. It also demonstrated the ongoing fashion for large, composite installation environments, rather than the more discrete, 'private symbolic spaces' typically occupied by paintings, prints and sculptures. As one cultural commentator has noted, installation art's increasing prominence reflects its travel from the margins to the centre (see Julie H. Reiss, *From Margin to the Center: The Spaces of Installation Art*, 1999). When, why and how this has came about are among the subjects discussed in this section.

Please look at Plate 13. This is a photograph of *20:50*, a work made by the British artist Richard Wilson (b.1953), which has become an iconic example of installation art.

Look carefully at the image: how would you describe what you see?

▶ *In a room an angular form seems to intersect the space, but there is an ambiguity about what this is and whether it is solid, hollow, vertical or horizontal.*

▶ *In fact, it is a trough, a tapering metal-sided corridor which, if you look closely, is set into what appears to be a highly reflective floor. But this is no ordinary floor; it is oil filling the room; a flat, black, reflective surface. Half the walls and windows of the room are a reflection in the oil. To view the installation, the visitor walks along the metal sided trough, which is about 1 m (about 40 in.) deep.*

Completed in 1987, and subsequently exhibited in several different exhibition spaces, the title of the piece stems from the standard viscosity of oil, which is the work's primary component.

Installations are not a particularly new form of art making, but
in various ways they reference an avant-garde tradition which
stretches back almost 100 years with works by earlier twentieth-
century artists such as Kurt Schwitters, Claes Oldenburg's mid-
century *The Store* (see pp. 29–30) and Hamilton, Voelcker and
McHale's *This is Tomorrow* exhibit (see Plate 2).

So what does the word 'installation' actually mean? When used
in a general sense, it refers to the hang or placement of art within
a gallery or exhibition space. For example, we might describe the
installation of a particular exhibition as good, bad or indifferent
on the basis of whether its physical arrangement, format and
presentation within a given space actually accentuates or detracts
from the perceived qualities or attributes of the exhibits. But used
more specifically, installation refers to a particular category of art
practice which addresses the viewer in what the teacher and writer
Claire Bishop has described as a 'literal presence in the space'
(Bishop (2005), p. 6). Installations typically engage the responses
of the spectator and also the actual conditions and contexts of
display and exhibition.

Please look again at Wilson's *20:50* (Plate 13). As we have
noted, when encountering this work, you are invited to walk
along a tapering metal trough. Reaching its end, the tendency
is to automatically look down into the expanse of dense,
viscous oil which gives a tangible experience of vertigo and
disorientation. Usually, when looking at a painting, we are
pre-positioned by the scale and size of a two-dimensional
canvas attached to a wall. Of course, we can shift the angle,

distance and sight line of that encounter, although the tendency for glass framing, small barriers to stop us getting too close, and angled lighting can make this difficult. Nevertheless we are habitually encouraged to view paintings or sculptures in particular or predetermined ways. By contrast, installations, as three-dimensional arrangements of objects or environments in real space, invite a more dynamic interaction from the viewer, rather than a static encounter in which meaning is dictated or fixed in advance.

Returning to Wilson's 20:50, you might have noticed the dramatic visual contrast between the seemingly unknown depth of the pitch-black sump oil and the exhibition space, which its surface both absorbs and reflects. Unlike a painting with a particular narrative or subject, there may be no intended or implied meaning, although experiencing it one is immediately struck by its formal properties, scale and configuration. That said, we might choose to interpret the installation in various ways, one of which might be to read it as an exploration of the broader ambiguities and uses associated with its principal medium – oil.

Please think about possible associations, perhaps actual and symbolic, in Wilson's use of oil as a medium for his work.

> ▶ *There are many potential connotations that oil might have, from its links to the Middle East and a source of wealth for some to its use as a lubricant for machines, as the title suggests.*
> ▶ *Oil is a toxic by-product of deep geological time that powers the increasingly urbanized and seemingly 'denatured' economies of the developed and developing world. As a resource it literally fed the engine and motor technologies associated with transport, industrialization and manufacturing.*
> ▶ *It is an increasingly scarce commodity which has also provoked conflict and war.*
> ▶ *It is also technologically versatile. Combined and refined with other bio-chemicals, it indirectly makes possible a range of synthetic materials, plastics and painted interiors which we associate with fashionable exhibition spaces such as London's Matt's Gallery, the venue at which 20:50 was initially displayed.*

These are just some of the things we might associate with Wilson's work that may lead us to understanding the meanings it can have for us. However, part of this work's success and its iconic status as an installation has arisen from the mystery of the oil's actual depth and the mechanics of its placing and containment within the chosen gallery space. Both remain closely guarded secrets. Frequently asked about its depth, Wilson has cryptically replied that it is as 'deep as the viewer wants it to be!' (Interview, *The Eye: Richard Wilson*, Illuminations, 2001).

Although only one example of the installation genre, we can note various characteristics which 20:50 demonstrates:

- ▶ *It combines and contrasts varied or composite media.*
- ▶ *The installation's scale and physical configuration requires an active encounter from the viewer – it cannot be fully explored without movement or from just a fixed standpoint.*
- ▶ *It provokes a perceptual and physiological response, in this case one of tangible disorientation and even vertigo.*
- ▶ *The installation can sustain various interpretations – in this case it might be explored indirectly as a metaphor or symbol for a range of issues or concerns.*
- ▶ *The immediate context and space within which the installation is experienced directly contributes to its effect and interpretation, rather than being a passive backdrop to the spectator's encounter.*
- ▶ *The choice of materials and forms may use or evoke aspects of contemporary or mass culture rather than being limited to particular styles or idioms more typically associated with 'high' art.*

Although these responses relate principally to 20:50, some of these points of emphasis can provide a useful framework for thinking about our engagement with examples of installation practice more generally. Also, while some of these attributes situate encounters with other art disciplines like painting or sculpture, the experience of installation is arguably distinctive because it can operate across all of these registers simultaneously.

If you think back to Hal Foster's quote on p. 40, you might consider that installation art encourages the viewer to become 'an active reader of messages'. No longer physically separate from the work or wholly reliant on a mimetic system, as in painting, the viewer is subject to a temporal and spatial experience. While contemplation may be demanded or given, installations more frequently require physical and mental engagement, not least because viewers occupy the same space as the work and are obliged to consider the subsequent relationships between the forms, the space and themselves. Therefore, the actuality of the work and the viewer's tangible engagement with it, convey meaning in a way that a detached contemplation of the art object can never do.

Various explanations have been given as to why installation art has become so widespread in recent years. As discussed in Section 1 of this chapter, the reaction to abstract painting and particular forms of medium-specific sculpture encouraged the adoption of more diverse materials by many artists in the 1960s and 1970s. The choice of materials was itself a symbolic refusal of some of these earlier Modernist forms of art practice and the assumptions about value, quality and meaning which they encompassed.

Secondly, as noted in Chapter 2, forms of art practice which moved away from previously dominant disciplines like painting were seen, at least in the mid to later 1960s, as symptomatic of the impetus and cultural direction associated with the idea of the Postmodern. In using comparatively new materials (aluminium, plastics and Plexiglass/perspex were especially popular), together with more automated and industrial techniques of production, artists were making indirect points about the connection of art to the broader realities of life beyond the studio.

This had been one of the ideas explored by the literary theorist Peter Bürger in what became a widely quoted book, *Theory of the Avant-garde* (see Chapter 2, pp. 22–3). Bürger had identified the innovative art practices of the 1950s and 1960s (installation,

in addition to happenings, impromptu art events, as well as performance and conceptual art), as examples of 'neo-avant-garde' art. Although they looked back to the earlier 'historical avant-gardes' of the 1920s and 1930s such as Dada, Surrealism and Constructivism, their practitioners were working within entirely changed social, cultural and economic circumstances (hence the slightly disparaging use of 'neo' in the collective description given to their work).

According to Bürger's argument, one of the defining attributes of the earlier or 'historical avant-gardes' of the twentieth century was in the desire to link art with the 'praxis', or practice, of everyday life. So, for example, artists used and re-presented everyday materials or, like the Constructivists in Soviet Russia, they created designs or objects that had particular or practical uses for the new society. The idea that art should simply be produced for its own sake without a social purpose was vehemently opposed by the 'historical avant-gardes'.

Fast-forward to the 1960s and 1970s, and social radicalism of various kinds was again part of the cultural scene. But according to Bürger it was historically inauthentic for the avant-garde to attempt to re-create some of these earlier strategies, not least because modern art had lost so much of its oppositional or critical edge through its adoption and widespread commercialization by the marketplace. Instead, he argued that in the very different circumstances of consumer capitalism, it might be better if the neo-avant-garde attempted to preserve the distinctness of its practice (including installation), so safeguarding some degree of critical independence or 'free space within which alternatives to what exists becomes conceivable' (Bürger, p. 54).

Although some of these arguments may seem somewhat remote when looking at contemporary installation art, they are important because they underline the historical links and precedents which have helped to define the genre. The neo-avant-gardes of the 1960s were particularly influenced by some of the 'historical avant-garde'

practice of Marcel Duchamp, Kurt Schwitters (1887–1948) and Man Ray, which earlier in the twentieth century had questioned the traditional boundaries and associations of art making by exhibiting and sometimes refashioning previously functional objects, including bottle racks, snow shovels, urinals and flat irons (see Figure 1.2).

For example, Schwitters was famously known for his *Merzbau* or *Merz Building*, the first of which he began between 1919 and 1923. The Hanover version was a complex, architecturally sized installation of found, made and combined objects, sometimes given by or taken from friends and colleagues (he called these 'spoils and relics') which were installed or suspended from the ceilings and walls of the several floors of his apartment. Subsequently destroyed in Allied bombing, the Hanover *Merzbau* was an unfinished and dynamic piece of art that Schwitters was continually adapting and changing as his interests and circumstances allowed. After leaving Germany and coming to England, Schwitters continued the project, demonstrating the extent to which the installation was neither location nor space specific (see http://www.merzbarn.net).

While many commissioned installations are conceived and made to be site specific (that is made for a particular location), many are not, indirectly referencing this earlier avant-garde tradition of free-wheeling innovation and experimentation. Avant-garde figures like Schwitters and Duchamp shared the conviction that art was ultimately concerned with ideas and concepts, rather than just images and colours to divert and please the eye. For Duchamp and some of his contemporaries, the artist alone had the cultural authority to designate a chosen object, process or performance as 'art'. Ordinary objects and materials taken from everyday use and exhibited in gallery spaces could appear different or 'de-familiarized'. The previously functional became functionless 'ready-mades'. Many of the composite installations that you may encounter are 'hybrid' extensions of this tradition. In other words, they extend and develop this process of selection and making, refashioning heterogeneous objects and materials into landscapes, collaged effects and simulated environments.

Some of these earlier traditions of installed or modified 'objects' were echoed not just by the neo-avant-gardes of the 1960s and 1970s, but became fashionable for a subsequent generation of artists. In the UK, for example, one theory is that the economic downturn associated with the late 1980s and early 1990s, and the disruption it caused to galleries and the art market, encouraged the generation of yBas, fresh out of art college, back on their own resources.

As an object-based practice, installation can assume any form, scale or material. For some among this new generation of artists, the need to curate their own work, melded with installation as a highly flexible, pragmatic and economical way of making art. For example, many of the generation of British artists who came to notice in the 1990s, including Jake and Dinos Chapman (see Figure 5.2), Anya Gallaccio, Damien Hirst (see Plate 9), Tracey Emin, Angus Fairhurst, Michael Landy and Sarah Lucas, established their names primarily through making installations.

Please look at Plate 9, a work by the British artist Damien Hirst (b.1965). What is your immediate reaction to the image and why? How does the open space between the two display cases contribute to your response?

▶ *The installation's title is* Mother and Child, Divided, *a reference to the bisected Friesian cow and calf which are presented and preserved in parallel formaldehyde display cases, or vitrines. In addition to having played a formative, organizational role in the early promotion of a generation of Goldsmiths College–based art students (the yBas), Hirst has also made his name and reputation through the signature style of his work. Animals, objects and tableaux, either within single formaldehyde tanks or as parts of more detailed multi-piece installations, have brought him widespread acclaim and criticism in equal measure.*

▶ *As you will have realized, the installation's title is a literal reference to the re-presentation and vivisection of the two half bodies of cow and calf. In one sense, you may have felt this is a very prosaic presentation of bovine anatomy, in a way that might be encountered in a medical laboratory. But Hirst's use of space is a formative part of this piece and*

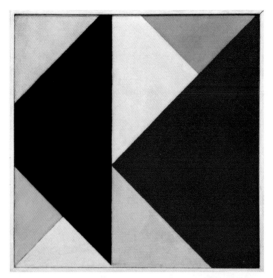

Plate 1 Theo van Doesburg, *Counter Composition XIII*, 1925-1926. Oil on canvas: 49.9 x 50 cm (19.65 x 19.68 in). Peggy Guggenheim Collection, Venice © AKG Images.

Plate 2 Richard Hamilton, John McHale, John Voelcker, Group 2, *This is Tomorrow*, 1956 (1991 reconstruction). Wood, paint, fibreglass, collage, foam rubber, microphone, film projectors: approx. 4 m (13.12 ft) at highest point. Hood Museum of Art, Dartmouth College, Hanover, New Hampshire, USA. Photo: Graham Whitham.

Plate 3 Matthew Barney, *Cremaster 1: Goodyear Chorus*, 1995. Production still. C-print in self-lubricating plastic frame: 111 x 136.5 x 2.5 cm (43.7 x 53.7 x 1 in.) each. Edition of 6 © Matthew Barney. Photo: Michael James O'Brien. Courtesy: Barbara Gladstone "CREMASTER 1" 1995.

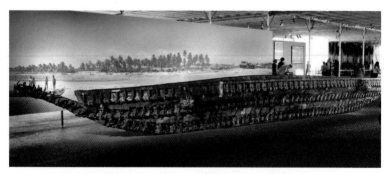

Plate 4 Romuald Hazoumé, *Dream*, 2007. 421 plastic oil containers, glass bottles, corks, cords, photograph mounted on board. Installation area 1660 x 1200 cm (54.46 x 39.37 ft), photograph 250 x 1250 cm (8.2 x 41 ft), boat 177 x 1372 x 128 cm (5.8 x 45 x 4.2 ft) Kassel Documenta 12, Germany. Photo: Graham Whitham © ADAGP, Paris and DACS, London, 2010.

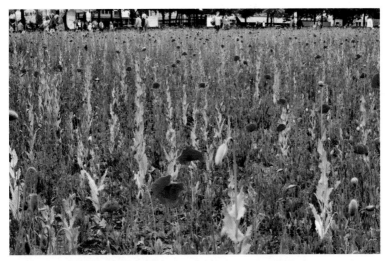

Plate 5 Sanja Iveković, *Poppy Field*, 2007. Installation of planted Papaver rhoeas and Papaver somniferum poppies with 6,590 qm loudspeakers, playing revolutionary songs performed by Le Zbor (CRO) and RAWA (AFG), Friedrichsplatz, Kassel with the support of the Office for Gender Equality of the Government of the Republic of Croatia. Co-produced by Thyssen-Bornemisza Art Contemporary for Documenta 12, Kassel, Germany. Photo: Graham Whitham.

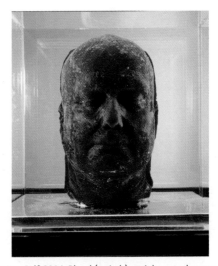

Plate 6 Marc Quinn, *Self*, 2001. Blood (artist's), stainless steel, perspex and refrigeration equipment: 80 11/16 x 25 9/16 x 25 9/16 in. (205 x 65 x 65 cm) © Marc Quinn. Photo: Stephen White. Courtesy: Jay Jopling/ White Cube (London).

Plate 7 Maurizio Cattelan, *La Nona Ora* 1999, Mixed Media: Painted wax, fibreglass resin, clothes, stainless steel, volcanic stone. Dimension: Lifesize. Installation: Kunsthalle Basel, 1999. Courtesy: Maurizio Cattelan Archive. Photo: Attilio Maranzano.

Plate 8 Anselm Kiefer, *Your Golden Hair, Margarete*, 1981. Oil, emulsion, and straw on canvas: 130 x 170 cm (51.2 x 66.9 in.). Collection Sanders, Amsterdam © Anselm Kiefer. Courtesy: Gagosian Gallery.

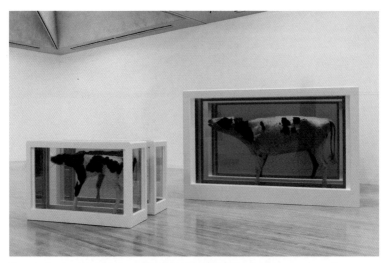

Plate 9 Damien Hirst, *Mother and Child Divided*, 1993. Steel, GRP composites, glass, silicone sealants, cow, calf, formaldehyde solution: dimensions variable. © Tate, London, 2010 and © Damien Hirst. All Rights Reserved, DACS, 2010.

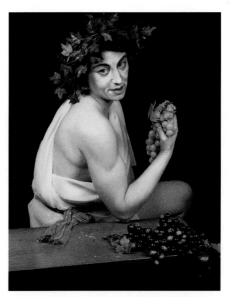

Plate 10 Cindy Sherman, *Untitled (No.224)*, 1990. Colour photograph: 111.8 x 137.2 cm (48 x 38 in.). Courtesy of the Artist and Metro Pictures.

Plate 11 Peter Doig, *The Architect's Home in the Ravine*, 1991. Oil on canvas: 200 x 275 cm (78.7 x 108.3 in.). Courtesy: Victoria Miro Gallery and the Saatchi Gallery, London © Peter Doig.

Plate 12 Gary Hume, *Hermaphrodite Polar Bear*, 2003. Gloss on aluminium: 198 x 150 cm (77.15/16 x 59 1/16 in.) © Gary Hume. Photo: Stephen White. Courtesy: Jay Jopling/White Cube, London.

Plate 13 Richard Wilson, *20:50*, 1987. Used sump oil, steel. Dimensions variable. Courtesy of the Saatchi Gallery, London © Richard Wilson, 2009.

Plate 14 Fiona Rae, *Night Vision*, 1998. Oil and acrylic on canvas: 243.8 x 213.4 cm (96 x 84 in.). © Fiona Rae. Courtesy: Timothy Taylor Gallery, London; Tate Collection.

Plate 15 Angus Pryor, *The Deluge*, 2007. Oil based paint and builder's caulk on canvas: 240 x 240 cm (94.5 x 94.5 in.) © Angus Pryor. Photo: Jez Giddings.

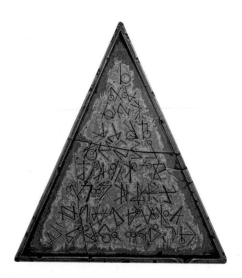

Plate 16 Mark Dolamore, *The Pyramid Art*, 2004. Nitrocellulose on polyester and wood: 76 x 67 cm (29.9 x 26.4 in.) © Mark Dolamore. Photo: Jordane Coustillas.

In other, associated works, like *Away from the Flock* (1994),
Hirst has explored this theme with a single animal, or in other
instances, the seriality of multiple versions of the same or similar
subject (repetition was a familiar device used by makers of art we
might consider as installation in the 1960s such as Donald Judd
(see Figure 2.1), Robert Morris and Sol Le Witt). In presenting
Mother and Child, Divided as an art object that can be viewed in
the round, Hirst offers the familiar as spectacle, a sight of interest,
curiosity or provocation. Allowing us to walk along a small spatial
corridor which does not (cannot) exist in ordinary circumstances,
our gaze is privileged in a way which is engaging, perhaps even
compelling. We become, in effect, voyeurs of freeze-framed
death. The ambivalence which this installation, and others like it,
provokes is in large part due to Hirst's use and manipulation of a
360-degree viewing space as part of our experience of the work.

The popularity of installation as a form, or genre, which can be
used to mobilize compelling spectacle is apparent in the work of
Hirst's Italian-born contemporary Maurizio Cattelan (b.1960).
Cattelan started making art only in the mid-1980s, coming to
wider notice after being selected for the Italian Pavilion at the
1997 Venice Biennale. *La Nona Ora* (Plate 7) is probably his
best-known installation, having been widely seen in the 1999
Apocalypse exhibition held at London's Royal Academy of Arts.
The installation's title (in English, *The Ninth Hour*) refers to the
time of Christ's supposed death.

**Please look carefully at Plate 7. How would you describe what
you see?**

> ▶ Cattelan has created a diorama which re-creates an entire interior,
> perhaps somewhere in the papal apartments within the Vatican City.
> *(Contd)*

> *The late Pope John Paul II, depicted in a life-size wax model, and in the full ceremonial robes of his office, has just been struck by a meteorite. Broken glass from the shattered roof marks its impact with the rock having embedded itself in the Pope's side. The installation captures this cataclysmic moment when the Pontiff is thrown to the floor.*
>
> ▶ *The shattered glass and debris strewn around the thick red carpet, and the opulence of the constructed setting, give this installation a surreal and strangely compelling quality. Entering the viewing space for the installation, it is as if we have just witnessed the cosmic event itself and time has been suspended.*

With *La Nona Ora*, Cattelan skilfully blends macabre satire with spectacle, creating an object which both provokes and disorientates. As the critic James Hall has noted, the meteorite might be read as an ironic reference to the Pope as the 'rock' of the Church, and the Pontiff's apparently blithe expression as a satire on 'blind faith' (Hall (1996), p. 89).

What are your responses to this installation?

> ▶ *You are likely to have a myriad of responses, perhaps ranging from vague amusement to repulsion, interest to indifference, or maybe concern at the sacrilegious use of subject matter.*
>
> ▶ *Initially, the work may seem sacrilegious but, thinking about how James Hall interpreted it, this may not be the case. The point here is, whatever Cattelan's intentions,* La Nona Ora *has layers of possible meaning.*
>
> ▶ *But there is something else worth considering. Your responses are to a photographic reproduction and, as such, you are probably reacting differently than you would if faced by the actual work. As we noted previously, the three-dimensionality and presence of an installation, combined with your own physical engagement to it, mean that a photographic reproduction provides you with an essentially different experience.*

Cattelan's installations frequently use bizarre juxtapositions and surreal imagery, which generates a sense of 'spectacle' – understood

here as a visually striking performance or display. Some critics have suggested that one of the reasons for installation's popularity as a genre is just this ability to use or mobilize spectacle to compel the interest of the audience. According to this view, large-scale art installations indirectly compete with, and ostensibly share, some of the attributes of other media attractions such as multiplex cinemas, shopping malls and other highly packaged examples of consumer pastimes.

On the face of it, this may seem a strange argument, but if you consider the extent to which public galleries and museums have frequently adapted ideas from business to increase 'footfall' through blockbuster shows, major touring exhibits and 'big names', the comparison may not seem so far fetched. As Julian Stallabrass has noted, with large-scale, exclusively commissioned installations, the public has to visit the venue or gallery to really see and experience it (Stallabrass (1999), p. 17).

Consider for instance some of the recent, high-profile installations by artists such as Louise Bourgeois, Carsten Höller, Anish Kapoor and Olafur Eliasson. In these examples, the scale and the spectacle of each installation has become synonymous with its display venue – London's Tate Modern Turbine Hall.

Insight

As well as providing spectacle, installations can offer us a wider sensory experience. Not only do we see and 'feel' but, because we are literally *in* the work of art, it can engage all our senses.

So far, we have explored installations which engage attention through the juxtaposition of materials and spatial ambiguity, by the choice of provocative subject matter or through the use of scale and size. But in other instances, practitioners have been less concerned with spectacle and immediate visual effect, but have instead explored more subtle and cumulative inter-relationships of form, material and space.

Please look at Figure 2.1. The work is by the American Minimalist artist Donald Judd (1928–94). It comprises four anodized aluminium and Plexiglass (perspex) boxes that have been placed at equidistant spaces directly onto the gallery floor. While this work might be considered as sculpture, in that it is a three-dimensional form to be looked at by walking around it rather than into or through it, we want to consider its potential as installation, or at least, a form of proto-installation.

How do you think the choice of material and the work's placement determine or affect your response to it?

▶ *As you may have guessed, Judd's composite materials deliberately references machine manufacture and, for the period it was made, the relatively new media of aluminium and Plexiglass, valued for their durability in construction and design.*

▶ *The equidistant spacing of the four boxes explores the effect of seriality and establishes a dynamic if repetitive interaction between void and space which becomes part of the work.*

In both the artist's intention and the effect on the viewer, this work might be regarded as an installation as much as it is a sculpture. Judd was concerned to make installations which activated the 'neutral' exhibition or gallery space. The placement of *Untitled* and its status as a three-dimensional 'object' determines that we walk around it, rather than experience it from a single perspective or fixed vantage point. In walking around a work, the physical encounter is more tangibly one of both space and time. Judd's tendency to refuse titles, which might be used to suggest or imply subjects, themes or narratives, underlined this refusal to impose meanings or readings for his work.

One of Judd's US contemporaries, Robert Morris, made the 'literal' difference between installations and other art forms such as painting, more explicit. In his 'Notes on Sculpture' Morris wrote: 'the sculptural facts of space, light and materials have always functioned concretely and literally…the human body enters into

the total continuum of size and establishes itself as a constant'
(quoted in Harrison and Wood (2003), pp. 829–31).

In the later 1960s Morris and Judd were among those involved
in what became a bitter art-world dispute with the Modernist art
critic Michael Fried. In a polemic text called 'Art and Objecthood'
(1967), Fried had argued that object-based art of the kind made by
Minimalist artists was fundamentally inauthentic and staged. This
he believed arose because of the object's 'literalist' character which
theatricalized the relationship between the spectator and the object.
For Fried, 'the negation of art' occurred when concerns over the
'actual circumstances in which the beholder encounters literalist
work' (quoted in Harrison and Wood (2003), pp. 838–9) took
precedence over everything else. He believed that the orchestrated
physicality of object-based work, and the time or duration which
walking around it inevitably required, had resulted in nothing
less than a corruption of aesthetic sensibility and a flawed basis
for responding to art. According to this view, Minimalist works
demonstrated little more than a staged and theatrical search for
transient and increasingly self-conscious effects.

As a Modernist art critic, Fried's preference was for flat, abstract
paintings, to which the viewer, he believed, could respond both
intuitively and involuntarily. In other words, the quality of an
abstract canvas could be understood in an instant – taken in
through a glance. For his critics, Fried's ideas simply represented
a form of unspecific transcendentalism at odds with the scope and
direction of their own ideas about art. Instead, they believed in a
more participative and open-ended interaction with the spectator
and the context of display.

However, these disputes were not just about different forms of
art, but more fundamentally concerned issues of 'phenomenology' –
the origins of perception – how we respond to what we encounter
and see. During the 1960s the work of the French philosopher
Maurice Merleau-Ponty (1908–1961) was being translated and
made available in the English-speaking world for the first time.

Merleau-Ponty believed that both the viewer (the subject) and the things being viewed (in this case the art 'object') were integrally related, or as he put it: 'the thing is inseparable from a person perceiving it, and can never be actually in itself because it stands at the other end of our gaze or at the terminus of a sensory exploration which invests it with humanity' (Merleau-Ponty (1998), p. 320).

According to this view, human perception is 'embodied' – it arises from and communicates our experience of being in the world, instead of there being a strict split between mind and body. Rather than privileging sight alone, phenomenology emphasizes that our response to the world and all the things in it – including art – is experiential and mediated through all the senses. Theories of embodied perception were widely discussed when Modernist painting was beginning to lose its dominant status throughout Europe and America, the immediate background to the Fried debate.

Unsurprisingly, given the discursive and open-ended meanings associated with much installation, object-based and performance art of the time, Merleau-Ponty's ideas were widely embraced by the neo-avant-gardes of the 1960s. In the following decade, perspectives associated with post-structuralism, gender theory and social anthropology further questioned the conventional wisdom of a centred and unified human identity, developments which further supported the phenomenological debates already being applied to cultural practice.

Although some of these debates and issues were in circulation before the installation practice explored here was actually undertaken, they provide an important theoretical context for understanding the genre of installation and some of the tacit assumptions made and accepted by its practitioners. In particular, the discursive and potentially open-ended encounter between viewer, space and installation is a key feature of installation art and remains a concern for contemporary practitioners, curators and galleries.

Claire Bishop's influential study *Installation Art: A Critical History* (2005) has approached installation's development and diversity by characterizing four distinct types of aesthetic experience offered to the embodied subject by and through installation practice. Although the various characterizations are not mutually exclusive, the ordering provides a useful starting point for identification and comparison, arising from differences in viewer experience. She identifies:

▶ *a dream-like encounter in which the viewing subject is immersed; the installation providing a total environment in which disbelief is temporarily suspended*
▶ *installations which accent bodily experience and response*
▶ *examples which explore the apparent disintegration of the subject, adapting the psychoanalytic idea of 'thanatos', or the death drive*
▶ *examples which situate and address the viewer as a politicized subject* (summary of Bishop *(2005), p. 10).*

So, to give some instances of the above, Hirschhorn's *Cavemanman* discussed earlier can be seen as an immersive installation – we can physically enter inside it and walk around the constructed space. Wilson's *20:50* might be seen to emphasize bodily experience and response through the impressions of vertigo and disorientation that we might experience when exploring it. Similarly *Test Site* 2006, a series of slides installed in the Turbine Hall of London's Tate Modern by Carsten Höller (b.1961), can also be seen as foregrounding a physical response – in this case one of speed, anxiety or just sheer terror! (see http://www.tate.org.uk/modern/exhibitions/carstenholler).

The subject matter of Damien Hirst's *Mother and Child Divided* can be read as accenting the experience of death and disintegration through the preservation of its bovine subject matter. Cattelan's *La Nona Ora* can be seen in various registers: as an immersive reconstruction of an environment; as a secular critique and parody of papal claims to inviolability; and equally as imaging, through Cattelan's vivid tableau, the disintegration of the subject.

Of course, these interpretations are just that – possibilities which arise from one particular reading or response. They are not mutually exclusive, because installations can be interpreted as flexible interventions which cut across or combine attributes from these broad characterizations. However, they do demonstrate how some of the general categories suggested by Bishop can be very useful in providing us with a basis for developing our own readings, comparisons and interpretations.

From reading these categories, it becomes apparent just how central the viewer is as the installation's ultimate 'subject', perhaps rather more than the object itself. The embodied response to these interactions – subject, object and space – further individualizes and dramatizes the encounter with the genre. Other commentators have noted how some of the viewer-centred and participative ideas associated with installation art have begun to influence directions within contemporary art practice more generally. This has been one of the themes explored by the French curator and writer Nicolas Bourriaud (b.1965). In two books, *Relational Aesthetics* (2002) and *Postproduction* (2005), Bourriaud has emphasized the ongoing importance of a phenomenological reading of art within contemporary or post-industrial society. In *Relational Aesthetics*, he writes: 'The artwork of the 1990s turns the beholder into a neighbour, a direct interlocutor. It is precisely the attitude of this generation towards communications that makes it possible to define it in relation to previous generations' (Bourriaud (2002), p. 43).

For Bourriaud, installation and performance practice – see Section 4 of this chapter – are both 'relational' forms of art because they encourage more open responses from viewers. Although the various examples of installation art which we have looked at in this section are very different in medium, appearance and shape, and may encourage diverse interpretations, they share what Bourriaud describes as an 'unfinished discursiveness'. They require an embodied response, which in practice means that we are encouraged to think about, look and walk around the works,

before coming to our own conclusions. For Bourriaud, within an increasingly controlled and directed society, such demands can be positively linked to broader ideas of cultural politics and human freedom (Bourriaud (2002), pp. 14–16, 27). Rather than be told or instructed how we should respond, installation art opens up free spaces for engagement, provocation, distraction and politicization.

Thinking for a moment about Bourriaud's viewpoint, and as a closing example of installation in this section, please look at Romuald Hazoumé's (b.1962) mixed-media installation *Dream* (2007) (Plate 4), which was exhibited at the Kassel Documenta 12 in 2007. Among the curatorial questions which underpinned this important international art fair were the following:

▶ *Is humanity able to recognise a common horizon beyond all differences?*
▶ *What do we have to learn in order to cope intellectually and spiritually with globalization?*

We will be exploring aspects of this broader context to Hazoumé's *Dream* in Section 2 of Chapter 5. But as a concluding exercise, noting the above questions and what you have explored so far in this section, think about how you would describe and characterize this example of installation.

▶ *Hazoumé's installation seems to fall into Bishop's fourth category, which situates and addresses the viewer as a politicized subject. If you look back to Chapter 3, pp. 53–54, you can read about the specific political contexts of the work, as you can if you look forward to Chapter 5, pp. 213–214.*
▶ *As a physical presence it is not an installation into which we can walk and be 'immersed', but rather one that we walk around, or view from the front and sides, partly because the large photographic image is presented like a poster hoarding that blocks our view from the other side. However, we can walk between the boat and the photograph. In this way, it is different from Hirschhorn's*

(Contd)

> *Cavemanman, into which we enter and are immersed. Therefore, our experience of the work does not result from total immersion but it is still, in Bourriaud's sense, 'relational' and, to use Merleau-Ponty's language, we have the opportunity for an 'embodied response'.*
>
> ▶ *What we do sense as we look at this work is its artifice; we are aware of the gallery situation as we view the piece, and the photograph of what we might suppose is the Benin coast, looks unreal simply because it is a photograph on a hoarding. But the boat is a real, tangible object. You might think that this sharp contrast between the two-dimensional reproduction and the real boat adds to the work's artifice; on the other hand, you might think that they complement each other by playing off reality against illusion.*

In this section we have explored the form, or genre, of installation art, starting with some general definitions and sketching its origins with the Duchampian tradition of the ready-made. We have considered some examples, both from the neo-avant-garde of the 1960s and 1970s, as well as more recent works by artists who have come to wider public notice.

As an approach to art making, installation has often been associated with a refusal of the medium-specific ideas associated with Modernism and the support it gave to particular forms of painting and sculpture (see Chapter 2). For the avant-gardes of the 1960s and 1970s, these connotations made it attractive and novel. The discursive licence that the installation genre gives has encouraged very diverse forms of practice, response and engagement. For a more recent generation of yBas, it has also proved attractive, not least because it was easily adaptable to the themes and subjects of spectacle and consumer culture. Its heterogeneity also made it an ideal art form at a time of economic uncertainty in the late 1980s and early 1990s when art market patronage was shifting in response to diminishing incomes and buying patterns.

Among the most varied forms of art, installation practice is also the most discursive. Regardless of size, medium, location and context,

installation is centred around engaging and provoking spectator response. It occupies our space, it literally gets in the way, rather than discretely occupying the private, symbolic (and sometimes peripheral) wall space of a painting, drawing or print.

Although a truism for much contemporary art, for installation in particular there really are no correct interpretations or readings. Assuming that our response to what we see is embodied – the cumulative outcome of all that we are and have experienced – installation art does mirror in oblique and sometimes challenging ways, who, what and where we are.

Suggestions for further reading

Claire Bishop, *Installation Art*, Tate Publishing, 2005

Michael Fried, *Art and Objecthood: Essays and Reviews*, The University of Chicago Press, 1998

Nick Kaye, *Site Specific Art: Performance, Place and Documentation*, Routledge, 2000

William Malpas, *Installation Art in Close-up*, Crescent Moon Publishing, 2007

Nicolas de Oliveira and Nicola Oxley, *Installation Art in the New Millennium: The Empire of the Senses*, Thames and Hudson, 2004

Julie H. Reiss, *From Margins to Center: The Spaces of Installation Art*, MIT Press, 1999

Mark Rosenthal, *Understanding Installation Art: From Duchamp to Holzer*, Prestel, 2003

Section 6 Land and environment art

I don't do proper gallery shows. I have a much more direct communication with the public.

(Banksy, 2006)

Please look at Figure 4.2. How would you describe what you see?

▶ *The work, titled* Yellow Line Flower, *adapts some of the pictorial devices typically associated with still-life or* trompe-l'œil *painting – literally that which seeks to deceive the eye – through accomplished use of perspective and figurative detail.*

▶ *Looking at the work, we follow what are bright yellow double lines up the wall which, snake-like, originally left the road, sinuously forming a*

(Contd)

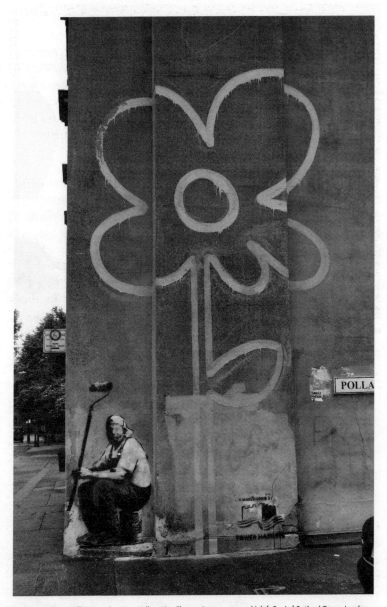

Figure 4.2 Banksy, graffiti image known as Yellow Line Flower. Approx. 250 cm high (98.4 in.) Bethnal Green, London, 2008. Banksy image courtesy of Pest Control Office. Photo: Graham Whitham.

*single-headed flower. In a further pictorial signature, there is a
stencilled image of the artist (perhaps a self-portrait) sitting on a
bucket of paint, complete with extended roller, work overalls and cap.*

This image is by the street artist popularly known by the pseudonym
of Banksy (probably b.1974). His real name remains a subject of
continuing speculation despite various attempts to identify him by
the press, although he is generally believed to have grown up in and
around the town of Yate in south Gloucestershire, UK.

The image was painted on the side of a private building (a working
men's club) at the visually prominent junction of Pollard Street
with Pollard Row in Bethnal Green, East London. Its position on
private property was probably designed to prevent it being painted
over by the local council, although since Banksy's commercial
success this particular practice seems to have stopped!

**Keeping in mind some of the other forms of aesthetic practice that
we have explored so far, where would you place this as a genre –
installation, cartoon, painting, or a piece of environment or urban art?**

▶ *Although Banksy's image adapts pictorial devices from painting and
some of the stylization we expect from cartoons, it uses the urban
environment, rather than a gallery space, as its chosen location. You may
think that it is this, more than anything else, that identifies* Yellow Line
Flower *as a piece of street or environment art. In choice of subject matter
too – a single flower – the image provides a natural foil to the drab
urban landscape and the restrictions suggested by the double yellow
lines which, of course, have very different connotations for residents
and commuters familiar with London's densely populated boroughs.*

Graffiti means an image or design which is scratched or scribbled
onto a wall or any other urban surface. As such, it carries illicit
connotations as a subversive, and often youth, subculture. Of
course, as an art form, it is not particularly new; mark making of
various types extends into human prehistory, but Banksy's work is
emblematic of a new form, widely popularized as street art through
what began as the New York–based trend for hip-hop bands and

fashion in the early 1980s. Some of those associated with this and similar types of street art include Jean-Michael Basquiat, D* Face, Shepard Fairey, Keith Haring and Antony Micallef. For the past decade Banksy has made extensive use of stencils, a technique which has since become his trademark style. As stated in the self-authored book, he started using stencils because of their speed and accuracy – and as a means of not getting caught (Banksy, *Wall and Piece* (2006), p. 13).

Looking at and thinking about *Yellow Line Flower*, we might make several observations:

▶ *As an example of street or environment art, it incorporates the existing urban landscape as an integral part of its technique and subject matter.*
▶ *It is not designed or intended to be shown within the art interior of a 'white cube' gallery, but within a public, urban space.*
▶ *Although it adopts some of the conventions of other, perhaps more recognizable, forms of art,* Yellow Line Flower *directly employs subversive humour and some element of gentle provocation in the choice and presentation of its subject matter.*
▶ *It is not intended to be a durable image; as an example of street art it has in turn been 'tagged' and covered with other images and graffiti.*

Insight

Yellow Line Flower ultimately raises issues about how a work of art might be recorded, the relevance, or otherwise, of curation, and what should come to constitute the actual art work – the possibly short-lived original or a photograph of the work in situ.

For a second, and very different, example of environment art, please look at *Hanging Tree No.1* (Figure 4.3) by the British sculptor, photographer and environmentalist Andy Goldsworthy (b.1956). A site-specific work (from a series of three), it was made as part of a major retrospective of the artist's work hosted at the Yorkshire Sculpture Park, near Wakefield, UK.

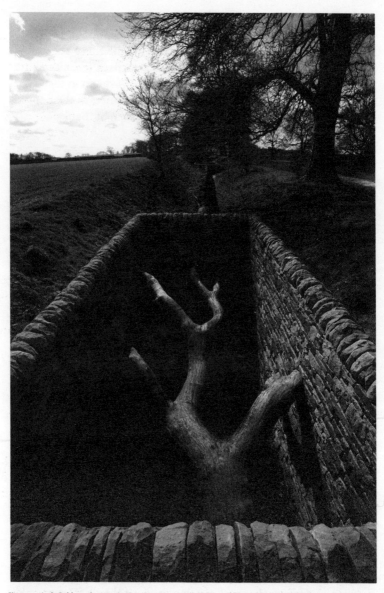

Figure 4.3 Andy Goldsworthy, Hanging Tree No.1, 2007. Tree and stone wall. Exhibited at the Yorkshire Sculpture Park, 2007–08.

Please try to describe this work.

- ► Hanging Tree No.1 *has used a found object, in this case a dead tree trunk with its major boughs intact, which has been embedded within a rectangular, dry-stone wall pit.*
- ► *A tangible part of this work is the juxtaposition between natural and crafted forms – the smooth curvature and striations of the tree's bark surface and the constructed, angular forms of the surrounding stone wall.*
- ► *It is a work which is accented by the context of the environmental conditions of its location – these are found and re-arranged objects within the existing landscape.*
- ► *Unprotected exposure to environmental conditions – light, air, rain and time – will ultimately change and refashion this piece of environment or 'land art'.*

Goldsworthy's work refuses the synthetic in favour of the organic and the natural; he is frequently described as a 'steward' of natural forms and resources, which he fashions and arranges into examples of environmental art. *Hanging Tree No. 1* is among the larger and more architectural pieces he has undertaken. The work has been described as an 'outclosure' – a pun on the typical 'enclosure', with its historic connotations of ownership, exclusion and restrictions of land use. But unlike much of the art that we have considered, it is not literally functionless since *Hanging Tree No.1* actually forms part of the sculpture park's existing boundary.

Although the two examples of environment art which we have so far looked at may suggest an unlikely combination (one highly urban in location, the other eminently 'natural'), they share a common point of origin in some of the earlier neo-avant-garde practices that we have explored and discussed in previous sections and chapters.

In the 1960s and 1970s, land or environment art was one of the genres which developed as a particular reaction against the dominance of Modernism and the emphasis on abstract painting. American artists such as Robert Smithson (1938–73) and Michael Heizer (b.1944), as well as their British contemporary

Richard Long (b.1945), a graduate of London's St Martins School of Art, a hotbed of conceptually based practice in the 1960s, developed work which was characterized by natural and human interventions within landscape as the focus of their respective art practice.

However, there remained considerable variations in the work of these artists, with Smithson and Heizer interested in the idea of scale and the sublime (the monumental and awe-inspiring), while much of Long's work was deliberately conceived to be small scale, naturally produced, transient and finite. Characteristically, Long's 1967 *A Line Made by Walking* was created by repeatedly walking forwards and backwards along the same line across a field, thereby 'naturally' flattening the grass. The trace of his presence became the work of art but lasted only until the grass sprang back or grew over his line made by walking (see http://www.richardlong.org/sculptures/1.html).

In contrast, Heizer's *Complex City* (1972–6) is a 7 m high, 366 m long and 159 m deep structure made of steel, concrete and compacted earth and sited in the Nevada desert. It was not created using 'natural' means, but by mechanical diggers, dumper trucks and other construction machines more often found on construction sites (see http://doublenegative.tarasen.net/city.html). Unlike *A Line Made by Walking*, its scale and sharp angular forms set against the flat desert and distant mountains give it a monumental appearance. Heizer noted: 'It is interesting to build a sculpture that creates an atmosphere of awe...Immense, architecturally-sized sculpture creates both the object and the atmosphere...Awe is a state of mind equivalent to a religious experience' (quoted in Heizer *et al.* (1984), p. 33). Some critics have seen in the apparent monumentality of Heizer's work, and that of other land artists who have adopted a similar scale of art making, a modern interpretation and expression of the 'sublime' – a phenomenon which can awe or literally terrify the spectator.

In Smithson's case, the iconic example of land art was *Spiral Jetty* (started in 1970), a coiled earthwork of more than 450 m comprising mud, rocks and salt crystals, which covered a

4-ha site at Rozel Point, within Utah's Great Salt Lake (see http://www.spiraljetty.org). Despite its scale as a piece of land-based engineering, like Heizer's *Complex City,* it was constructed using earth-moving machinery which was required to shift more than 6,000 tons of rocks and earth – Smithson also had an interest in what was then the early stages of the ecology movement.

Although, in contemporary terms, the carbon footprint of *Spiral Jetty*'s making may seem at odds with Smithson's publicized views on ecology and radical politics, he described it as a 'traffic jam of symbolic references' (quoted in Dickie). Smithson had profound interests in the processes of deep geological time and the laws of entropy – the gradual slowing down and eventual stasis of all natural phenomena. In fact, shortly after work on *Spiral Jetty* had been completed, the lake's water level rose, putting the work under water. When the level fell again, its exposed rocks had been bleached white by the lake's high salt content. Like Goldsworthy's *Hanging Tree No.1, Spiral Jetty* is a work in progress; durable, but slowly changing in rhythm with nature and time.

The land art of the 1960s and 1970s became associated with the period's counter-culture, which eschewed possessions and the dominance of consumerism, looking instead to a more 'organic' relationship between humankind and the natural world. In particular, much of the land and environment art produced by the neo-avant-garde was implicitly critical of the gallery and dealer structure which, according to its critics, had 'commodified art', reducing it to a saleable object to be purchased and owned.

Thinking about the examples of land and environment art we have discussed so far, to what extent do you think they evade or challenge some of the conventional expectations of art works?

▶ *In every case, the works do not exist in a gallery; this has implications for viewing them. Heizer's and Smithson's pieces require the spectator to make relatively difficult journeys to see them; Long's work is typically experienced in photographs and written accounts; Banksy's* Yellow

(Contd)

Line Flower is on the wall of a building in a London East End street. Only Goldsworthy's Hanging Tree No.1 *is, in any sense, situated in a place designated for art, but the Yorkshire Sculpture Park is designed to embed art within the natural environment.*

▶ *The locations, scale and transience of each work make it impossible for them to be owned in any conventional sense. Unlike a painting or more traditional sculpture, land and environment art is often made so it cannot be owned, thereby challenging the idea and expectation that the work is a commodity to be bought and sold.*

▶ *The materials and techniques used in each of the works are not those usually associated with making art. Smithson, Long and Goldsworthy use natural materials that will, over time, change; Heizer employs materials more commonly associated with architecture and engineering; Banksy sprays paint from an aerosol can, a material and method alien to conventional picture making.*

Insight

Seeing art in a location not usually designated for that purpose; negating its potential to be owned and displayed; making it from materials that are unconventional, which will change their form or even disappear over a relatively short time, all seem to support the view that land and environment art evades or challenges conventional expectations. That said, its inclusion on websites and books such as this do make it accessible. This is due in no small measure to its mediation by photography. Photographic copies of *Yellow Line Flower*, for instance, are widely available for purchase, ensuring that what might otherwise be a transient image noticeable only to passers-by and those in the immediate neighbourhood will have a far greater audience and visual circulation.

But of course, this raises another issue. In the case of Banksy's street art, for instance, to what extent is the subversive message and intent of this genre undermined once it becomes commercialized?

In July 2008 Bristol's City Museum gave Banksy his first 'official' exhibition. A year earlier, work by Banksy was auctioned for over £500,000 with particular examples achieving record sums for the

artist. Examples such as *Avon and Somerset Constabulary* (which depicted two policeman looking through binoculars) achieved £96,000, while *Lenin on Rollerskates (Who Put the Revolution on Ice?)*, was purchased for £48,000, over twice its reserve price. Now among the stable of artists looked after by the Lazarides Gallery in London's Soho, Banksy now finds his work avidly collected by Hollywood 'A-listers', professional collectors and buyers of contemporary art across the world. This is what Gareth Williams, a senior picture specialist for the auction house Bonhams, said at the time of a major auction of the street artist's work in 2007: 'The most incredible aspect of the Banksy phenomenon is... that as a self-confessed guerrilla artist, he has been so wholeheartedly embraced by the establishment he satirises. We are sure that this irony is not lost on today's buyers' (reported in Bannerman, 2007). You may wish to look back to the start of this section and the introductory quote attributed to Banksy from earlier in his career. The apparent irony of street art achieving the same cultural and artistic prominence of so-called more 'serious' art poses intriguing questions about the social and political role and expectations of contemporary visual culture in general. This is one of the issues that we will look at in more detail in Chapter 5.

Another aspect of land and environment art is as a catalyst for social and economic regeneration. Please look at Anthony Gormley's *Angel of the North* (Figure 4.4). Since its unveiling in 1998, Gormley (b.1950) has arguably become one of the best-known contemporary artists in the UK. Subsequent projects have included *Field* (40,000 small terracotta sculptures), which won the 1994 Turner Prize, *Event Horizon* (numerous sculptural figures arranged across London rooftops and skylines in the summer of 2008) and *One & Other* (using Trafalgar Square's Fourth Plinth for selected members of the public to self-exhibit for one-hour intervals over 100 days between July and October 2009).

The *Angel of the North* is situated on a hilltop abutting the A1 road and is adjacent to the London to Edinburgh East Coast mainline railway just outside Gateshead in North-East England. It is 20 m high with a 54-m wingspan, and made from 200 tons of steel and copper. Its exposed position demands resistance to wind

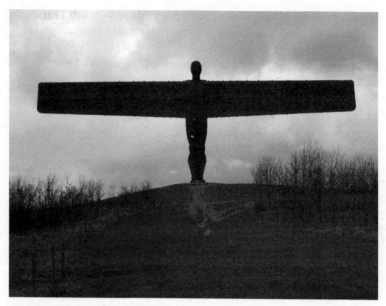

Figure 4.4 Antony Gormley, Angel of the North, 1994–98. Steel: 20 × 54 m (65.6 × 177.2 ft) Gateshead, UK. Photo: Graham Whitham.

speeds in excess of 100 mph. The rusted red-brown appearance of the work testifies to a decade of oxidization from atmospheric and environmental effects.

Looking at Figure 4.4 and considering the description of the work given above, how would you assess the relationship between the work and the surrounding environment?

▶ The scale of the work dominates the hill and, to some extent, the surrounding landscape.

▶ The giant figure stands out from the landscape, which is undulating and characterized by grass, bushes and trees (although there are houses nearby). In this sense, the work does not visually integrate with the landscape.

▶ The materials from which it is made have been affected by the natural conditions; rain, wind and pollution in the atmosphere (from the cars passing along the nearby A1 road, for example) have changed the patina (the surface of the work) from its original appearance.

Do you think the *Angel of the North* is an example of sculpture, installation or landscape art?

▶ It remains a point of discussion which of these forms best describes the work.

▶ It appears to be a monumental sculpture: its scale, materials, three-dimensional form and human-based subject might define it as such.

▶ While it may not be an installation in the sense of Claire Bishop's 'dream-like encounter in which the viewing subject is immersed', the Angel of the North *is part of the bigger natural environment and so might be regarded as an installation, perhaps one that 'accents bodily experience and response' (see Section 5 of this chapter).*

▶ Although the work fails to visually integrate with the natural environment, its presence in the landscape, like Heizer's Complex City *or Smithson's* Spiral Jetty, *has a sense of the sublime, noted earlier. Equally, it is outside the gallery, and the viewer has to make a special journey to see it (albeit not as arduous a journey as that required for the Heizer and Smithson works).*

The *Angel of the North* was commissioned from Gormley by Gateshead Council to stand on the site of a former colliery at Team Valley, on the southern approach to Tyneside. Its extended wings stretch over land that was once quarried and mined for coal, previously one of the North-East's biggest industries. This information about the work might lead you to consider it as having a social and even political significance. Moreover, as religious symbols, angels are messengers of God and agents of divine will and its execution on earth (Hall (1996), p. 16). As such, we might see Gormley's example as symbolic of north-eastern England's post-industrial rebirth after the loss of many of its regional industries such as mining, textiles and engineering in the 1980s and early 1990s.

The *Angel*'s spectacular size and wingspan might additionally suggest the role of guardian (angel) over the people and land of the North-East – angels were frequently depicted as protectors and stewards of the righteous. Traditionally, angels also had an

'annunciatory' purpose – they brought good (and sometimes bad) news to the recipient.

Despite a very mixed public reception when it was first erected, Gormley's work seems to have been taken to heart. Just before Newcastle United's Football Association Cup Final meeting with Arsenal in 1998, just after the *Angel* had been erected, a 30-ft replica of Alan Shearer's number nine football shirt was ingeniously hoisted by fans across the work, using weights and catapults. Like the example of Banksy's work being 'tagged' by others, this act of appropriation also suggests recognition, ownership and affiliation, which might be other characteristics that we can associate with land and environment art.

The *Angel of the North* underlines the extent to which environmental art, and much contemporary art in general, is perceived to have a wider cultural and economic role in regional regeneration and civic 'rebranding'. The success and recognition that Gormley's piece has brought to the area has been cited as one of the influences behind another large-scale example of environment art – Mark Wallinger's *White Horse*, which will be sited in North Kent's Ebbsfleet Valley, between Gravesend and Dartford in the UK.

In this section we have explored and discussed some examples of land and environmental art, considering aspects of the genre and some of the issues which it raises. Like the installation practice discussed in Section 5 of this chapter, it might be argued that the perceived popularity of large sculptures or environmental works is in part because they are intended to be 'relational' – emblematic of a desire for a broader audience and social engagement beyond the confines of the 'white cube' gallery space. They might also be seen to be adjusting to a contemporary desire for compelling (or at least diverting) visual spectacle within and across our urban and rural spaces.

In the case of street or graffiti art, it might be understood, at least in origin, as part of a desire for 'voice' and social recognition that

has both an individual and a more directly politicized dimension, something which we will explore further in Chapter 5.

One more aspect of contemporary art practice, which seems to be reflected within recent land and environment art, is the extent to which particular genres of art are becoming less distinct. So, for instance, we might see examples of work by Goldsworthy and Gormley as adapting and changing some of the conventional assumptions (size, medium and location) about what a sculpture is understood to be. In doing so, one artistic genre is combined with another, creating innovative, composite and 'hybridized' works of art.

Suggestions for further reading

Banksy, *Wall and Piece*, Century, 2006

Amy Dempsey, *Destination Art*, Thames and Hudson, 2006

Mel Gooding, *Song of the Earth: European Artists and the Landscape*, Thames and Hudson, 2002

Jeffrey Kastner (ed.), *Land and Environmental Art*, Phaidon, 1998

Michael Lailach, *Land Art: The Earth as Canvas*, Taschen, 2007

William Malpas, *Land Art: A Complete Guide to Landscape, Environmental, Earthworks, Nature, Sculpture and Installation Art*, Crescent Moon Publishing, 2007

Gary Shove, *Untitled: Street Art in the Counter Culture*, Pro-Actif Communications, 2008

Ben Tufnell, *Land Art*, Tate Publishing, 2006

THINGS TO REMEMBER

▸ *Land and environment art incorporates the existing landscape as an integral part of the work. As such it frequently denies the possibility of exhibition in a gallery space and often cannot be directly commodified and owned.*

▸ *Land and environment art is often conceived to be transient, impermanent and subject to change. Light, air, rain and time can ultimately alter and modify works of environment or land art, just as the hand of others can, because many works are in open and public locations. In this way, land and environment art might be seen to challenge the permanent and enduring nature we generally associate with art.*

▸ *Like examples of performance art in particular, land art has been heavily reliant upon photography to provide it with an element of durability and memorialization; this process may, in turn, be considered part of the aesthetic and exhibiting process, especially where the location or size of the actual example of land art may make visiting it in situ difficult.*

▸ *While each example has to be judged on its merits, land art has historical associations with the counter-culture of the 1960s and 1970s, and as part of more general critique of the social and cultural values that reduce land and nature as 'means' rather than as 'ends' in themselves.*

5

Themes and issues in contemporary art

In this chapter you will learn:

- *to recognize some principal themes and issues in contemporary art*
- *how art that engages with themes and issues might be approached and understood by the viewer*
- *how some contemporary artists communicate their views, ideas and perceptions of these themes and issues*
- *the ways in which contemporary art creates different perspectives of understanding, which stimulate and increase our awareness and insight.*

Introduction

The conventional genres and subjects that dominated art prior to the emergence of the avant-garde in the nineteenth century, such as historical, mythological and religious themes, landscapes, portraits and still life, were the result of historically established traditions often based on the taste of controlling institutions and powerful individuals. By the early years of the twentieth century the avant-garde contested this by creating unconventional art, such as Man Ray's *Gift* (Figure 1.2) or by eliminating the subject altogether, as with van Doesburg's, *Counter Composition XIII* (Plate 1).

By mid-century the classification of art by genre or subject became all but impossible and, as a result, a fairly pointless means of classification (see Plate 2 and Figure 1.1). However, rather than wholly dismissing subject matter and embracing Clement Greenberg's Modernist claim that it was irrelevant to art's purpose, status and quality (see Chapter 2, pp. 16–17), much contemporary art has done completely the opposite by focusing on content (what art is about) rather than form (how it looks). Refusing established subjects and genres, it engages with socio-political, economic, moral and cultural themes and issues.

We might understand themes as a set of unifying ideas about something and issues or things important to the individual and society at large that demand consideration, discussion and response. The themes and issues explored by contemporary artists are frequently associated with the conditions, circumstances and contexts of society or, put another way, of everyday life. While art has always responded to or engaged with everyday life to one degree or another, we would argue that art now is much more closely associated with it than at any previous time in history. This begs an important question about art's role and status that you might want to consider:

If contemporary art engages so closely with the themes and issues of everyday life, what distinguishes it from any other activity that reflects and comments on, responds to, or discusses these things? Another way of asking this question might be: what is art? or, at least, what distinguishes it as an activity different from any other?

▶ *If you look back to Chapter 2, p. 37, you can read Joseph Beuys's claim that everyone is an artist, and from this it follows that anything anyone does is art.*

▶ *On the other hand, we value art (both financially and culturally) above many other activities and so this idea may be too permissive for what we actually experience.*

So what makes art different and, arguably, important and meaningful?

> ▶ In our everyday lives we hear or take part in discussions about issues; politicians and pundits debate foreign policy or tax cuts on television and radio; conversations in the street, the supermarket, the pub and at home focus on the rise in crime, religion, the price of groceries, what is or is not art, and so on. Just like us, contemporary artists are concerned with those issues and circumstances that impinge on their lives and on society as a whole.
>
> ▶ However, unlike the greater part of media debate and our own day-to-day discussions, the nature of artistic practice often encourages distinctive ideas and views that rarely reiterate conventionally held attitudes, consequently providing us with a different and frequently critical perception. Reasons for this might range from art's avant-garde legacy to its essential independence from political control and the inherent individualism of artistic creation.

It would be simplistic to claim that the themes and issues with which contemporary art engages, has simply replaced genres, but our understanding of recent art benefits little from applying generic or subject categories. For example, the subject genre of Shirin Neshat's *Rebellious Silence* (Figure 3.4) is portraiture, specifically self-portraiture, but this is insufficient to advance our understanding of the photograph very far or reveal its meanings. However, the theme of the work might be identified broadly as religious belief and, arguably, this opens up a richer seam of possible interpretations. Anselm Kiefer's *Your Golden Hair, Margarete* (Plate 8) is a landscape but this tells us little or nothing about the painting's significance. Its general theme may be identified as the Second World War, which immediately provides us with avenues of exploration to tease out important intentions. The genre of Gary Hume's *Hermaphrodite Polar Bear* (Plate 12) is that of an animal painting, but the form of the picture may suggest concerns for visual beauty through the impact of flat shapes and colours, and the theme of aesthetic appreciation, with all that entails as possible celebration or parody of Greenbergian Modernist dogma.

However, a theme might connect with a raft of ideas and it would be misleading to believe that works of art are not capable of being interpreted from a variety of related positions. Neshat's photograph seems to be about more than simply religion; among its referents are the role and position of women in Islamic culture, implied violence, and the difference between the East and the West (see p. 72). Kiefer's painting is based on the poem *Death Fugue*, written as a direct response to the poet's experiences in Nazi labour camps, and so its themes may embrace man's inhumanity to man, racial and religious intolerance, and post-war German guilt (see pp. 75–76).

Hume's work might be comic, because the style is cartoon-like, but the painting makes reference to genital deformities of young polar bears, a consequence of chemical pollution in the Arctic that prevents them from reproducing (see pp. 211–212). You would probably consider this as an issue rather more than a theme. Equally, you might ascribe the issue of difference – male and female, Western and Eastern, Christianity and Islam – to Neshat's work, and issues concerning the legacy of history and genocide to Kiefer's painting.

Two things are evident from the examples given above:

1 *that themes and issues are interconnected and, sometimes, indistinguishable*
2 *that works of art are rarely, if ever, about one thing or, put another way, their meanings are various.*

In this chapter, we have identified three sets of themes and issues we consider to be important in art of the past 40 or so years. However, these categories are subjectively chosen, albeit based on our experience and understanding of contemporary art; given the task, other commentators may select different themes and issues, although, we would hope, not too different. Furthermore, our themes and issues are by no means definitive or discrete; they sometimes interrelate, displaying similarities and connections with each other. Equally, the works of art we have chosen to illustrate these themes and issues are not wholly confined to these categories, as you will see.

Section 1 Gender, sex and abjection

GENDER AND SEX

To be naked is to be oneself. To be nude is to be seen naked by others and yet not recognized for oneself. A naked body has to be seen as an object in order to become a nude.

(Berger (1977), p. 54)

John Berger's observation has itself become an iconic comment on the role of gender within the study of art history and visual culture. The distinction that he makes concerns the way in which the female body has typically been made an 'object' or fetish of the male gaze. Such interests were culturally rationalized through the popularity of the 'nude' as a major genre within Western art. These cultural and visual traditions, stylistically adapted by canonical figures such as Matisse and Picasso, have continued within some of the contemporary art practice of the twentieth and twenty-first centuries.

Although challenged within Western culture, it might be argued that representations of gender have not fundamentally changed,

but rather have been modified for contemporary purposes. For example, as discussed in Section 3 of this chapter, the fashion, cosmetics and advertising industries continue to objectify the female body and to exploit gender stereotypes for profit. But what do we mean by gender, and how might it be relevant to looking at and understanding aspects of contemporary art?

Gender, understood as a broader cultural definition of sexual identity, is one of the central, contemporary concerns of the developed and, increasingly, of the developing world. Although a person's sex is conventionally determined by biological and physical attributes, gender is associated with a looser range of socially based values, roles and expectations. But increasingly within contemporary Western cultures, gender and identity, rather than being fixed, are understood as 'performative'. That is, they are realized not just through our personal, social and professional roles, but are negotiated and explored through self-perception, experience and desire. This applies to all expressions of human subjectivity, gender and identity, whether heterosexual, gay, bisexual, transgender or transsexual. Some of these shifts and ambiguities, and the contradictions that underpin them, have been explored by contemporary artists. Although some of the broader cultural and political points will be discussed in the next section, it might be useful to consider a number of images which identify and explore aspects of these issues.

Please look at *What does possession mean to you?* (Figure 3.3) by Victor Burgin (b.1941) and the related discussion on pp. 111–113.

To begin with, how might you describe the arrangement and imagery of the work?

▶ *Image and text are centrally organized in a vertical layout. The rectilinear inset photograph of the couple repeats this layout, suggesting the formality of an advertising tableau.*

▶ *Our gaze is struck by dramatic visual contrasts between the black background, the white lettering and the white clothing of the couple.*

▶ *The font size of the two text sections is just sufficient to balance them with the central image – we encounter text and image simultaneously.*

Now look at the image of the couple and describe what you see.

▶ *The couple are cropped by the rectangular frame of the picture and so fill it, making them the only objects within the image.*

▶ *Both male and female are young; she has long blonde hair and wears make-up; each wears white.*

▶ *They are embracing. She leans towards him; he remains more upright. Her left hand lightly holds the back of his head and neck, her right tenderly touches his arm. His left hand is around her waist. Her eyes are closed and she rests her cheek against his while almost imperceptibly pursing her lips as though kissing him.*

▶ *The depth of the photographic field creates a sharp image; the cropping of the picture by the photographic frame makes us feel close to the couple; her closed eyes and their general obliviousness to our presence, situates us as a voyeur, looking across at them.*

What does this analysis of the image suggest about gender?

▶ *The most obvious thing here is that this appears to be a heterosexual couple. Their appearance, dress and posture all suggest this.*

▶ *On one level, there is male–female equality: each is the same height within the photograph, each takes up a similar amount of space, and each appears to show an equal amount of affection.*

▶ *Perhaps one might argue that she leans more towards him than he towards her; she is, in a sense, the one 'giving' and he might be regarded as the one accepting. You might see this as an example of gender stereotyping that reinforces the image's broader conventionality as a whole.*

This sort of iconographical analysis is useful in interpreting particular aspects of works of art. Of course, our focus here has been on gender and its representation. In order to establish a more holistic interpretation, it would be necessary to consider how this might relate to the other concerns with which the work engages. *What does possession mean to you?* is also about social class and economic issues and uses gender stereotyping to convey these.

As mentioned earlier (p. 112), a conceptual artist, photographer and writer, Burgin was commissioned by the Arts Council to produce

some images promoting an exhibition of contemporary art in Newcastle upon Tyne in the UK. As we will discuss in Section 3 of this chapter, in this example he used some of the conventions and production values of commercial advertising, including a stock agency photograph of professional models that employs studio lighting, make-up and poses. The text puns on the stereotypical ideas of sexual possession, exclusivity and desire, which are reinforced by the image of the embracing couple. Burgin then subverts this association by framing the question's response in terms of explicit social inequality and class hegemony. Although the poster has broader political and cultural contexts, Burgin uses some of the conventional techniques of gender presentation and bias in order to question and critique the very system of representation and the ideologies – or ways of thinking – which underpin it.

Burgin's explicit address to the viewer also recognizes another shift in the understanding of gender as it might be presented through art and other contemporary forms of visual representation. In 1975 the film theorist Laura Mulvey wrote the essay 'Visual Pleasure and Narrative Cinema' (in *Visual and Other Pleasures*, Macmillan, 1989), which has since been influential in focusing attention around the concept of the gaze, noted in Berger's opening quote.

Mulvey's essay discussed how representations of men and women within film and, by implication, visual culture more generally, could be explored and understood using psychoanalytic theory derived from Freud and Lacan. According to Mulvey, the onscreen objectification of women, both by the film's male characters and those within the audience, contributes to erotic fantasy. Secondly, the male viewer's identification with the film's principal male protagonists contributes to misleading self-perceptions, with implications for the future understanding of social roles, behaviour and expectations. Thirdly, the combination of the above contributes to a desire for sadistic control or agency over the female figure, resulting in the tendency to fetishize and so negate the female as an object.

Look again at the image in Burgin's work (Figure 3.3). While
you may not go as far as to summon up ideas about sadistic
control, fetishization and negation, you might think about
how the image is created to suggest the possibilities of fantasy
and identification with the protagonists.

Although films are, of course, a different visual genre to paintings
and sculpture, in some of the conventions surrounding the
representation of women there are, nevertheless, clear continuities
and connections. Why and how is this important and relevant
in looking at contemporary art more generally? As the cultural
theorist Margaret Olin has suggested (in 'Gaze', an essay in
Critical Terms for Art History, pp. 208–219), if we can understand
some of the manipulations behind the structuring of cultural
representations within films and works of art, then we can begin
to expose, identify and undermine their more negative effects and
consequences.

To give another example, the photographer and former graphic
designer and art director Barbara Kruger (b.1945) created a series
of works adapted into large billboards and based on imagery
appropriated from US advertising of the 1950 and 1960s (see
http://www.barbarakruger.com). In one, titled *We Don't Need
Another Hero* (1986), an admiring girl leans across to feel the
underwhelming biceps of a small boy who is clearly straining with
the effort of the impromptu demonstration. As with Burgin's *What
does possession mean to you?*, the title, presented as a centre text
strapline, undermines and questions the image's implicit gender roles.

Like Burgin and Kruger, other contemporary artists have explored
visual codes of representation but in respect of their own identity.
Cindy Sherman (b.1954) is an American photographer and
film-maker who initially made her name by reconstructing and
photographing, in black and white, a series of untitled vignettes
based on film noir and B-movie stills. Sherman used various social
and gender stereotypes, many of which implicitly touched on some
of the issues and readings offered by Mulvey and discussed earlier.

Please look at Cindy Sherman's *Untitled (No.224)*, 1990 (Plate 10). The photograph is from the 1989–90 *History Series* in which Sherman appropriated (that is, copying, quoting or creating a pastiche of an already existing work of art) the subjects of canonical paintings. In this case, using prosthesis, she presents herself in the form of Bacchus, the Roman deity of wine, as depicted by the Italian painter Caravaggio in the late-sixteenth-century, as we noted in Chapter 4 (pp. 109–111). Unlike some of the examples we have so far discussed, the artist is both the subject and artist, the performer and orchestrator of this image.

Keeping these facts in mind, how does it affect our response to the image?

▶ *In assuming the role of author, or auteur, as it often called in the French when used with reference to visual arts, Sherman effectively theatricalizes the process of representation. In doing so, she also assumes agency and control in the representation, or mis-representation, of her identity and gender.*

▶ *We might interpret both versions of Bacchus – Sherman's and Caravaggio's – as an implicit exploration of the artificiality of visual imagery, but in another way Sherman's is an adaptation and parody of the work of a canonical male artist.*

▶ *However, in considering the work as a 'gendered' image, you might think it more important to know that the painting is, in all likelihood, a self-portrait of Caravaggio, just as Sherman's photograph is a self-portrait; this might lead us to delve further.*

▶ *Caravaggio's painting was probably made when he was fulfilling commissions for Cardinal Francesco del Monte, a leading connoisseur and collector. A number of the paintings Caravaggio made for del Monte have a homoerotic feeling.*

▶ *Given this information, Sherman's image takes on an extra dimension, as it were. It is a portrait of a woman made to look like a man whose pose is, arguably, more stereotypically female than male and which may have allusions to gender ambiguity.*

▶ *There is also another layer of possible interpretation or metaphor here. Bacchus was symbolized as the deity of liberation, enabling escape from oneself either through wine or ecstasy. Sherman*

Insight

Increasingly, art registers the relationships between image,
viewer and creator. As with the earlier discussion of the
relational character of much installation practice (Chapter 4,
Section 5), contemporary art can be understood in the
context of the viewer's visual experience, gender and identity.
What it means (or can mean) to be a man, woman, gay or
transgender, is an experience determined by the culture and
environment in which people live and work.

**Please look at the reproduction of Shirin Neshat's (b.1957)
black-and-white photograph *Rebellious Silence*, 1994 (Figure 3.4).
How would you describe what you see?**

▶ *The head and shoulders of the subject fill the picture area; there is
 nowhere else to look.*
▶ *The deadpan formality and self-possession of the partially veiled
 subject suggests a staged portrait.*
▶ *The clarity of the black-and-white photographic medium has
 been used to dramatize contrasts between dress, text and the
 undifferentiated background to the female figure.*
▶ *The barrel of a gun bisects the face of the female figure, casting half
 into shade and vertically dividing the composition.*
▶ *Text has been drawn across the sitter's face.*

Rebellious Silence is a photographic self-portrait of the Iranian-
born artist Shirin Neshat and is part of her *Women of Allah* series
made between 1993 and 1997 (see also pp. 72–74). Neshat's work
makes extensive use of photography and video to document the
interface between gender, sexuality and Islamic culture. As Katrin
Bettina Müller notes of images within this series: 'The clothing and
weapons suggest both women's defence of Allah in the revolution
and their defence of privacy and chastity...there is a clear but

ambiguous contrast between defence and attack, secrecy and exposure, eroticism and aggression' (http://www.culturebase.net).

The calligraphy, employed throughout the series, is Farsi poetry by contemporary female writers; Farsi is the most widely spoken and one of the oldest Persian languages. The photograph's title, *Rebellious Silence*, and its subject matter variously suggest affiliation, constraint and self-censorship in negotiating the gender expectations of a traditional and largely conservative Islamic culture. The Farsi calligraphy, mediating the plurality of voice of contemporary women authors, also implies a further intercultural association; that of an historic Persian culture and its mediation through poetry, music and history by men – and women.

The sort of gender stereotyping we saw exploited in Burgin's *What does possession mean to you?* (Figure 3.3) and Barbara Kruger's work might make us think that gender assignment and sexual identity are definite and finite polarities. But this is not necessarily true. Herculine Barbin was recorded as having been born in France in 1838. She was otherwise unexceptional, but for the fact that she had both female and male genitalia. Barbin lived initially as a woman, before being designated male by legal authority. The late French cultural theorist Michel Foucault (see Chapter 3, pp. 71–72) has been one of several commentators who has mentioned Barbin's example in order to question the stability of sexual identity and the concept of the hermaphrodite body – that which exhibits, like Barbin's, the sexual attributes of both male and female.

In recent years, cultural theory and examples of artistic practice have explored and developed some of these ambiguities. For example, the 1990s saw the emergence of queer theory, which arose out of gay and lesbian studies. Annamarie Jagose (*Queer Theory*, University of New York Press, 1997) has suggested that queer theory can be used not only to question the old binary distinctions of sex and gender, but as a critique of identity per se. Other theorists have taken this further, rejecting the idea that there are any natural 'sexual configurations' at all (Phoca and Wright, pp. 104–7).

Consider the photograph *The Three Graces,* which you will find online at http://www.art-forum.org/z_Witkin/Ip/JPW_graces.htm, taken in New Mexico in 1988 by the American artist Joel-Peter Witkin (b.1939); how might this representation of transgender subject-matter affect our response to the image?

> ▶ *The Three Graces were frequent choices of subject matter throughout the Renaissance and Enlightenment, with painted and sculptural versions by artists such as Raphael, Rubens and Canova. In the western tradition, the three figures are represented as naked females who personify gracefulness, peace and happiness, although within Greek and Roman mythology they often embodied other attributes or qualities.*
>
> ▶ *The naked figures and their arrangement in the tradition of Western art provided Witkin with an opportunity to explore the genre of the nude against the culturally sanctioned background of mythological and religious imagery.*
>
> ▶ *However, although Witkin retains the subject's conventional compositional format of linking the three personifications, he uses black and white photography to suggest the patina or appearance of age, which references the tableaux's historic associations (see pp. 116–117); the photograph's use subverts the traditions upon which it is partially based.*
>
> ▶ *The image suggests that the naked or semi-clad bodies are presented and composed for the male gaze, but instead of the traditional female nudes, the artist depicts three masked pre-op transsexuals, each of whom holds the severed head of a monkey, a symbol of death, or memento mori (literally 'remember you shall die').*

Witkin has made a similar transposition in another work, *Gods of Earth and Heaven* (1989), derived from Botticelli's *Birth of Venus* (early 1480s). In other instances, he has substituted still life motifs (which reference death metaphorically), with actual cadaver parts. For example, his *Feast of Fools* (1990) is a transposition of *Still-Life with Fruit and Lobster* (c.1648–9) by the Dutch Baroque painter, Jan Davidsz de Heem.

**What do you think is the effect of the gender substitution in
The Three Graces?**

▶ *It might be suggested that Witkin subverts the genre and, with it,
conventionally fixed perceptions of what sexual identity
and gender actually mean. Rather, his image challenges accepted
social and cultural norms through the use of ambiguity and
visual difference.*

ABJECTION

Other works by Witkin (which can be found online at
http://www.zonezero.com/exposiciones/fotografos/witkin2) explore
the corporeal as subject, using whole cadavers or body parts which
are adapted for meticulously shot and processed photographic
tableaux. They may reference the idea of the human body as a
'landscape' of desire and spectacle, but often temper this with
a sense of abjection. The concept of the abject was examined
by the Bulgarian-French philosopher Julia Kristeva (b.1941) in
her essay *Powers of Horror* (1980) and has since influenced a
number of artists. In simple terms, the abject refers to aspects of
the body and related subject matter which challenge conventions
of public display and stereotypes of identity. As a concept, the
abject transgresses and threatens our sense of propriety and even
cleanliness.

More generally, the abject and the realm of ambiguity remain
significant themes within recent and contemporary art.
Practitioners as varied as Marina Abramović (see Figure 3.2),
Vito Acconci, Chris Burden, Jake and Dinos Chapman (see
Figure 5.2), Franko B, Gilbert and George, Eva Hesse, Rebecca
Horn, Robert Mapplethorpe and Andres Serrano have explored
transgressive and sometimes scatological iconography.

The contemporary British painter Jenny Saville has explored
the theme of transgender in figurative images such as *Passage*
(2004), in which the subject has prominent breasts and male
genitalia. In discussing this subject, Saville has suggested that

she was interested in exploring 'the idea of a floating gender' (http://www.saatchi-gallery.co.uk/artists/jenny_saville.htm).

Insight

The sexual ambiguity which is given representation here refuses conventional markers of gender difference and challenges the idea of binary oppositions which underpin them. Similarly, Saville might also be interpreted as questioning the exclusive gender associations which have historically defined the nude as an art genre.

The British artist Grayson Perry (b.1960) has also touched upon ideas of non-binary sexuality, not least because he sometimes dresses as 'Claire', his alter-ego. As a man who adopts the dress of a woman, we might classify him as a transvestite, but to further confuse the issue, he does not affect female mannerisms and behaviour and is happily married with a daughter.

Please look at Figure 5.1, *Golden Ghosts*, by Grayson Perry. What imagery do you see on the surface of the pot and how might you interpret it?

▶ *You may be able to recognize outlined images of melancholic children and behind them a landscape dotted with coffins. This is said to be a reference to the Chernobyl Nuclear Power Station disaster, although it is not obvious. The imagery is also apparently related to Perry's unhappy youth when he was rejected by his parents for his cross-dressing behaviour.*

▶ *Other outlined images, applied in gold, appear in various sizes overlapping and behind the images of the children. These are the 'golden ghosts' of the work's title and include images of Perry himself, dressed as his alter-ego 'Claire'.*

Perry's work is not exclusively about gender, but his adopted persona of 'Claire' and his public appearances dressed in extravagant female costumes (he accepted the 2003 Turner Prize wearing a dress decorated with hearts, flowers, rabbits and the words 'Sissy' and 'Claire'), make it difficult to disassociate his behaviour from what he makes.

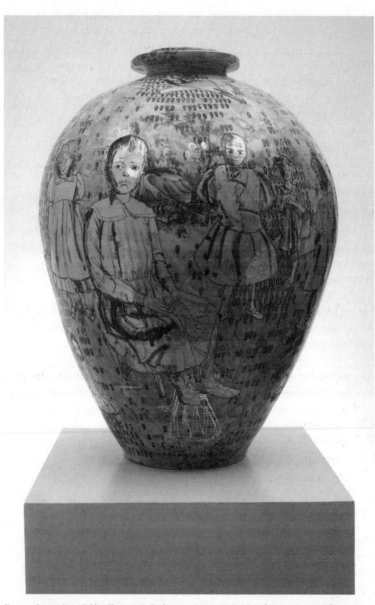

Figure 5.1 Grayson Perry, *Golden Ghosts*, 2001. *Earthenware*: 63.2 × 26.8 × 26.8 cm (24.9 × 10.6 × 10.6 in.). Tate Gallery, London.

Moreover, Perry is an artist whose work crosses the boundaries between conventional forms of fine art, such as painting and drawing, which have traditionally been associated with male creativity, and the crafts, traditionally associated with women. In making pots on which he draws, he can be said to be short-circuiting the once male-dominated discipline of drawing with a form often associated with women and the domestic.

Historically within the modernist avant-garde, there are critiques of the binary opposites of gender and the way they are stereotyped. However, more recent art has demonstrated greater reflexivity concerning issues of identity, gender and how forms of visual representation determine perceptions of 'normality'.

Suggestions for further reading

Carol Armstrong, *Women Artists at the Millennium*, MIT Press, 2006

John Berger, *Ways of Seeing*, Penguin, rev. edn 1977

Rosemarie Buikema and Iris van der Tuin (eds), *Doing Gender in Media, Art and Culture*, Routledge, 2009

Judith Butler, *Gender Trouble*, Routledge, 1999

Charlotte Cotton, *The Photograph as Contemporary Art*, Thames & Hudson, 2004

Kirstin Mey (ed.), *Art and Obscenity*, I.B. Tauris, 2006

Margaret Olin, 'Gaze', in Robert S. Nelson and Richard Schiff (eds), *Critical Terms for Art History*, University of Chicago Press, 2003

Gill Perry (ed.), *Gender and Art*, Yale University Press, 1999

Gill Perry (ed.), *Difference and Excess in Contemporary Art: The Visibility of Women's Practice*, Wiley Blackwell, 2004

Gill Perry and Paul Wood (eds), *Themes in Contemporary Art*, Yale University Press, 2004

THINGS TO REMEMBER

▶ *Iconographical analysis that explores a theme or issue in a work of art can lead to meaningful interpretation and understanding.*

▶ *Rather than understanding gender and sexuality as fixed and essential attributes, they can be understood as performative – realized through experience and negotiation.*

▶ *The cultural category of the abject has provided artists with subject matter that extends the basis on which we might understand the range and spectrum of human sexuality and desire.*

▶ *Issues of gender and identity should not be considered in isolation from other themes within contemporary art practice. Together with an increasingly globalized agenda, they contribute to broader cultural politics and an awareness of our increasing interconnectedness and interdependence.*

Section 2 Politics, difference and the global

POLITICS

I am not sure what my stand on lasting really is ... Life doesn't last; art doesn't last. It doesn't matter.'

<div align="right">(Eva Hesse, quoted in Nixon and Nemser (2002), p. 18)</div>

Regardless of whether particular art forms and their effects are finite, the conviction behind this book is that the realms of the aesthetic and visual culture are profoundly consequential. Aside from its intrinsic value, art is an expression of human consciousness, reflexivity and the experience of being in the world.

It might be argued that all of these have a 'political' dimension, understood less as the partisan affiliations of the ballot box and being allowed to vote periodically, but as the broader choices we make (and are made for us) in respect of our lives and the values of the societies and cultures in which we make them. In this, more expansive sense, we might understand the political as an integral part of human society; an expression of what and who we are, or might be. To use a phrase popular with the counter-culture and feminist debates of the 1960s and 1970s – 'the personal is political'.

The first part of this section is concerned with the idea and exploration of the political in its broadest sense in relation to selected examples of contemporary art, some of which we have explored elsewhere in this book but from a different perspective.

Casting your mind back to Chapter 2, you may recall that the original meaning of the 'avant-garde' had expressly political and social connotations. Taking this as a point of departure, it is plausible to construct a history of art from the 1850s onwards which is principally understood as an encounter with, and a response to, the dynamic conditions of an urbanized modernity and all that followed. As we have seen, the Modernist theory associated with the critic Clement Greenberg edited out the various avant-garde movements that emphasized figurative styles and narrative content, in favour of those strands which accented a supposed logic of radical abstraction, devoid of social meaning. However, as discussed earlier, the so-called 'historical avant-gardes' of the interwar years had been deeply engaged in the social and political realities of the period, as were the various 'neo-avant-gardes' of the

1960s and 1970s, although the challenges faced by that generation were very different.

Since then, many contemporary artists have continued to engage with subjects and narratives which have explicit political, social and historical dimensions. Please consider *Your Golden Hair, Magarete* (Plate 8) by Anselm Kiefer. We have already discussed an interpretation of this work in relation to some of the ideas of Roland Barthes (see Chapter 3, pp. 74–76) and its formal aspects have been explored in Chapter 4, pp. 84–86. Now we want to examine the political dimensions of the painting.

As we have noted, its title derives from Paul Celan's poem 'Todesfuge' or 'Death Fugue', written in 1945, a work which makes symbolic references to the Nazi genocide carried out at the Auschwitz extermination camp. Celan, who came from a Romanian Jewish family, escaped incarceration, although many of his family perished there. His poem uses two symbolic identities: the Teutonic-sounding name of Margarete with its Jewish counterpart, Shulamith. Four of the lines from one of the stanzas read:

> **death is a master from Germany his eyes are blue**
> **he strikes you with leaden bullets his aim is true**
> **a man lives in the house your golden hair Margarete**
> **he sets his pack onto us he grants us a grave in the air.**

<div align="right">(From Paul Celan: Poems, trans. Michael Hamburger,
Carcanet New Press (1980), pp. 51–3)</div>

The arch of straw on the surface of Kiefer's painting, discussed earlier as a formal element, seems to reference Margarete's Aryan identity while its symbolic placement in a barren landscape perhaps echoes both the destruction of war and the Nazi desire for *Lebensraum* – 'living space' that would allow the Aryan expansion eastwards.

Given this sort of background information, how might you now understand Kiefer's painting?

> ▶ You may feel that, like Celan's poem, Kiefer's painting is a symbolic representation. The inclusion of the painting's title written on the canvas seems to be a clear indication of this. The straw is an equivalent of blonde (Aryan) hair and the painterly brush marks could reference Shulamith's darker hair.
>
> ▶ Of course, both the straw and the brush marks also indicate landscape and, as we noted, might be a reference to the disastrous consequences of Lebensraum.
>
> ▶ The landscape is painted in strong directional brushstrokes that lead the eye into the distance, but the vigour of their application might be seen to suggest something else. Rather than a conventional perspective that creates depth, the effect is of the landscape rushing up to us with the straw and more chaotic brushstrokes in the foreground. If we read the painting in this way, and if it is a symbolic work, then this might be the past reaching into the present. This would require us to look further into the contexts of the painting.

Born in 1945, Kiefer belongs to the so-called *nachgeboren* generation – literally those born posthumously, 'after the death of the father', or those who came after the Second World War. The Holocaust and its legacy have remained deeply problematic subjects within Germany's post-war history. Although Kiefer has been accused of using counter-productive iconography and subject matter, in more recent decades this once taboo subject is at last being more widely discussed and acknowledged, with some critics welcoming his work as a form of cultural catharsis. They have seen it as an attempt to give expression to a suppressed history in order to effect a process of mourning, memory and healing.

Insight

Kiefer was the first contemporary German artist to be given a dedicated exhibition at the Israel Museum, Jerusalem, a major and symbolic recognition of his artistic contribution to the cause of Holocaust remembrance.

To continue this theme, please look at *Poppy Field* (Plate 5) by Sanja Iveković (b.1949). This work was part of Documenta 12,

the five-yearly art exhibition held in Kassel in central Germany (see Chapter 6, p. 246). We discussed the work (pp. 55–56) with reference to the opium trade, the Taliban and women's rights in Afghanistan, but now we want to consider it in a different context. Iveković planted her poppies in the Friedrichplatz in Kassel, an open square in front of the Fridericianum museum of art.

We considered Kiefer's painting in relation to the context of Germany's more recent history, but how might Iveković's work be interpreted in this context?

▶ *Like Kiefer's painting, this example might be understood as a work of symbolic re-inscription and re-appropriation. The Friedrichplatz was used for military parades and, in the 1930s, for National Socialist rallies. Thus, although* Poppy Field *is intended to comment on more recent events in Afghanistan, its location can also be seen to engage with German history.*

▶ *Moreover, the poppy is a traditional symbol of sleep and death. In the twentieth century it has become an international symbol of remembrance for those who have died in wars. Therefore, Iveković's work can be seen as a powerful emblem with varying connotations of war, death, remembrance and resistance, ideas reinforced by its location in a place where military and political events occurred.*

The events with which Kiefer and other artists engage raise broader questions about the drift and direction of modern history. Throughout the 1930s and 1940s the major competing ideologies of socialism, Soviet communism and fascism offered various world views and particular perspectives on 'correct' ways of living for their adherents. Some of these rested on arguments about supposed racial superiority and entitlement, while others were concerned with a belief in the subordination of the individual to the will of the 'collective' and the authority of the State.

All these ideologies employed art and visual culture, to varying extents, as forms of propaganda; that is, a means of communicating their doctrines and ideas to a wider audience. But regardless of

whether the ideology was politically extreme or a form of liberal democracy, it could be argued that many of the claims and promises made have proved to be illusory. The title of Victor Burgin's 1976 photograph with text 'Today is the tomorrow you were promised yesterday' (see http://www.artvehicle.com/ events/103) seems to crystallize a pervasive sense of scepticism which, for some theorists, has been the prevailing cultural and social ethos of recent decades.

This cultural malaise was the subject of Jean-François Lyotard's 1979 book *The Postmodern Condition: A Report on Knowledge*. Lyotard termed the various ideologies mentioned 'metanarratives' – that is, grand narratives or stories which, in offering a better world, had either simply not delivered, or at least were perceived as not having done so (see pp. 69–70). Many of these accounts had their origin in the civic ideals and promise of the Enlightenment, the period when human endeavour, rational philosophy and science appeared to offer a basis for a progressive and positive future.

To illustrate this and some related issues, please look at Figure 5.2. This mixed-media work is, in effect, a three-dimensional interpretation of one etching from a series called *The Disasters of War*, made by Francisco Goya between 1810 and 1820, portraying the atrocities in Spain during the Napoleonic Wars. In the original, Goya depicted the bodies of Spanish peasants mutilated by French soldiers and hung from a tree by way of warning to their compatriots.

The interests the Chapman brothers (Jake b.1966 and Dinos b.1962) have in the work and legacy of Goya is well documented, but why the particular choice of artist and work?

In order to find an answer, we need to understand something about Goya and the times in which he lived and worked. During the later eighteenth century, Goya was closely associated with Spanish liberals and secularists. Many of these writers, artists and freethinkers made an indirect contribution to the eventual direction of Spain's culture and the gradual rise of social ideas and values

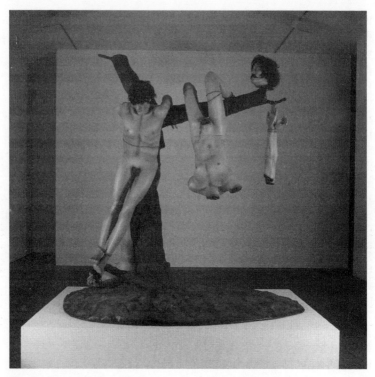

Figure 5.2 Jake and Dinos Chapman, Great Deeds Against the Dead. Mixed media 277 × 244 × 152.5 cm (109.1 × 96.1 × 60 in.). Saatchi Collection.

that were defined against the absolutist values of a previously hegemonic Church and monarchy. In this regard, and given the clearly humanist orientation of Goya's work as a professional artist, he is frequently seen as a champion of the Spanish Enlightenment.

However, the context of Goya's long life, which witnessed the monarchy's reactionary ideas and the Inquisition, along with other repressions practised by Spain's Roman Catholic Church, culminated in the French invasion of the Iberian Peninsula in 1808. This provided subject matter in direct conflict with Goya's progressive ideals and convictions and resulted in a powerful series of images depicting the brutality, slaughter and sadism of war and insurgency. In this regard, Goya's work has been described as 'disabused'; much of the slaughter he

documented and portrayed during the Peninsular War had been attributed to Napoleonic troops. Because France had been the cradle of Enlightenment ideas and Napoleon was an articulate and noted sponsor of Enlightenment rationalism, this was a depressing and disheartening betrayal of Goya's convictions.

How might we connect the above information with the iconography of Jake and Dinos Chapman's *Great Deeds Against the Dead*?

▶ *Interviewed on the subject of Goya and the iconography of their work, Dinos Chapman stated that 'Goya points out this removal from the state of grace'* (Newsnight Review, 2006).

▶ *In another interview, and acknowledging the contradictions which the artist had to face in his own time, the Chapman brothers made the point that Goya's work was a 'euphemistic jab at a certain kind of modernity'* (Front Row, 2006).

▶ *Seen in this respect,* Great Deeds Against the Dead *might be interpreted as a parody of Enlightenment values and a poignant comment concerning Goya's own credulity when faced with such barbarity.*

How might this now be understood in light of Lyotard's ideas about metanarratives?

▶ *The Chapman brothers are making serious and trenchant observations here about the viability of contemporary claims to the ongoing project of the Enlightenment. In other words, to what extent, and how often, do the high-sounding claims made by this or that ideology actually deliver? For example, as a reader of this book, do you believe that the manifesto pledges habitually made by political parties will ever really be delivered? Interviewed in 2003 by Jonathan Jones on the subject of Goya, scepticism and metanarratives, the Chapmans noted: '…then you hear George Bush and Tony Blair talking about democracy as though it has some kind of natural harmony with nature, as though it's not an ideology'* (quoted in Jones, 2003).

Although *Great Deeds Against the Dead* takes this point to extremes, it remains a provocative parable about realpolitik and the ambiguities of 'enlightenment' and ideology.

Although we have used one particular example of contemporary art to reference this point, many could have been chosen. Keeping this in mind you might want to look at Marina Abramović's (b.1946) *Balkan Baroque*, 1997 (Figure 3.2). You might want to refresh your memory about the contexts of this work by looking back to pp. 56–58, and then think about its possible meanings in relation to the above discussion and, indeed, in the light of the following paragraphs.

In the aftermath of the collapse of the Berlin Wall and the disintegration of the Soviet Union, one sound bite widely touted by Western European politicians was the idea of the 'post Cold War peace dividend'. The idea was that, because the liberal Western democracies had in some way 'won out' against the irrational forces of repression and totalitarianism, there would be a new age of relative consensus and stability. For example, a widely read and influential book at the time was *The End of History and the Last Man* (1992) by the social economist and historian Francis Fukuyama (b.1952). According to Fukuyama's thesis, the dominance of liberal capitalism and a free market economy symbolized the culmination of the post-Enlightenment (one of Lyotard's 'metanarratives') and was the best that could be realistically hoped for. Implicit in this thesis seemed to be the idea that the rest of the globe was keen to emulate this particular model of how to live and, indeed, what to live for.

Although Fukuyama's thesis was not a blanket apology for liberal capitalism, his views were adopted by some as an intellectual justification for the kind of prosaic and simplistic statements such as the one above, which were widely reported in the heady aftermath of 1989. Subsequent events and historical distance have cast a cold eye on the optimism of this political and cultural moment. For example, the disintegration of Yugoslavia and the ethnic genocide which followed, the intervention and insurgency in Iraq and Afghanistan, and events in Pakistan, Iran, Rwanda and Somalia, suggest a rather more complex and fluid reality. We might think that it is one in which the ideological assumptions of Western Europe and North America, may, or may not, be enthusiastically shared across the world. But more of that in the final part of this section.

So far we have looked at examples of contemporary art work
which, in various ways, have made social or cultural points which
concern broader ideas, beliefs and values. In these particular
examples, the artist either intended the work to be exhibited within
a gallery space or at an agreed institutional or environmental
location (Iveković's piece for Documenta 12 is an example of the
latter). Whatever the apparent meaning and stated intentions of
these examples, they did not include opposition to the art world's
mechanisms of promotion, display and sale.

In previous chapters, we have discussed Banksy's *Yellow Line
Flower* (Figure 4.2) in a variety of contexts but now we want to
look at it in relation to social and political issues.

**In what sense do you think graffiti or the broader genre of
environment art might be understood as an engagement with
social and political issues?**

▶ *You might see graffiti as a form of vandalism and so a social issue
in terms of its 'unsocial' status and 'political' in that it is a crime to
deface public places.*

▶ *However, this is what Banksy writes in defence of graffiti in the
preface to his book* Wall and Piece:

*The people who truly deface our neighbourhoods are the
companies that scrawl giant slogans across buildings and buses
trying to make us feel inadequate unless we buy their stuff. They
expect to be able to shout their message in your face...but you're
never allowed to answer back. Well, they started the fight and
the wall is the weapon of choice to hit them back.*

(Banksy (2006), p. 8)

(Contd)

▶ An explicit opposition is being suggested here between the officially sanctioned presence of the consumer industries and their colonization of public and urban space, and the refusal of graffiti which is not concerned with profit, but with asserting 'voice' and presence of a different kind.

The refusal of the blandishments of the advertising and commodity industry recalls one of the earlier strategies used by a strand within the neo-avant-garde of the 1950s and 1960s. The Situationist International or SI (see p. 38) was the name given to a grouping of artists who developed innovative and highly experimental forms of practice intended as a critique of capitalism and the cult of consumption. In particular, the SI sponsored forms of art, such as the happening, performance, statements, 'transient texts' and 'urban journeys', which were deliberately difficult for the art world to commodify and to sell.

In particular, the SI favoured two devices: the *dérive* and the *détournement*. The *dérive* corresponded to the idea of an informal journey or passage through an urban space, a kind of impromptu journey. The *détournement* was the term given to the re-use or adaptation of existing artistic elements or structures. Both of these devices were conceived as contributing to a subversive and potentially revolutionary consciousness.

Although we are not suggesting that Banksy, or indeed other environment or land artists, share this particular agenda, there are implicit points of connection between the two types of practice.

Looking again at *Yellow Line Flower* and Banksy's statement, what do you think these might be?

▶ *To make the obvious point, graffiti like* Yellow Line Flower *makes impromptu and illicit use of existing urban surfaces – walls, pavements, bridges, road signs and so on. This is similar in spirit to the SI concept of the* détournement.

> ▶ We conventionally encounter graffiti in our journey through, and negotiation of, urban spaces. Although this tends to be more functional and practical than the SI had in mind (commuting, shopping, driving, etc.), it might be argued that what we encounter on the way can play its part in our residual consciousness and mindset.
>
> ▶ The reference to corporate advertising in Banksy's quote suggests an awareness of how commercial interests and the remorseless spectacle of endless consumption, despite the patently finite nature of everything, keep the show on the road, so to speak.

There is some more discussion of these ideas in the next and final section of this chapter, and you may wish to return to what has been said here when you come to them.

In the first part of this section, we have taken an open-ended view of what the political might mean – the cultural values, issues, ideas we hold, and the broader social context, institutions and environments in which we make and experience them. It might be argued that some of the most challenging and innovative contemporary art is that which offers indirect and sometimes quite lateral perspectives on these concerns. In doing so, it may not suggest or provide easy answers or, indeed, any answers, but rather, it may prompt us to rethink who, what and where we are.

DIFFERENCE AND THE GLOBAL

The postcolonial today is a world of proximities. It is a world of nearness, not an elsewhere... the very space where tensions that govern all ethical relationships between citizen and subject converge.

(Okwui Enwezor quoted in Jason Gaiger and Paul Wood (2003), p. 321)

What does globalization mean to you? Cheap holidays, international cuisine, the assurance that wherever you travel, there will be recognizable brands, languages, customs and somewhere to charge your mobile phone? Perhaps even the possibility that throughout the world there is a creeping homogeneity or sameness between cities, countries and the ways in which people live?

To risk the cliché, the world appears to be getting smaller, but there is also a sense that our fates, from Sub-Saharan Africa to the land masses of Asia, Europe and the Middle East, are interconnected in ways that are both tangible, invisible and yet to be fully realized.

To give an example, even before the near collapse of the international banking system throughout Europe and America in 2008–9, the People's Republic of China had been discretely taking up large trading positions in dollar currencies. This was in addition to sealing extensive land deals and securing commodity extraction rights throughout Africa and elsewhere in the developing world. Since then, China has played a major part in underwriting the American economy's burgeoning capital and trade deficit. Where once the elites of the old imperial powers redrew the borders of colonized countries on maps with a ruler and some gunboat diplomacy, new economic, political and technological realities are refashioning and re-ordering the world in front of our eyes.

So what does globalization actually mean and signify? Although it may seem a nebulous term, it might be understood as the increasing integration and interconnection of trade, technology and communication across the world. As a pervasive feature, perhaps *the* defining feature of the postmodern, globalization has become especially apparent since the 1940s and 1950s with the diminishing territorial status of the old imperial powers – the United Kingdom, France, Germany, Russia, Spain and the United States. The collapse of the Berlin Wall, along with the break-up of what had been the Eastern Bloc and the partial dismemberment of the Soviet Union's former territories, can be seen as having accelerated the process of global integration and the sense of nearness and proximity recognized by Enwezor's observation. Closely linked with globalization is the associated idea of the post-colonial or the post-imperial, characterized as the attempts of previously colonized peoples and countries to secure equal status and parity of treatment with Western economies and societies. This process, apparent since the 1940s, is ongoing and its full consequences have yet to be realized and understood.

Globalization, and the reach of communications technology which it has facilitated, has had other, perhaps unintended consequences. We know, for example, that the Inuit way of life is threatened by the spectre of climate change and the Arctic's receding ice. We also know that in the next half-century or so (the timescale has been revised down several times), a proportion of the densely populated land masses in the southern hemisphere will be submerged beneath rising sea levels, resulting in massive population shifts and displacements. There is, of course, an international political dimension to this. In the short to medium term, the realities of global warming and climate change will, to some extent, be cushioned by the relative affluence of the economies of the northern hemisphere and some of the positive effects of globalization. It will be the developing and underdeveloped economies which will feel the immediate consequences of these changes. In the long term, unless the global community acts decisively, the prognosis for humankind and much of the Earth's flora and fauna is bleak.

In July 2009 a series of previously classified images taken by US military spy satellites were realized by the Obama administration. Recorded between July 2006 and July 2007, they graphically show the disappearance of the summer ice cover in the Chukchi Sea, just off the port of Barrow in Alaska. The loss of ice in the high latitudes confirms the accelerating effects of global warming and one of the negative effects of globalization; what happens in one part of the hemisphere inevitably impacts somewhere else.

Please look at *Hermaphrodite Polar Bear* (Plate 12) by Gary Hume (b.1962). How might you characterize this image?

▶ *At first glance it is a humorous image, completed in Hume's trademark bright colours with a fish-eye view of the Arctic carnivore painted in a simplistic, cartoon-like style.*
▶ *Its colours, simplified shapes, stylized representation and the way it fills the picture area seem to indicate that the image is intended to be amusing and even comical.*

But if you refer back to the Introduction to this chapter (p. 184), you will see that there is a darker subtext to the image. To expand on this, between 2003 and 2005 the Cape Farewell organization, established by the artist David Buckland, undertook three expeditions to the Arctic's Svalbard archipelago. Hume accompanied Cape Farewell's first 'Art & Science Expedition' in order to explore some of the effects of climate change. Among the findings was the increased volume of pollutants and toxic chemicals from Europe and North America that end up in the various ocean currents surrounding the Arctic. These are ingested by the polar bears, causing hormonal change and damage to the genital system which prevents the animals from reproducing.

Now look again at Plate 12 and think about why Hume has used this style to represent such a distressing issue.

▶ *In one stylized and simple image, Hume conveys a sad message about how humankind's thoughtless actions continue to impact upon the planet's biodiversity. The apparently comical image, with its appealing colour and cartoon-like appearance, operates in an ironic way. We are used to seeing animals represented in this stylized manner in animated films and children's book illustrations, and this masks the reality of their actual existence. Hume has adopted this convention, creating a paradox between humour and seriousness and so reinforcing his message.*

Insight

More immediately than the issue of pollution and its effects on the polar bears, the animals rely upon the ice shelves as platforms for living and hunting; once the ice is gone, they will starve.

The fact that pollution is happening in the previously untouched and undamaged expanse of the Arctic links back to the theme of our interconnectedness, not just as a species, but through the effects of globalization and international patterns of consumption, to the animals and plants with which we share Earth's finite resources.

So what have globalization and the post-colonial to do with contemporary art?

As with everything else, and as we shall see in the last chapter, the art market is already highly internationalized. In many respects it offers a pattern or a 'paradigm' of a globalized, lucrative and lightly regulated business. But how are these realities registered by contemporary art and artists?

Please look at *Dream* (Plate 4) by Romuald Hazoumé (b.1962). As explored on pp. 53–54 and pp. 163–64, this installation references the kind of makeshift crafts which are frequently used by those seeking a sea route out of the poverty of their country or personal circumstances to a better life in the West, hence the work's title. Of course, patterns of migration are not new. For example, the UK has been a nation of migrants since the land mass detached itself from the larger continental shelf at some point in prehistory. Similarly, North America is famously a nation of ethnic and cultural diversity, attributes which have driven its economic, cultural and political supremacy.

However, it could be argued that globalization and the effects of decolonization have accelerated this process, rendering it pervasive and constant. The process of diaspora, a term initially applied to the dispersal of Jewish peoples, is now used generally to describe the movement and migration of peoples, often forced, from the places of their birth to other countries and continents. Symbolically, the form and appearance of Hazoumé's *Dream* also references one aspect of this process directly – it is made from black oil cans used for smuggling fuel in the artist's homeland, Benin. This thriving, illicit market underlines the harshness of the country's economic conditions.

Looking at Plate 4, how do you think Hazoumé has used irony?

▶ Like Hume's *Hermaphrodite Polar Bear*, *Hazoumé's* Dream *employs irony to help make its point. In this case, the installation's backdrop suggests an idyllic beach setting, the sort that many of*
(Contd)

In *Orientalism* (1978), the late Palestinian academic and writer Edward Said outlined how the West had historically developed the idea of the Orient as the 'other' in order to reinforce and reassert its own sense of identity. Since the eighteenth century this idea of 'otherness' and difference underpinned the imperialist outlook of the Western powers, being used to determine and justify the subordinate status of colonized countries and their 'subject' peoples. The repressive logic of this relationship and the denial of voice of those colonized, whether men or women, was the subject of another iconic essay by the Indian critic and theorist Gayatri Chakravorty Spivak, the pointed title of which was 'Can the Subaltern Speak?' (originally published in 1988).

Even in the nineteenth century and the subsequent period of modernism, canonical figures such as Delacroix, Matisse and Picasso sustained the 'Oriental' stereotype through the depiction of the exotic female nude and the cult of 'primitivism', which was essentially a European take on how to homogenize and eroticize 'difference' for a white, principally male audience. Fredric Jameson, in his book *Postmodernity, or the Cultural Logic of Late Capitalism* (1991), has linked this and related phases of modernist art with the dynamic of international capitalism, the period in which the European powers were asserting power over their colonies and peoples. Both Said and Jameson have identified the West's historic relationship with the East – and with the rest of the globe – as one of appropriation and hegemony.

We can also recognize similar biases and exclusions within the history of art as an academic discipline. As a subject, it grew out of the Enlightenment and the cultural practice of the Grand Tour. By and large, until well into the twentieth century, its principal focus was the Western canon of art making – primarily

based around Italy, Greece and Northern Europe. In turn, this established powerful norms, traditions and exclusions, evident in Ernst Gombrich's account *The Story of Art* (1950). As you can guess from the title's use of the definitive article, what is implied and offered is a Western metanarrative on great 'male' artists. Interventions by Said and other important cultural theorists such as bell hooks, Homi K. Bhabha and Spivak have been instrumental in refashioning the cultural framework, not just for art history but, more importantly, the overall context in which contemporary art is created, displayed and discussed.

In the face of the increasingly complex and fluid realities briefly sketched earlier, the politics of globalization suggest the need for greater international co-operation, reliance and inter-governmental collaboration on a scale larger than ever. One of the characteristics of much recent and contemporary art in this respect is the extent to which its makers foreground or visualize, either directly or tacitly, some of the cultural and ideological differences and challenges that characterize the political landscape of the early twenty-first century.

Please look at Figure 3.4, Shirin Neshat's (b.1957) photograph *Rebellious Silence*. Given some of the West's historic and contemporary characterizations of Islamic culture, how would you interpret the image? You may want to refer back to pp. 72–74 and pp. 191–192.

▶ *On one level, Neshat's photograph self-consciously parodies historic Western perceptions of Islamic and Eastern culture as the 'other'. The concealment of much of the body by the traditional* hijab *connotes the particular and arguably fetishized status of women within Islamic culture.*

▶ *More stereotypically perhaps, the dramatic contrast of the partially concealed face suggests mystery, allure and difference, familiar stylistic devices within Western modernism and the genre's objectification of women.*

But these are deliberately contrasted with devices which suggest other, potentially conflicting readings.

How has the artist achieved this?

▶ *Neshat directly returns the spectator's gaze in a way that almost challenges it.*

▶ *The inscription of Farsi text by women authors suggests points of difference between and within non-Western cultures (in this case, that of ancient Persia and Islam) rather than conflating and homogenizing difference for the sake of the simple, binary descriptor – 'non-Western'.*

▶ *The paradox of the title and the iconography of the gun, summon up the spectre of 'radical Islam', while simultaneously suggesting the subject's refusal of patriarchal culture and of a militant Islamic world view.*

Insight

It might be argued that in visually dramatizing these cultural ambiguities, Neshat alerts us to the historic (and perhaps ongoing) failure of simple Western and non-Western categorizations within today's increasingly globalized order where difference is so proximate and yet so frequently contested.

In closing this section, please look again at Hazoumé's *Dream*. The installation was exhibited at the Kassel Documenta 12 in 2007. Established in 1955, the founding aim of Documenta was to reconcile 'German public life with international modernity and also to confront it with its own failed Enlightenment' (http://www.magazines.documenta.de/geschichteo.html?&L=1). On each occasion the *Documenta* is held, an international team of curators meet to agree a particular framework or focus for their selection. In 2007 the following questions were set for the *Documenta*:

▶ *Is humanity able to recognize a common horizon beyond all differences?*

▶ *What do we have to learn in order to cope intellectually and spiritually with globalization? (http://www.magazines. documenta.de/geschichteo.html?&L=1)*

These issues and questions are beyond the scope of art to resolve and, for that matter, for us as individuals acting alone. But

contemporary art does have an important part to play in extending our social, cultural and environmental consciousness and for providing perspectives and a sense of orientation within the world.

Suggestions for further reading

Diana Crane *et al.* (eds), *Global Culture: Media, Arts, Policy and Globalization*, Routledge, 2002

Jonathan Harris (ed.), *Globalization and Contemporary Art*, Wiley Blackwell, 2010

Catherine King (ed.), *Views of Difference: Different Views of Art*, New Haven CT and London, 1999

Gill Perry and Paul Wood (eds), *Themes in Contemporary Art*, New Haven CT and London, 2004

Edward Said, *Orientalism*, Penguin Books, London 1978

Gayatri Chakravorty Spivak, 'Can the Subaltern Speak?', in Cary Nelson and Lawrence Grossberg (eds), *Marxism and the Interpretation of Culture*, University of Illinois Press, 1988

Julian Stallabrass, *Contemporary Art: A Very Short Introduction*, Oxford University Press, 2006

Brandon Taylor, *Art Today*, Laurence King Publishing, 2005

THINGS TO REMEMBER

▶ *Contemporary and recent art can communicate social and political meanings in ways in which are both direct or more mediated and oblique.*

(Contd)

> ▶ *In recent decades some of the established ways of looking at the world and its values have become discredited. Contemporary artists have also explored and given expression to this sense of scepticism, challenge and possibility.*
>
> ▶ *To paraphrase Karl Marx, the various parts of the world are interconnected and interdependent in ways which are both tangible and seemingly invisible. This is all the more so in relation to the contemporary, in which our interdependence has been made more apparent by globalization and post-colonial politics.*
>
> ▶ *Many artists make work which explores and comments upon some of these relationships and interconnections, and which provokes our response to the realities and challenges of these changing and dynamic conditions.*

Section 3 Popular culture, the media, celebrity and consumerism

POPULAR CULTURE AND THE MEDIA

When the artists Richard Hamilton and John McHale, together with their architect colleague John Voelcker, created an exhibit for the 1956 show *This is Tomorrow*, they made explicit reference to cultural forms that were generally regarded as outside the conventional concerns and interests of art. Their use of imagery from films, advertising, mass-circulation magazines and the sound of popular music of the day, which was played on a juke box to the left of the structure illustrated in Plate 2, were not the stuff of art exhibitions. While this was by no means the first example of art drawing its inspiration from popular culture and consumerism, since a number of Picasso's pre-1914 collages used such material, as did work made between the wars by Raoul Hausmann, Stuart Davis, Gerald Murphy, René Magritte and others, *This is Tomorrow*

acknowledged that cultural forms created for a mass audience were beginning to establish themselves as significant aspects of modern Western life.

Although the advent of mass production was initially associated with the Industrial Revolution of the eighteenth and nineteenth centuries, it was during the twentieth century that the purchase of material possessions became central to perceived satisfaction and happiness for significant numbers of people. Equally, the nature of popular culture was transformed from what were essentially vernacular customs and practices to mass audience participation, the result of new technologies that had given rise to films, radio and television programmes, Internet websites, glossy magazines, recorded music and, more recently, podcasts and interactive games on Wii and other screen-based technologies.

The relationship between a technologically driven mass culture and consumerism is fundamental and the two have become increasingly difficult to separate as they form a substantial part of everyday life in many countries of the world. Similarly, the distinction between art and consumerism has become increasingly blurred (see Chapter 6), although there is no inherent connection between mass culture and art. Until relatively recently, art was a cultural phenomenon separate from popular visual forms such as television, film, advertising and magazine imagery, although at times art might draw upon such things for its sources and inspiration. But as our culture became more concentrated and dependent on the media of mass communication, some artists engaged with this and related themes. Most notable were the mid-twentieth century Pop artists. Roy Lichtenstein's paintings appropriated the style and imagery of comic books; Andy Warhol reproduced consumer products such as Campbell's soup and explored the phenomenon of media-created celebrities like Marilyn Monroe; Derek Boshier's pictures examined the influence of advertising; Peter Blake's celebrated pop music; Claes Oldenburg created pastiches of manufactured items sold in downtown New York shops (see Chapter 2, pp. 28–29).

For commentators such as Clement Greenberg, popular culture was contemptible because it threatened high culture, and Pop Art, they argued, demonstrated precisely this. Modernists like Greenberg believed the distinction between popular culture and art was oppositional, one at the top of cultural attainment, the other at the bottom, and that the two should remain separate. But since the emergence of Pop Art, it seems that this 'high and low' view might have become rather obsolete, especially as many contemporary artists draw freely on the mass culture of the media. But we should examine this claim because, if it were true, how do we distinguish between something we call 'art' and something we might not label 'art', such as a television programme, a computer game, a feature in a glossy magazine, or a movie?

Please look at Plate 3, an image taken from the film *Cremaster 1* by Matthew Barney (b.1967). Why do you think this is in a book about art?

> ▶ *There are two straightforward answers to this question: Barney does not consider himself a film-maker but an artist who makes films, and Cremaster 1 is not shown 'at a cinema near you' but in art galleries and at specialist film festivals.*
>
> ▶ *Although it is not clear from Plate 3, Cremaster 1 does not follow the conventions of popular films. A synopsis makes this clear. In a football stadium, chorus girls position themselves under the direction of Miss Goodyear, a starlet who lives simultaneously in two blimps floating above. She arranges grapes in diagrammatic configurations of cells splitting and multiplying, a barbell and reproductive organs, which are then duplicated by the positions of the girls on the football field below.*

While *Cremaster 1* draws on traditions of more conventional films, such as the intricate choreography of Hollywood starlets in Busby Berkeley's *Dames* (1934) and Nazi supporters in Leni Riefenstahl's *Triumph of the Will* (1934), and while it has an array of lavish costumes, a cast of over 60, an original musical score, and 3D graphics animation, its conception and form exclude it from popular consumption. Such detachment from popular cultural

forms, although drawing on them for inspiration, characterizes Lichtenstein's paintings, Oldenburg's pastiches of manufactured items, and installations like that illustrated by Plate 2, as much as it does Barney's films.

With an evolving popular mass culture in the twentieth century, art began to distinguish itself as elitist, frequently esoteric (see Plate 1), and even superior. As the century progressed and some artists became increasingly fascinated with the mass media, it seemed that art was abandoning its elevated position and embracing popular forms, as Plate 2 and Pop Art illustrate. While this may have been true, it is important to understand that it always remained art, something beyond and, arguably, above popular forms. Contemporary art shows no lessening of the fascination with mass media and popular culture, although it continues to maintain a critical scepticism of the way media manipulates, controls and influences.

Paul McCarthy's (b.1945) *Caribbean Pirates* installation (Figure 4.1) is a pastiche of the theme park ride replicated in California's, Tokyo's and Paris's Disneylands and of the films inspired by these rides. One commentator noted that it was:

> ...like visiting a theme park, but one that has gone dreadfully wrong...turning [entertainment] on its head...It presents the dark side of the Caribbean myth. There's all sorts of debauchery and violent behaviour going on – people's limbs being cut off, ketchup splattered everywhere. It's very gory. There are orgies and battles.

But, he added:

> ...it is clearly influenced by the US invasion of Iraq...some of the scenes in Abu Ghraib, the abuse of prisoners. There's a serious element to it as well as slapstick and farce.

(Arendt, 2005)

Caribbean Pirates has provoked criticism and even revulsion, but it does make a point about art's relationship to mass popular

culture. Arendt remarked that it turned entertainment 'on its head', implying that it was not a work necessarily meant to entertain, at least in the way a Disneyland ride or a Hollywood movie might. Moreover, he made a connection between it and the mistreatment of prisoners after the Second Gulf War. From this we might deduce that art does not have the same role or serve the same purpose as popular culture, but we might suppose it has 'something to say' in a way that can offer us a different perception than that which we would expect from newspapers, magazines, television and online sources.

McCarthy's parody of a theme park ride with apparent references to the injustices of Abu Ghraib prison in 2004 was, in some ways, paralleled in the 2007 exhibition *People Like War Movies* by New York artist Jonathan Horowitz (b.1966). One exhibit, a video entitled '*58 / '93* is a montage of scenes depicting Elvis Presley, beginning with him in the US army in 1958, posing for photographs and watching a Hollywood war film, and ending with him, overweight and sedated by drugs, performing on stage in Hawaii in 1973. Intercut with these scenes are clips from the 2003 film *Black Hawk Down*, which relates the story of an American soldier nicknamed Elvis, killed in the disastrous 1993 US operation in Somalia. '*58 / '93* suggests that war is legitimized by popular culture or, equally, that there is little difference between watching the realities of war and its Hollywood doppelgängers, an idea that the working popcorn machine at the entrance to *People Like War Movies* seems to reinforce (see http://www.frieze.com/shows/review/jonathan_horowitz).

Daily News, a work by the Polish-born artist Aleksandra Mir (b.1967), illustrates a similar artistic strategy to both McCarthy's and Horowitz's work in its appropriation and pastiche of established popular forms, but her work has a different purpose. In 2002 Mir invited 120 friends to contribute articles, images and any other type of content found in the tabloid newspaper format to a self-published newspaper called *Daily News*, which was then printed in an edition of one thousand copies.

On one level, *Daily News* was a celebration of the artist's birthday on 11 September 2002, exactly one year after the terrorist attacks on New York and Washington, DC. But it was more than this; Mir noted: 'I am not looking for any rehash of what the media has produced and served us, but for stuff that fell through the cracks or took off on its own' (www.aleksandramir.info). This indicated that the project also contested the media's control of news; the personalized content of *Daily News* questioned the media's monopoly of what was worthy to be considered news. Implicit in this was a critical scepticism of the media's power and control; we are 'fed' news which may or may not interest, affect or be of significance to us as individuals simply because the media communicates to the mass. This, Mir's work might suggest, negates our individuality and denies our voice (see http://www.frieze.com/issue/review/aleksandra_mir2).

CELEBRITY AND CONSUMERISM

The media's propensity to manipulate and influence is at its most blatant in advertising and contemporary artists have often engaged with this. As we have seen in Chapters 3 and 4, Victor Burgin's (b.1941) *What does possession mean to you?* (Figure 3.3) appropriates the language of advertising in order to subvert its customary purpose of persuading us to buy something. Because this work was reproduced in an edition of 500 and then posted on city street billboards, it further confounds distinctions between art, advertising and consumerism.

What do you think distinguishes Burgin's *What does possession mean to you?* from magazine and poster advertising?

▶ *In its form and visual content, Burgin's work differs little from the sort of magazine advertisements and posters one might have seen in the mid-1970s. However, the text is far from typical. The intention is not to sell us anything but rather to ask a rhetorical question and supply a statistic. It would be difficult to think of an advertisement that promotes the inequality of wealth distribution.*

(Contd)

> ▶ *The distinction between Burgin's* Possession *and commercial advertising is embodied in their different purposes. Free from the aspirations of manufacturers and advertising agencies to sell a product, Burgin uses their language to communicate a message redolent with social significance and political implication. Whether you think this is the role of art depends on your understanding of art, but there is no denying that Burgin's work has aesthetic qualities, albeit ones that have been established by graphic designers, and that* Possession *was printed in a limited edition of 500, far fewer than any mass poster campaign and more like the edition of an art print.*
>
> ▶ *Although you might not necessarily accept* Possession's *status as art, it is worth considering that Burgin created an awareness of something that hitherto may have been a minor news item or buried in the pages of* The Economist *(the source of the statistic). Since art has a longevity through collections, exhibitions and books like this one, Burgin's work lives on in a way a news item or magazine article does not. Moreover, unlike the media, contemporary art is, essentially, unregulated and so offers a platform for all possible views and comments, albeit those of the artist.*

A similar strategy to Burgin's has been used by the American artist Barbara Kruger (b.1945) who, from the late 1970s, juxtaposed cropped black-and-white photographs with simple white sans-serif text on a red background (see p. 189). The form Kruger used drew on her experience as a graphic designer and art director for the fashion magazine *Harper's Bazaar* during the 1960s; like Burgin, however, she utilized contentious texts with essentially unrelated images to create meaningful messages. *We Don't Need Another Hero* (1986) questions male aspirations to conventions of courage and gallantry as perpetuated in Hollywood films; *I Shop Therefore I Am* (1987) plays on the philosopher Descartes's famous dictum 'I think, therefore I am' but implies a criticism of consumerism's power, advertising's persuasiveness and the commodification of modern identity.

Appropriating the forms and conventions of advertising is a tactic used by a number of contemporary artists who, like Burgin and

Kruger, are generally critical of consumerism and the means employed to encourage it. Faced with a large LED display in Times Square, New York City, we would expect to see advertising exhorting us to buy this or that, but in 1985 the words 'Protect me from what I want' shone out. This was an example of Jenny Holzer's *Survival Series*, which consisted of texts created for plaques, T-shirts, printed posters and stickers, as well as LED billboards (see http://www.pbs.org/art21/artists/holzer/index.html#).

Why do you think Holzer (b.1950) 'exhibited' her *Survival Series* in the street and not in an art gallery?

▶ *You might have thought that Holzer wanted as many people as possible to see her work, and this would probably be correct. After all, more people look at the advertisements in Times Square than visit an art gallery to see an exhibit. But perhaps what was important was the way the work was displayed. In various forms, advertising is a feature of our towns and cities, so by using these forms to display her aphorisms, like 'Protect me from what I want', Holzer was reversing and so challenging advertising's function of selling a product.*

▶ *On the other hand, you might think that Holzer was selling a product – her art. In fact, although the* Survival Series *was initially made for street display, some of the works were shown in galleries and you might consider this reinforces your interpretation.*

▶ *Then again, there may be another reason why Holzer exhibited her work in a public place. It has been argued that she was reclaiming urban space in order to provide a platform for comment unprejudiced by corporate interests. This view implies that Holzer believed the individual voice was no longer heard amid the clamour of the media's promotion of consumerism.*

If Holzer's work is a criticism of the media's influence and control, she is not alone. In 2002 in Berlin's Alexanderplatz, the French graffiti artist known as Zevs (b.1977) 'kidnapped' the image of a female model from a large billboard advertisement for the Italian coffee company Lavazza. Using a scalpel, he cut the image

from the giant poster and took it 'hostage', writing on the poster 'Visual kidnapping. Pay now!' and then demanded a 500,000 euro donation to the Palais de Tokyo, a contemporary art museum in Paris (see http://pingmag.jp/2008/08/11/zevs-visual-kidnapping).

A similar critique of consumerism was made in 2008 by the British graffiti artist Banksy (probably b.1974) on a wall in north London (see http://www.artofthestate.co.uk/banksy/banksy_tesco_pledge_your_allegiance.htm). The image of children, hands on chest, pledging allegiance to a carrier bag from the supermarket chain Tesco, painted as if attached to a flagpole, alluded to notions of brand loyalty and reverence for the company. Since the Tesco bag/flag bore an uncanny resemblance to the stars and stripes, other interpretations about corporate and political power come to mind.

The work of Kruger and Holzer exploits forms of commercial advertising and in doing so undermines them, while the examples of Zevs and Banksy illustrate a more blatant criticism of consumerist culture. Banksy's use of graffiti draws on its long-standing tradition as a form of subversive popular culture and *Yellow Line Flower* (Figure 4.2) illustrates this, not only confronting the control of authority but also the loss of the natural environment to urban sprawl. In addition, the image of the artist sat on a tin of paint next to his handiwork makes an indirect reference to the theme of celebrity in media-influenced culture. Banksy is an 'art celebrity' but remains anonymous, a shadowy figure about whose identity the press frequently speculate. In *Yellow Line Flower* he represents himself as artist-creator, not as artist-celebrity. This image is not necessarily a likeness, perhaps telling us that he is famous but resistant to temptations of the cult of celebrity that pervades media culture.

If the examples of Burgin, Kruger, Holzer, Zevs and Banksy illustrate a criticism of popular culture, the media and consumerism, then the work of some other contemporary artists seems to take an opposing view. While we suggested in Chapter 3 that *New Hoover*

Convertibles, Green, Red, Brown, New Shelton Wet/Dry 10 Gallon Displaced Doubledecker (Figure 3.1) by Jeff Koons (b.1955) can be interpreted as an ironic and critical statement about consumerism, it is difficult not to see the brightly illuminated Plexiglas case and machines inside as a celebration of its benefits.

Koons's work has included shiny electric toasters, limited-edition reproductions of magazine advertisements and inflatable vinyl flowers, which respectively appear to reflect upon consumerism, media and the kitsch aspects of popular culture. Just what standpoint this reflection takes is open to interpretation, but Koons's lifestyle might indicate his position. He appears to openly embrace celebrity: in 1999 he commissioned a song about himself on a pop album; he appeared on an American television series in 2006 and in a Hollywood movie two years later; he was the creator of a drawing for the home page of the Internet search engine Google and, in 1991, married the porn star and politician known as La Cicciolina, from whom he divorced the following year. Despite all this, in a 2008 interview Koons denied the significance of celebrity to his work:

> **The word 'celebrity' suggests that the artist is important, but it's not about the artist. It's about the work... There's a difference between being famous and being significant. I'm interested in significance – anything that can enrich our lives and make them vaster – but I'm really not interested in the idea of fame for fame's sake.**
>
> (Ayers, 2008)

Whatever we might think about his sincerity as an artist, some critics have accused Koons of being self-promoting and tacky. Thus Robert Hughes included his work in a 2004 television programme 'not because [it] is beautiful or means anything much, but because it is such an extreme and self-satisfied manifestation of the sanctimony that attaches to big bucks'. If we are to believe Hughes and other like-minded critics, it seems that Koons's art is fundamentally connected with money and consumerist culture in the contemporary Western world.

Insight

Art's connection with money and consumerist culture is not restricted to our own times. The middle class capitalist economy of seventeenth-century Holland is epitomized by displays of wealth and excess in still life paintings by Abraham van Beyeren, Jan de Heem and Willem Kalf, while the popular culture of fin de siècle Paris is observed in paintings such as Manet's *A Bar at the Folies-Bergères*, where everything can be bought, from the champagne and fruit to the evening's entertainment and perhaps even the barmaid herself.

Koons is by no means the only artist whose work records, is inspired by, or comments on aspects of consumerism. Andreas Gursky's (b.1955) *99 cent.* (1999) is an 11 ft (3.37 m) wide photograph of a store; the Swiss artist Sylvie Fleury (b.1961) exhibited shopping bags in 1992 and a gold-plated supermarket trolley eight years later; *Pharmacy* is a full-size replica of a chemist's shop created in 1992 by the British artist Damien Hirst (b.1965), which was subsequently purchased for the permanent collection of London's Tate Gallery. While apparently setting itself apart from consumerism, contemporary art displays a fascination with the theme.

In 2002 the Schirn Kunsthalle in Frankfurt and the Tate Gallery in Liverpool organized a show called *Shopping*, an exploration of the relationship between twentieth-century art and consumer culture (see http://www.tate.org.uk/liverpool/exhibitions/shopping/default.shtm). The exhibition included Hirst's *Pharmacy*, along with work by Gursky, Fleury, Barbara Kruger, Jeff Koons and American Pop artists such as Andy Warhol, Claes Oldenburg and Roy Lichtenstein. But it was the first exhibit that set the tone of the show. Conceived by the Belgian artist Guillaume Bijl (b.1946) and called *Your Supermarket*, it was a 'real' shop with shelves full of household products, drinks, packaged, tinned and fresh foods, and even baskets, trolleys and checkout tills. When shown in Frankfurt, this 'shop' was supplied and maintained by the German supermarket Tengelmann, while in Liverpool the British supermarket chain Tesco provided staff who stocked, tidied, re-arranged and repriced the

products. What Bijl presented was a familiar location but devoid of its function since nothing could be bought.

What point do you think Bijl might be making with his *Your Supermarket* installation?

▶ *You may think that replicating a supermarket in an art gallery has little or no point; after all, why not just visit a supermarket? However, there is a difference between a supermarket in which we shop and one in which we cannot shop because it is a work of art. As we previously saw, the French artist Marcel Duchamp created 'ready-mades' in the second decade of the twentieth century, objects he selected and 'made' into art. Bijl's* Your Supermarket *is similar in that once in an art gallery, it is no longer a supermarket; it may look like a shop but it does not function as one.*

▶ *As a result, one point Bijl might be making is that his work frustrates our desire to buy. Although our response when going into a shop might not actually be Pavlovian – that is, the shopping environment triggers our desire to buy – we do not usually go into supermarkets just to look. Following on from this, Bijl may be suggesting that the supermarket can provide us with an aesthetic experience; after all, Your Supermarket was in an art gallery, somewhere we go to look at art. The lines of shelves, packages, tins and so forth, create pattern, interesting shapes and splashes of colour, all of which may have a certain aesthetic attraction.*

▶ Your Supermarket *may be a celebration of consumer culture, in the way that a Willem Kalf still life or Manet's* A Bar at the Folies-Bergères *could be.*

▶ *Equally, Bijl could be helping us see the supermarket differently than we normally would by denying our role as consumers and making us detached observers.*

▶ *Or his work may facilitate our insight into twenty-first century consumer culture by allowing us to contemplate a 'supermarket' in a way we would probably not be able to do in our everyday life.*

▶ *Ultimately, Bijl's work illustrates that art is not life, however closely it may seem to represent it.*

Consumerism is an important aspect of twenty-first-century life; very few societies are untouched by it and veneration for commodities has sometimes been seen as replacing other values. As a consequence of mass production, competition and profit, consumerist dreams are driven by publicity and marketing in a variety of forms, but principally through the media of mass communication, such as print, television, the Internet and other forms of telecommunication. There is no doubt that these media have not only transformed our buying practices and but also wholly changed the world and our perceptions of it. One way in which this has happened can be seen in the significant changes to forms of popular culture, which were once almost exclusively associated with the authentic culture of the people but are now media created for mass consumption.

Suggestions for further reading

Jack Bankowsky et al (authors/editors) *Pop Life: Art in a Material World*. Tate Publishing, 2009

Andrew Murphie and John Potts, *Culture and Technology*, Palgrave Macmillan, 2002

Julian Stallabrass, *Art Incorporated: The Story of Contemporary Art*, Oxford University Press, 2004

Tate Liverpool, *Shopping: A Century of Art and Consumer Culture*, Hatje Cantz Publishers, 2002

John A. Walker, *Art in the Age of Mass Media*, Pluto Press, 2001

THINGS TO REMEMBER

▶ *Many works of contemporary art respond to the technologically driven mass culture and consumerism of more recent times, appropriating its media and forms to create gallery-based work.*

▶ *The apparent blurring of boundaries between so-called 'high' and 'low' culture challenges the Modernist position that demands art's separation from popular forms in order to maintain its elitism.*

▶ *By using the media and conventions of mass communication and consumerism but not conforming to their established and expected roles, artists allow us different and frequently insightful interpretations.*

6

Displaying and buying
contemporary art

In this chapter you will learn:
- *about the contemporary art market and its associated institutions, contributors and industries*
- *how the contemporary art market operates as a form of investment and where to buy art*
- *where contemporary art is displayed and can be seen*
- *how the art world pays tribute to itself, so further promoting links between art, money and celebrity.*

Section 1 Contemporary art and the market – buying art

Making money is art and working is art and good business is the best art.

<div align="right">(Andy Warhol)</div>

Contemporary art is a global business. Along with the sex and weapons industries, the international art scene is among the world's most lucrative and least regulated markets. Politicians and policymakers routinely describe art and the 'creative industries' as drivers of social regeneration, economic investment and growth. Art-related crime alone is a mini-industry reckoned to be worth over £3 billion a year. One report by Merrill Lynch recently

identified the new social and economic phenomenon of the 'super rich', apparent not only in the UK and North America but also in Asia, China and Russia, as a central factor which has driven the art market. More recently, the emergence of State-owned sovereign wealth funds have fuelled the reach of international capital and the things which it can buy and trade.

Although art may be valued for its intrinsic aesthetic or conceptual value, State policy and private investment in art is typically justified along more instrumental lines. The private galleries and national museums which sell and collect art are increasingly seen as drivers of economic and social regeneration – witness the Tate Modern and the Baltic Centre for Contemporary Art in Gateshead (see Figure 6.1), both in the UK, and Bilbao's Guggenheim Museum. Similarly, the vogue for new public statues in recent years is seen by some as an attempt to reclaim a social and communal role for art within consumer societies, which themselves appear increasingly fragmented and atomized. Rather less prosaically, Kenneth Clark, the late art historian, connoisseur, collector and gallery director, famously compared the motivation for buying art to falling in love.

Given Clark's view, why do you think people buy art?

▶ *Clark's belief is that people desire something which is visually or conceptually engaging – an image or object for display and ownership over the long term. If this is the case, its appeal and affordability, rather than any longer-term appreciation in value (however welcome), may be the main concern.*

▶ *However, you may think that the interests of art buyers and collectors is principally about return and is investment-based, in which case, just like studying form on racehorses, those involved might put in some real time and effort in researching the market.*

If the motivation for buying art is as an investment, and assuming that art is not purchased directly from the artist, the buyer will typically incur additional transaction and commission costs. Art is not the most liquid and divisible of assets. Unless the buyer is selling direct to a dealer, the time that it takes for work to go to

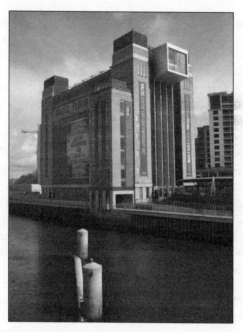

Figure 6.1 The Baltic Centre for Contemporary Art, Gateshead, UK. Opened 2002. Photo: Graham Whitham.

auction, or the possibilities of a reduced price or even the prospect of it not meeting a reserve if trading conditions are difficult, are ever-present considerations in the art market.

Like any other commodity, art is also subject to market and cultural fashion. For example, over the past decade or so, socialist realist paintings, posters, design and ceramics associated with Soviet Russia, as well as contemporary Russian art, have attracted increasing levels of buyer interest (and the attention of forgers). The same applies to icons and even to examples of pre-Revolutionary Imperial porcelain. In part, this has been driven by rich Western and Russian investors lured by the prospect of a new market as the former Eastern Bloc countries have opened up and begun the process of liberalization. Although as various commentators have also noted, in the case of Russian buyers of Soviet art, there may well be more complex and ambivalent feelings

of nostalgia, history and identity which have driven the market in recent years. The point is that people buy art for many reasons aside from, or in addition to, economic and investment-based considerations.

What advantages and disadvantages can you identify in buying art as an investment?

▶ Art can offer tangible returns as an investment. A work of art's value may increase dramatically, as was the case when the British collector Charles Saatchi bought Marc Quinn's Self (Plate 6) in 1991 for £13,000 and sold it 14 years later for £1.5 million. However, works of art can also depreciate in value, depending upon market conditions.

▶ While art can be hung or installed and enjoyed, it does not provide income unless sold and has to be insured, conserved and generally looked after.

▶ Buying art is often described as chic and an activity suggestive of social cachet and standing. For a new and younger generation of rich collectors it also provides more variety and interest than the usual trappings of wealth, power and status.

In commercial terms, art is just another tradable commodity, the market for which is driven by discretionary expenditure. In this sense, the art market can be highly volatile and trying to predict how it will perform over the longer term can be hazardous. For example, when the early 1990s recession was beginning to bite, the art market previously underpinned by rising share prices and buoyant transatlantic economies, was especially exposed and was one of the first asset classes to take the hit. Although estimates vary, anecdotal evidence suggests that from 1990 the contemporary art market lost around 60 per cent of its value, almost overnight, although, as we have seen in Section 2 of Chapter 3, art-based assets have continued to make a profit overall. Commentators make the point that the art boom of the 1980s was driven by the currency surpluses of the Japanese economy, making it vulnerable to downturns, as indeed happened after the stock market crash of 1989 when Japanese buyers withdrew from the market. One of the

lessons learned by a generation of British artists in a weak market was to circumvent gallery fee commissions altogether by initially curating and managing their own shows. 'Do it yourself' promotion and marketing became a feature of the yBas generation and remains widespread practice within the contemporary art market.

Fast-forward almost 20 years from the 'feeding frenzy' of the 1980s and an increasingly globalized art market was again scaling new heights, supported by record currency flows from Asia, China and Russia. In 2007 former Christie's finance director Philip Hoffman launched the first art-based hedge fund which buys art direct from contemporary artists. Various private banks and specialist insurers now routinely offer their clients art advisory and brokerage services, or otherwise provide guidance on managing existing art collections. With the onset of the credit crunch and the instability of the global financial markets it was predictable that the speculative bubble, which the international art market had become, would eventually deflate.

However, despite the financial instability of recent years, holding contemporary art is increasingly seen as a serious investment, along with the more traditional equities, gilts and property portfolios. Despite market fluctuations, since the 1970s art has proved to be a positive long-term investment, not least because Western economies have sustained overall growth, with recent global trends geared to liquidity (the availability of comparatively large amounts of international currency which can be spent on discretionary purchases).

As with any emerging market, talent spotting a rising generation of artists is an exciting, if speculative, business. Like other markets, the art world also trades on quality, sentiment, reputation and the judgement of peers. The usual 'market makers' are dealers, gallery owners, curators and those private collectors and corporate buyers who routinely acquire art for investment, interest, display or status. For example, when a major gallery like the Tate in the UK acquires or displays an artist's work, it tends to have a positive effect on the market value of other works by that artist. The same can apply to

major acquisitions by collectors or corporate buyers. Conversely, the apparent 'dumping' of a particular artist's work onto the market in a short space of time by a major collector or a former patron can have the opposite effect. The price of paintings by the Italian neo-figurative painter Carlo Mariani fell dramatically after Charles Saatchi famously sold off his stock of Mariani's work to make room for more acquisitions.

Other considerations are the condition and provenance, or 'history', of the art work. Of course, this may be less of an issue in cases of more recent work where an artist has a known association with a reputable gallery or dealer. If the art work has been sold at auction it will usually have a lot number, a catalogue entry and description. This history should help to verify the art work as an original rather than a fake or copy. When buying any kind or form of art, the buyer must verify and satisfy themselves concerning its authorship and authenticity. For example, if an original print, how many have been made and authorized? Has it been signed by the artist? Will the seller offer indemnities or guarantees as to the work's authenticity?

In the 1980s and 1990s London became a key player in the contemporary art market, a status it shared with New York. London's auction houses and a dynamic and entrepreneurial network of art dealers, gallery owners and buyers drove the market and cemented the reputation of a new generation of artists and market makers. Aside from the dominance of City and stock market finance, the UK's initial exemption from the levy typically paid to artists when their work is sold on the secondary market (the *droit de suite*), proved attractive to Continental and other overseas buyers.

Since the mid-1990s and the *Sensation* show of 1997, the name of Charles Saatchi has become synonymous with contemporary British art patronage, as have those of Jay Jopling, Larry Gagosian and Victoria Miro. 'A-list' celebrities such as David Bowie, Elton John and Dennis Hopper were as profiled for their burgeoning art

collections as they were for their music and films. One of the central figures behind the yBas, Damien Hirst (see Plate 9), has increasingly turned his attention to the collecting and curation of modern art, while established collectors such as Frank Cohen were given media recognition long focused on a London-oriented art world.

The recession of the early 1990s restructured the UK art market. Traditionally, West End–based galleries and dealers faced diminishing clients, punitive leases, tax costs and closure. The iconic *Freeze Exhibition* of 1988, co-curated by Carl Friedman and Damien Hirst in a disused Port Authority building in London's run-down Docklands, was as emblematic of a new exhibiting paradigm as it was of the decline of the UK's manufacturing industries. Commentators saw the pragmatic trend towards self-curation by artists, for example Sarah Lucas and Tracey Emin, who famously rented a former taxi office in Waterloo to sell art world merchandise, as an entrepreneurial response to Thatcherism and the free market.

These art world changes reflected broader social and cultural transformations. London's East End became a mecca for a new generation of artists and a magnet for dealers in search of new talent, forcing out the original population because of the high rents that resulted. At the time of writing, Hoxton, Brick Lane, Old Street, Southwark and Bethnal Green have become established art enclaves with Mile End and Stratford undergoing gentrification. Spitalfields and the area around Brick Lane, probably one of the most ethnically diverse areas of London, and home to artists such as Gilbert and George and Tracey Emin, has become a highly fashionable and desirable area, forcing up studio rents and living costs. Similar examples of regeneration, and the associated upsides and downsides, can be seen at work in the former Soviet sector of Berlin or New York's Harlem and Bowery districts.

AUCTION HOUSES

In the UK the dominant auction houses are Christie's and Sotheby's, names synonymous with the high-profile, transatlantic

art sales of the 1990s and the initial years of the new millennium. It has been estimated that over 90 per cent of the big name art sales have been handled by this effective duopoly. The smaller auction houses like Bonhams and Phillips de Pury are probably better known for what commentators regard as mid-range art sales and a wider range of disposals, including vintage cars, wines, furniture and jewellery. Although there are exceptions, one of the art market trends of the past decade has been for auction houses to offer sellers guaranteed prices – that is, an agreement to dispose of a particular art work for a minimum set price.

For example, where the 'hammer price' happens to be higher than the pre-sale guarantee, both seller and auction house take a share of the margin. This will be in addition to a sliding scale of commission charges (anywhere between 12 and 25 per cent of the sale price). Some observers have suggested that such practices have fundamentally changed the role of auction houses; rather than neutral agents in a free market, auction houses are increasingly seen as exercising an active 'brokerage' role in art sales. In the rising art markets of the past decade, this has helped to inflate margins, although in bear markets the auction house runs the risk of paying a hefty liability if sales fail to reach agreed reserves.

One of the developments noted in a recent profile by *The Economist* was for auction houses to reduce the potential downside. It was suggested they could do this by sharing the cost of their price guarantees with third-party private dealers and galleries who had an interest in the marketability of work by particular artists, or even specific genres or styles. As the CEO of one US bank specializing in art finance commented, it is 'a manipulated market' in which there is no neutrality.

Although auction houses deny that such a business model encourages partiality, there are numerous ways in which the perception of art work coming onto the market can be made more, or less, attractive. Everything from positive coverage and catalogue placement, to pre-auction previews, client guidance and press

releases to the trade and general press, can create a favourable environment for a particular auction and sale range. Despite what some allege to be far from transparent business practices, the dominance of the big auction houses does not look as if it is going to be challenged in the near future.

ART SCHOOLS, INSTITUTES AND COLLEGES

All art schools host end-of-year foundation and degree shows, exhibitions of work by graduating students. These are an excellent way to see work by a new generation of practitioners and also to buy new art at competitive prices. In London, for example, the leading art schools have come together as a single entity, the University of the Arts London, which includes the Chelsea College of Art & Design, Central St Martins College of Art & Design, Camberwell College of Arts, the London College of Communication, Wimbledon College of Art and the London College of Fashion. In addition, other leading places to consider are Goldsmiths College, the Royal College of Art, the Slade School of Fine Art and the Royal Academy of Arts Schools. End-of-year shows typically attract professional art buyers, dealers and agents looking for new prospects. If you see something you like and can afford, don't hang around – buy it! Other major annual events in London where art can be bought are the Affordable Art Fair and the Royal Academy's Summer Show.

BUYING ART ONLINE

One of the consequences of the expanding market in contemporary art has been the dramatic growth in the direct sale of art online. Most galleries, dealers and auction houses now routinely advertise their artists, exhibitions and forthcoming sales on the World Wide Web (www), but increasingly artists are directly marketing their own work either individually or collectively with other studios. Recognizing this trend, some galleries and collectors have started to encourage direct online approaches. For example, the art collector and gallery owner Charles Saatchi has moved into this market by launching a website which invites art students to submit their work direct for sale.

Although the private gallery system, and the various international art fairs and exhibitions remain central to the international art market, the online sale and marketing of contemporary art is a significant recent development.

What do you think might be the advantages for artists and collectors of online buying?

> ▶ For artists, it offers the prospect of reduced overheads and brokerage fees, as well as providing the possibility of international exposure.
> ▶ For prospective buyers it provides a potentially unlimited range of price-competitive art which can be viewed without ever having to visit a gallery or attend a private view.

What do you think might be the disadvantage for a collector buying online?

> ▶ Even high-resolution, digitized images rarely capture the immediacy and experience of the art work and its medium. Or put another way, would you normally buy any other potentially high-value item without seeing it and checking it over yourself?

There is additional information on buying art online in the 'Taking it further' section at the end of this book.

Section 2 Displaying contemporary art

CONTEMPORARY ART PATRONAGE – MUSEUMS AND BIG BUSINESS

As mentioned at the start of this chapter, the connection between art, private patronage and big business is nothing new. As the American art critic Clement Greenberg eloquently put it, avant-garde artists and the elite among the ruling class of society have 'always remained attached by an umbilical cord of gold' (Clement Greenberg, 'Avant-garde and Kitsch', reprinted in Harrison and

Wood (2003), p. 542). The Florentine Renaissance was driven by oligarchies and religious confraternities and the High Renaissance in Rome was underpinned by the cultural and political ambitions of the papacy and the ability to attract and retain some of the most innovative and skilful artists alive. In the 1880s in the UK the sugar baron and industrialist Henry Tate gave his name to the country's leading collection of then-contemporary art, and in the early twentieth century the cultural ascendancy of modernist art in America was intimately connected to the dynastic interests of leading families, individuals and the ambitions of a new nation.

However, in recent years, State support and private patronage has declined, as illustrated by the Tate receiving less than 40 per cent of its overall funding from the tax payer. Conversely, the extent and depth of corporate art sponsorship has mushroomed. For example, some of the UK's leading museums and galleries, including the Tate, the Victoria and Albert Museum and the Serpentine Gallery, are increasingly dependent on major companies and financial institutions such as Unilever, BP, Texaco, Deutsche Bank and Bloomberg.

Corporations look beyond temporary brand associations to what art market commentators are now calling 'deep ownership' – ongoing relationships with cultural institutions, rather than sporadic interventions relating to a particular exhibition or acquisition. For example, leading fashion brands such as Cartier and Prada have established their own art foundations, with other brand names establishing art prizes and competitions. Recognizing future trends, the Guggenheim Museum teamed up with Deutsche Bank in 1993 to open Berlin's Deutsche Guggenheim, and towards the end of the decade Giorgio Armani pledged $15 million to the museum, an exemplar of philanthropy that resulted in an exhibition of the designer's work at the New York and Bilbao Guggenheims.

Hybrid funding involving large-scale private and corporate philanthropy is increasingly how collections and museums are sustained and new ones built. As this trend develops, there is even less reason for direct State funding or dependency on private

and individual benefactions. Critics often point to the pragmatic reasons for the corporate sponsorship of art, or what architect Sir Norman Foster described in another context as 'lipstick on the face of the gorilla' (quoted by Glancey, 2002).

Artistic patronage offers the attractions of cachet, status and social profile when the activities of sponsors may altogether be more banal or even morally dubious, as is the case with companies which make and sell weapons or those which pollute the environment. But as Nick Hackworth has noted:

> *There is a cultural crudity about corporations because their bottom line is always money. Kings, aristocrats, oligarchs, plutocrats, popes, bishops, dictators and even democratic states tend, at least, to have more personal, complicated reasons to align themselves with art and artists.*
>
> (Hackworth, 2005)

As this trend continues it remains to be seen whether it will ultimately determine the kind of art which practitioners actually make and the examples routinely collected by sponsored galleries and museums. But whatever the merits or otherwise of private philanthropy, it looks set to become the real driver of visual arts patronage, making ever smaller the gap between artistic practice and mainstream commercial culture.

The biggest patrons of contemporary art remain private buyers and dealers. This was spectacularly underlined by Anthony D'Offay's philanthropic donation of a collection of 725 modern art works, valued at over £125 million, to the Tate and the National Galleries of Scotland. If exhibited in its entirety, one commentator estimated that the collection would fill most of the Tate Modern's existing wall space. The decision to make the gift only at the price originally paid (£26.6 million) brought the collection within the ambitions of English and Scottish taxpayers, both of which would have been outbid by private buyers had pieces from the collection been presented for auction.

The gap between what State-funded museums were able to afford and what the market could pay for really became apparent in the 1980s when the Tate established an acquisitions network of wealthy individuals and corporate donors. Since then, the contemporary art market has been driven by wealthy collectors and buyers from the worlds of business, fashion, music and football. In some cases, the gaps between celebrity culture and art have become very narrow. For example, consider Sam Taylor-Wood's video work of footballer and fashion icon David Beckham sleeping, or the association of leading contemporary artists, including Damien Hirst (Plate 9), Tracey Emin, Julian Schnabel and Marc Quinn (Plate 6), in selling their work to support the charity brand Red, set up by U2 star Bono to combat the Aids epidemic in Africa. Describing 'Red Event', Bono told journalists that it was a 'unique event, an unholy mix of commerce and activism, culture and politics. It's also a way of keeping the world interested' (O'Hagan, 2008).

In comparison to the private art market, government attempts at extending public ownership of contemporary art have been hesitant. In the UK, for example, the Arts Council–backed 'Own Art' scheme was started in 2004. The idea was to provide interest-free loans to encourage those on low incomes or on benefits to own and buy original works of art, craft, textiles or jewellery. Initial reports subsequently circulated in the press have suggested that the uptake came overwhelmingly from affluent or middle-bracket professionals rather than non-traditional and under-represented sections of the community.

WHERE TO SEE CONTEMPORARY ART

Although online art buying can save time and effort, there really is nothing better than actually visiting galleries, exhibitions and the end-of-year art school degree shows to get a sense of what there is. Local, regional and national events are covered by publications such as *The Art Newspaper* and *Art Monthly* (usually stocked by specialist bookshops and major gallery bookshops). More generally, listings publications such as *TimeOut* cover a broad

range of visual arts events and touring exhibitions. Taking the UK as an example, London remains one of the centres to see international art. When it opened in 2000, Tate Modern became one of the largest international exhibition spaces for contemporary art in the world. In its first year, it attracted over 4 million visitors, establishing it as a major international tourist venue.

At the other end of the scale is the relocation of many artists' studios and contemporary art galleries from the centre of London to the East End. In the past decade, areas like Bow, Hoxton, Walthamstow and Whitechapel have become highly fashionable with artists looking for more affordable studio space, cheaper leases and a more socially mixed environment in which to work. There are various online maps of London art galleries and studios, which might save time pounding the street just with an A–Z!

Although London remains an important centre in which to see contemporary art, showcasing it is increasingly evident throughout the UK. In 1999 Liverpool launched its first biennial, which displayed a range of contemporary, international art across the city. In Gateshead, the Baltic Centre for Contemporary Art (see Figure 6.1) opened in 2002 as the North-East's central arts venue. On the south-east coast, the Kent town of Folkestone has recently benefited from major investment with the aim of establishing an artists' quarter and, further along the coast in Margate, the Turner Contemporary looks set to establish the seaside resort as a future south-east art hub. In the east of the UK, Norwich has established a niche with a new biennale of international contemporary visual art featuring exhibitions, events and performances in museums, galleries and public spaces. EAST International, founded in 1991 by Norwich School of Art curator and lecturer Lynda Norris, is an annual submission art prize which has been noted for its inclusivity – there are no limits on genre, medium, subject, size or nationality and age of entrant.

On the whole, these developments are part of a broader recognition of the art and heritage industries as drivers of social and economic regeneration and investment. However, these projects also reflect

a broader shift in sensibility arising from unprecedented levels of public interest in, and engagement with, contemporary art.

CONTEMPORARY ART FAIRS

International art fairs have become so central to the contemporary art world that they tend to be described simply by the location which holds them – Basel, Kassel, London and Venice are among the regular venues. Despite their postmodern re-invention, art fairs have their origins in the grand exhibitions of the nineteenth century, where imperial and colonial powers vied for cultural and economic supremacy. As contemporary events, art fairs are powerful market makers, attended by practitioners, curators, collectors, members of the public – and the seriously rich. They are also increasingly major media and social spectacles which present new and existing work by known and emerging artists, and they are places where the latest art can be seen, thereby attracting tourism and capital investment.

Starting in 1955, Kassel has hosted the Documenta international art fair every five years. Virtually obliterated by Allied bombers and extensively rebuilt in the post-war period, Kassel was felt to be the appropriate location for an art fair that was designed to reconcile 'German public life with international modernity and also to confront it with its own failed Enlightenment' (http://www.magazines.documenta.de/geschichteo.html?&L=1). While all the art fairs are variously international, Documenta is probably the most globalized and inclusive when it comes to showcasing art practice from outside the Western economies. For example, in 2007 there was a strong presence of work from Asia, India, Russia (and former Soviet Republics and territories), in addition to artists from South America and China.

Close on Documenta's heels is Art Basel in Switzerland, which has been running since 1970. The 2008 show boasted work from over 300 galleries and 2,000 artists and was promoted as the world's largest art fair or, as the *Daily Telegraph* put it in 2004, 'the Olympics of the art world' (Horan). Not content with being the biggest, Art Basel has had a sister fair of the same name running at Miami Beach in Florida since 2002.

After Basel, London's annual Frieze art fair is probably the most influential. Launched in October 2003 by Matthew Slotover and Amanda Sharp, it was London's first international fair dedicated to contemporary art. It has since become a major agenda-setting cultural event on the international art scene. Annually hosted in London's Regent's Park, Frieze also set the trend for incorporating daily talks and events programmes, commissioned artists' projects, art catalogues and speciality restaurants as part of the art fair 'experience'.

The Zoo Art Fair (named after its initial venue, the bear pavilion at London's Regent Park Zoo) started in 2004 as a non-profit satellite event to Frieze. It has since established a good critical reputation for showcasing new and innovative British art and is funded by various organizations including the Arts Council, private galleries, dealers, publishers and commercial advertisers. Now hosted behind the Royal Academy of Arts at the Burlington Gardens, it attracts a younger demographic of artists and buyers.

Established in 1895, the Venice Biennale belongs to the era of grand national expositions mentioned at the start of this section. Presented in Venice's Giardini Park every two (odd) years, its distinctive feature is the 30 permanent national pavilions which house the selected exhibitions of participating countries. It is a highly prestigious cultural event and selection to represent work there on behalf of one's country is a major accolade for those contemporary artists chosen, only ranked in the UK perhaps by selection for the Turner Prize. Designed to showcase new artistic trends, it parallels similar events in film and architecture.

Section 3 Honouring contemporary art – contemporary art awards

Another dimension to the relationship between art and money has been the proliferation of annual art awards. Although the Channel 4-sponsored Turner Prize in the UK remains the most prestigious (but not the most lucrative), there is a wide range of other art prizes variously sponsored by businesses and educational interests. Apart

from the cutting-edge quality of much of what is submitted, these events provide an excellent opportunity to see new work by artists and to gauge some of the themes and directions of contemporary practice.

The annual Turner Prize and the media hype which surrounds it has become one of the central events of the contemporary art world. Launched in 1984, the winner selected from the customary shortlist of four artists, now receives a cheque for £40,000 and large amounts of media and tabloid coverage, which is probably worth as much as the kudos of the prize itself. The selection committee of five is chaired by the Tate Director and, by convention, includes one Tate Gallery patron as well as writers and curators from the UK and overseas. Formatted in three parts throughout the year, the process of selection for the Turner Prize starts with the announcement of the shortlisted artists, then the exhibition of their work, and finally the spectacle which surrounds the discussion and selection of the winner.

Named after a bequest left by the British landscape painter J.M.W. Turner (1775–1851), since 1990 the award has been given to British artists under 50 for outstanding work or exhibitions produced in the preceding year. Additionally, its brief is to promote public discussion and engagement with contemporary art. Interestingly, simply being a shortlisted nominee can be as career-enhancing as actually winning. For example, although Tracey Emin and Jake and Dinos Chapman have so far only been shortlisted, the recognition which nomination has brought has probably been as significant to their subsequent media and public profiles as actually winning. In fact, Emin's website bills her as 'the well-known modern artist who should have won the 1999 Turner Prize but didn't' (www.tracey-emin.co.uk).

Inevitably, the Turner Prize has attracted criticism. J.M.W. Turner's descendants have alleged that the prize actually ignores the original terms of the Turner bequest. Others have attacked its gender bias against women, while critics frequently note the absence of any transparency in the selection and award-making process. In one spat that reached the newspapers in 2005, it was alleged that the Tate had spent money generated by Tuner's estate on 'modern rubbish'. Some regard the Turner Prize as a highly

subjective platform for supporting the obscure in contemporary art practice, while others see it as a media spectacle lacking substance.

However, what cannot be doubted is the significant part which it has played in raising the profile of recent and contemporary British art and in promoting it to new audiences, both nationally and internationally. Its defenders point to the role played by the Turner Prize in supporting a 'perceptual shift' that has encouraged a wider public engagement with contemporary art in all its forms. While similar claims could be made about any number of prizes, galleries or individuals, there is no doubt that the Turner has played a part in the broader public engagement with contemporary art per se.

Since its launch, the Turner Prize has had increasingly prestigious competition. These now include the Citigroup Private Bank Photography Prize, the Beck's Futures Award (1999–2006) and the Jerwood Prizes. These awards underline the increasing links between corporate sponsorship, art institutions and contemporary art patronage. In the case of the Beck's Futures Awards, the selection panel of curators and artists made awards across all media to new and unknown artists, with individual prizes given to the value of £500 and a top prize of £20,000. The work of the winners was typically displayed at London's Institute of Contemporary Arts (ICA) before touring to other venues such as Glasgow and Manchester.

The Citigroup Private Bank Photography Prize was established in 1997 and was closely associated with the Photographers' Gallery in Ramillies Street, London. The top annual prize of £15,000 previously went to a contemporary photographer who had made an outstanding contribution to the medium in the previous year. This was replaced by the Deutsche Börse Photography Prize. The Jerwood Foundation is a charitable organization that funds the arts, education and science, and awards a number of prizes, including ones for drawing, painting and sculpture. As the titles suggest, the prizes are medium-specific and awarded for excellence in the particular discipline demonstrated in the previous year. Other high-profile and prestigious awards include the Hamlyn Awards and the John Moores Award.

Suggestions for further reading

Alan S. Bamburger, *The Art of Buying Art*, LTB Gordonsart Inc., 2007

Louisa Buck and Judith Greer, *Owning Art: The Contemporary Art Collector's Handbook*, Cultureshock Media Ltd., 2006

Bruno S. Frey, *Arts and Economics: Analysis and Cultural Policy*, Springer-Verlag Berlin and Heidelberg GmbH & Co. K., 2003

Rita Hatton and John Walker, *Supercollector: A Critique of Charles Saatchi*, Ellipses, 1999

Iain Robertson, *Understanding International Art Markets And Management*, Routledge, 2005

Julian Stallabrass, *Art Incorporated. The Story of Contemporary Art*, Oxford University Press, 2004

Don Thompson, *The $12 Million Stuffed Shark. The Curious Economics of Contemporary Art and Auction Houses*, Aurum Press, 2008

Paige West, *Art Addict: Demystifying the Process of Finding, Appreciating, and Buying Contemporary Art on Any Budget*, HarperCollins, 2007

Chin-Tao Wu, *Privatising Culture: Corporate Art Intervention since the 1980s*, Verso, 2002

http://www.newexhibitions.com

THINGS TO REMEMBER

▶ *The art trade is one of the least-regulated international markets, providing both opportunities and the need for caution – 'caveat emptor' or 'buyer beware' applies.*

▶ *In trading terms, art is just another commodity, subject to the fashions of the market and the dynamics of supply and demand, although it is generally regarded as a 'discretionary' asset, which means that it tends to be the first market area to decline when economic times become problematic, and can be among the last to recover when buying confidence returns.*

▶ *That said, some areas of the art market are more resilient than others; the trade in so-called 'old masters' – famous works by historically established and known painters, sculptors or printers – tend to attract a slightly different buyer demographic, one which is often more resistant to short-term market changes than perhaps is the case with many of the buyers and patrons of contemporary art.*

▶ *In recent decades, the proliferation of art fairs, awards and biennales has underlined the globalized and wholly international character of the art market.*

▶ *Although largely commoditized, the motivations for buying art (and the attractions of owning it), can be nuanced, relating to aesthetic, conceptual and historic interests; the desire for possession and ownership, social recognition and standing.*

▶ *The contemporary art market transcends the idea of a single nation, state or country. Similarly, many contemporary artists are not affiliated to a particular place, but have their work exhibited and curated across the world.*

▶ *Within a postmodern age, all art and forms of cultural production are proximate and adjacent, in what the Nigerian curator, critic and poet Okwui Enwezor has called the 'terrible nearness of distant places' (Enwezor, p. 44).*

Taking it further

There are many museums and galleries that exhibit contemporary art and the numbers are increasing annually.

While the following list is by no means exhaustive, we have included a wide international range of museums and galleries that have significant collections or exhibitions of contemporary art. In general, we have not included commercial galleries.

Argentina
Museo de Arte Contemporáneo de Rosario
Bv. Oroño y el río Paraná, 2000 Rosario, Santa Fe
http://www.macromuseo.org.ar

Australia
Australian Centre for Contemporary Art
111 Sturt Street, Southbank, Victoria 3006
http://www.accaonline.org.au

The Judith Wright Centre for Contemporary Arts
420 Brunswick Street, Fortitude Valley, Brisbane
http://www.jwcoca.qld.gov.au

Museum of Contemporary Art
140 George Street, The Rocks, Sydney
http://www.mca.com.au

Belgium
Aeroplastics Contemporary
32 rue Blanche, 1060 Brussels
http://www.aeroplastics.net

Musée des Arts Contemporains
Site du Grand-Hornu
Rue Sainte-Louise, 82, B-7301 Hornu
http://www.mac-s.be

Brazil
Museum of Contemporary Art at the University of São Paolo
Rua de Reitoria 160, 05508-900 São Paolo
http://www.mac.usp.br/mac

Museum of Contemporary Art of Niterói
Mirante da Boa Viagem
Boa Viagem, Niterói CEP 24210-390, Rio de Janeiro
http://www.macniteroi.com.br

Canada
Contemporary Art Gallery
1555 Nelson Street, Vancouver, British Columbia V6B 6R5
http://www.contemporaryartgallery.ca

Musée d'art contemporain de Montréal
185, Sainte-Catherine Ouest, Montréal, Québec H2X 3X5
http://www.macm.org

The Power Plant
231 Queens Quay West, Toronto, Ontario M5J 2G8
http://www.thepowerplant.org

Vancouver Art Gallery
750 Hornby Street, Vancouver, British Columbia V6Z 2H7
http://www.vanartgallery.bc.ca

Chile
Museum of Contemporary Art
Facultad de Artes, Universidad de Chile, Matucana 464, Santiago
http://www.mac.uchile.cl/travesias/english

China
Museum of Contemporary Art Shanghai
People's Park, 231 Nanjing West Road, Shanghai, 200003
http://www.mocashanghai.org

Shenzhen Museum of Contemporary Art
East Gate of Block A, Citizens' Center, Fuzhong 3rd Road,
Futian District
http://www.shenzhenmuseum.com.cn/English

Croatia
Museum of Contemporary Art
Habdeliceva 2, 10000 Zagreb
http://www.mdc.hr/msu

Czech Republic
Centre for Contemporary Arts Prague
Karlin Studios, Križíkova 34, Praha 8
http://cca.fcca.cz

Denmark
Arken Museum of Modern Art
Skovvej 100, 2635 Ishøj
http://www.arken.dk

Museet for Samtidskunst – Museum of Contemporary Art
Stændertorvet 3D, 4000 Roskilde
http://www.mfsk.dk

Finland
Kiasma – Museum of Contemporary Art
Mannerheiminaukio 2, FIN-00100, Helsinki
http://www.kiasma.fi

France
CAPC – Musée d'Art Contemporain de Bordeaux
7 rue Ferrère, Bordeaux 33000

Carré d'Art – Musée d'Art Contemporain
Place de la Maison Carrée, 30000 Nîmes

La Maison Rouge
10 boulevard de la Bastille, 75012 Paris
http://www.lamaisonrouge.org/en

Le Plateau – FRAC Ile-de-France
Place Hannah Arendt, 75019 Paris
http://www.fracidf-leplateau.com/en

Musée d'Art Contemporain
Cité Internationale, 81 quai Charles de Gaulle, 69463 Lyon cedex 06
http://www.mac-lyon.com

Musée d'Art Moderne et Contemporain
1 place Jean Arp, 67000 Strasbourg

Musée National d'Art Moderne – Centre Georges Pompidou
Place Georges Pompidou, 75191 Paris
http://www.centrepompidou.fr

Museum of Modern and Contemporary Art
Promenade des Arts, 06364 Nice cedex 4
http://www.mamac-nice.org/english

Palais de Tokyo
13, avenue du Président Wilson, Paris
http://www.palaisdetokyo.com

Germany
Deichtorhallen Hamburg
Deichtorstraße 1–2, D-20095 Hamburg
http://www.deichtorhallen.de

Kunsthalle
Glockengiesserwall, D-20095 Hamburg
http://www.hamburger-kunsthalle.de

Kunstmuseum Bonn
Museumsmeile, Friedrich-Ebert-Allee 2, 53113 Bonn
http://kunstmuseum.bonn.de

Museum für Moderne Kunst
Domstrasse 10, 60311 Frankfurt am Main
http://www.mmk-frankfurt.de

Neuer Berliner Kunstverein
Chausseestrasse 128/129, D-10115 Berlin
http://www.nbk.org

Greece
Deste Foundation Centre for Contemporary Art
Filellinon 11 & Em. Pappa Street, N.Ionia, 142 34 Athens
http://www.deste.gr

Italy
Museo d'Arte Moderna di Bologna
Via Don Minzoni 14 – 40121 Bologna
http://www.mambo-bologna.org/file-sito/eng

Casoria Contemporary Art Museum
Via Duca d'Aosta 63/A, 80026 Casoria, Napoli
http://www.casoriacontemporaryartmuseum.com

Japan
21st Century Museum of Contemporary Art
1-2-1 Hirosaka, Kanazawa City, Ishikawa 920-8509
http://www.kanazawa21.jp/en

Contemporary Art Museum Kumamoto
2-3 Kamitoricho, Kumamoto City, 860-0845
http://www.camk.or.jp/english

Hara Museum of Contemporary Art
4-7-25 Kitashinagawa, Shinagawa-ku, Tokyo 140-0001
http://www.haramuseum.or.jp

Museum of Contemporary Art Tokyo
4-1-1 Miyoshi, Koto-ku, Tokyo 135-0022
http://www.mot-art-museum.jp/eng

Liechtenstein
Kunstmuseum
Städtle 32, 9490 Vaduz
http://www.kunstmuseum.li

Macedonia
The Contemporary Arts Center
Kurshumli An, ul. Kurchiska b.b. 1000 Skopje
http://www.scca.org.mk

Netherlands
De Pont Museum
Wilhelminapark 1, 5041 EA Tilburg
http://www.depont.nl

Groninger Museum
Museumeiland 1, 9711 ME Groningen
http://www.groningermuseum.nl/?lan=Engels

Stedelijk Museum
Post Box 75082, 1070 AB Amsterdam
http://www.stedelijkindestad.nl

Witte de With, Center for Contemporary Art
Witte de Withstraat 50, 3012 BR Rotterdam
http://www.wdw.nl

New Zealand
Centre of Contemporary Art
66 Gloucester St, Christchurch
http://www.coca.org.nz

Norway
Astrup Fearnley Museum of Modern Art
Dronningensgate 4, Oslo
http://afmuseet.no/?&language=en

Poland
Centre for Contemporary Art
Ujazdowski Castle, ul. Jazdów 2, 00-467 Warsaw
http://csw.art.pl

Portugal
Fundação de Serralves
Rua D. João de Castro, 210, 4150-417 Porto
http://www.serralves.pt

Fundação de Arte Moderna e Contemporânea – Colecção Berardo
Praça do Império, 1449-003 Lisboa
http://www.museuberardo.pt

National Museum of Contemporary Art
Museu do Chiado, Rua Serpa Pinto, 4, 1200-444 Lisbon
http://www.museudochiado-ipmuseus.pt

Puerto Rico
Museum of Contemporary Art
Edificio Histórico Rafael M. de Labra, Ave. Juan Ponce de León,
esquina Ave. Roberto H. Todd, Parada 18, Santurce
http://www.museocontemporaneopr.org

Romania
National Museum of Contemporary Art
Izvor St. 2–4, wing E4, Bucharest
http://www.mnac.ro

Serbia
Museum of Contemporary Art Belgrade
Ušće 10, blok 15, 11070 Novi Beograd
http://www.msub.org.rs

Singapore
8Q SAM
8 Queen Street, Singapore 188535

Slovakia
Moderna Galerija
Tobacna ulica 5, SI-1000 Ljubljana
http://www.mg-lj.si

Spain
Guggenheim Museum
Abandoibarra Et.2, 48001 Bilbao
http://www.guggenheim-bilbao.es/?idioma=en

Museum of Contemporary Art Barcelona
Plaça dels Angels, 1, 08001 Barcelona
http://www.macba.cat

Sweden
Bildmuseet
Umeå University, SE- 901 87
http://www.bildmuseet.umu.se

Kulturhuset
Kulturhuset, Sergels torg, Box 164 14 ,103 27 Stockholm
http://www.kulturhuset.stockholm.se

Switzerland
Centre for Contemporary Images Saint-Gervais Genève
5, rue du Temple, CH - 1201 Geneva
http://www.centreimage.ch

Kunsthalle
Helvetiaplatz 1, CH-3005 Bern
http://www.kunsthalle-bern.ch/en

Turkey
Istanbul Contemporary Art Museum
Buyuk Hendek Caddesi. No:21 Kuledibi, Istanbul 34420
http://istanbulmuseum.org

Proje4L / Elgiz Museum of Contemporary Art
Meydan Sokak Beybi Giz Plaz B Blok, Maslak 34398 Istanbul
http://www.elgizmuseum.org

United Kingdom
Arnolfini
16 Narrow Quay, Bristol BS1 4QA
http://www.arnolfini.org.uk

Baltic Centre for Contemporary Art
Gateshead Quays, South Shore Road, Gateshead NE8 3BA
http://www.balticmill.com

Centre for Contemporary Arts
350 Sauchiehall Street, Glasgow G2 3JD
http://cca-glasgow.com

Cornerhouse
70 Oxford Street, Manchester M1 5NH
http://www.cornerhouse.org

Hayward Gallery
Southbank Centre, Belvedere Road, London SE1 8XX
http://www.southbankcentre.co.uk/visual-arts

Ikon Gallery
1 Oozells Square, Brindleyplace, Birmingham B1 2HS
http://www.ikon-gallery.co.uk

Institute of Contemporary Arts
The Mall, London SW1Y 5AH
http://www.ica.org.uk

Modern Art Oxford
30 Pembroke Street, Oxford OX1 1BP
http://www.modernartoxford.org.uk

The New Art Gallery
Gallery Square, Walsall WS2 8LG
http://www.artatwalsall.org.uk

The Photographer's Gallery
16–18 Ramillies Street, London, W1F 7LW
http://www.photonet.org.uk

Saatchi Gallery
Duke of York's HQ, King's Road, London SW3 4SQ
http://www.saatchi-gallery.co.uk

Serpentine Gallery
Kensington Gardens, London W2 3XA
http://www.serpentinegallery.org

Tate Modern
Bankside, London SE1 9TG
and
Tate Britain
Millbank, London SW1P 4RG
http://www.tate.org.uk

Whitechapel Art Gallery
77–82 Whitechapel High Street, London E1 7QX
http://www.whitechapelgallery.org

White Cube
48 Hoxton Square, London N1 6PB
and
25–26 Mason's Yard, London SW1Y 6BU
http://www.whitecube.com

United States
The Aldrich Contemporary Art Museum
258 Main Street, Ridgefield, Connecticut 06877
http://www.aldrichat.org

Art Space
50 Orange Street, New Haven Connecticut 06510
http://www.artspacenh.org

Atlanta Contemporary Art Center
535 Means Street, NW, Atlanta, Georgia 30318
http://www.thecontemporary.org

Boulder Museum of Contemporary Art
1750 13th Street, Boulder, Colorado 80302
http://www.bmoca.org

Center on Contemporary Art
6413 Seaview Avenue NW, Seattle, Washington 98107
http://www.cocaseattle.org

Contemporary Art Museum St Louis
3750 Washington Boulevard, St. Louis, Missouri 63108
http://www.contemporarystl.org

Contemporary Art Center of Virginia
2200 Parks Avenue, Virginia Beach, Virginia 23451
http://www.cacv.org

Contemporary Arts Center
900 Camp Street, New Orleans, Louisiana 70130
http://www.cacno.org

Contemporary Arts Center
Lois & Richard Rosenthal Center for Contemporary Art
44 East Sixth Street, Cincinnati, Ohio 45202
http://www.contemporaryartscenter.org

Contemporary Arts Museum Houston
5216 Montrose Boulevard, Houston, Texas 77006-6598
http://www.camh.org

Contemporary Museum
100 W. Centre Street, Baltimore, Maryland 21201
http://www.contemporary.org

The Contemporary Museum Honolulu
2411 Makiki Heights Drive, Honolulu, Hawaii 96822
http://www.tcmhi.org

Delaware Center for the Contemporary Arts
200 South Madison Street, Wilmington, Delaware 19801
http://www.thedcca.org

Electronic Arts Intermix
535 West 22nd Street, 5th floor, New York, NY 10011-1119
http://www.eai.org

Exit Art
475 Tenth Avenue, New York 10018
http://www.exitart.org

Indianapolis Museum of Contemporary Art
340 N. Senate Avenue, Indianapolis, Indiana 46204
http://www.indymoca.org

Institute of Contemporary Art
100 Northern Avenue, Boston, Massachusetts 02210
http://www.icaboston.org

Kemper Museum of Contemporary Art
4420 Warwick Boulevard, Kansas City, Missouri 64111
http://www.kemperart.org

Madison Museum of Contemporary Art
227 State Street, Madison, Wisconsin 53703
http://www.mmoca.org

Mattress Factory
500 Sampsonia Way, Pittsburgh, Pennsylvania 15212.4444
http://www.mattress.org

Massachusetts Museum of Contemporary Art
1040 Mass MoCA Way, North Adams, Massachusetts 01247
http://www.massmoca.org

Museum of Contemporary Art
220 East Chicago Avenue, Chicago, Illinois 60611
http://www.mcachicago.org

Museum of Contemporary Art
8501 Carnegie Avenue, Cleveland, Ohio 44106
http://www.mocacleveland.org

Museum of Contemporary Art
1485 Delgany, Denver, Colorado 80202
http://www.mcadenver.org

Museum of Contemporary Art Detroit
4454 Woodward Avenue, Detroit, Michigan 48201
http://www.mocadetroit.org

Museum of Contemporary Art
333 North Laura Street, Jacksonville, Florida 32202
http://www.mocajacksonville.org

Museum of Contemporary Art
250 South Grand Avenue, Los Angeles, California 90012
and
The Geffen Contemporary at MoCA
152 North Central Avenue, Los Angeles, California 90013
and
MoCA Pacific Design Center
8687 Melrose Avenue, West Hollywood, CA 90069
http://www.moca.org

Museum of Contemporary Art
770 NE 15 Street, North Miami, Florida 33161
http://www.mocanomi.org

Museum of Contemporary Art San Diego
700 Prospect Street, La Jolla, California 92037-4291
and
1100 & 1001 Kettner Boulevard, San Diego, CA 92101
http://www.mcasd.org

New Museum of Contemporary Art
235 Bowery, New York 10002
http://www.newmuseum.org

P.S.1 Contemporary Art Center
22–25 Jackson Avenue, Long Island City, New York 11101
http://www.ps1.org

Rochester Art Center
40 Civic Center Drive SE, Rochester, Minnesota 55904
http://www.rochesterartcenter.org

Roq La Rue Gallery
2312 2nd Avenue, Seattle, Washington 98121
http://www.roqlarue.com

The Renaissance Society (University of Chicago)
5811 S. Ellis Avenue, Bergman Gallery, Cobb Hall 418, Chicago,
Illinois 60637
http://www.renaissancesociety.org

San Francisco Museum of Modern Art
151 Third Street, San Francisco, California 94103 USA
http://www.sfmoma.org

Scottsdale Museum of Contemporary Art
7374 East Second Street, Scottsdale, Arizona 85251
http://www.smoca.org

SITE Santa Fe
1606 Paseo de Peralta, Santa Fe, New Mexico 87501
http://www.sitesantafe.org

Solomon R. Guggenheim Museum
1071 Fifth Avenue, New York 10128-0173
http://www.guggenheim.org

Southeastern Center for Contemporary Art
750 Marguerite Drive, Winston-Salem, North Carolina 27106
http://www.secca.org

Walker Art Center
1750 Hennepin, Minneapolis, Minnesota 55403
http://www.walkerart.org

Urban Institute for Contemporary Arts
41 Sheldon Boulevard SE, Grand Rapids Michigan 49503
http://www.uica.org

Whitney Museum of American Art
Madison Ave at 75th Street, New York
http://whitney.org

For lists of other galleries that display contemporary art refer to:

http://en.wikipedia.org/wiki/Category:Contemporary art galleries
http://en.wikipedia.org/wiki/Museum of Contemporary Art
http://witcombe.sbc.edu/ARTHcontemporary.html

FINDING OUT MORE ABOUT CONTEMPORARY ART: MAGAZINES AND JOURNALS

Magazines and journals devoted to contemporary art often provide more recent and up to date information than books. Most magazines can be bought on subscription, at art museums and galleries, or larger newsagents. Some of the magazines are also available on line; some are only available online. In some cases you will have to pay a subscription.

We have listed only English language titles or those where a translation into English is available, and the following list is not exhaustive.

Aesthetica
PO Box 371, York, YO23 1WL, UK
http://www.aestheticamagazine.com

Afterall
Central Saint Martins College of Art and Design, 107–109 Charing Cross Road, London WC2H 0DU, United Kingdom
and
California Institute of the Arts, 24700 McBean Parkway, Valencia CA 91355-2397, USA
http://www.afterall.org

A-N Magazine
First Floor, 7–15 Pink Lane, Newcastle upon Tyne NE1 5DW, UK
http://www.a-n.co.uk

Artforum
350 Seventh Avenue, New York, NY 10001 USA
http://www.artforum.com

Artillery
PO Box 26234, Los Angeles, California 90026, USA
http://artillerymag.com

Art in America
575 Broadway, New York, NY 10012, USA
http://www.artinamericamagazine.com

Art Margins. Contemporary Central and Eastern European Culture
University of California, Santa Barbara, Santa Barbarba, CA 92106, USA
http://www.artmargins.com

Art Monthly
4th Floor, 28 Charing Cross Road, London WC2H 0DB, UK
http://www.artmonthly.co.uk

Artnews
48 West 38th Street, New York, NY 10018, USA
http://www.artnewsonline.com

The Art Newspaper
70 South Lambeth Road, London SW8 1RL, UK
and
594 Broadway, Suite 406, New York, NY 10012, USA
http://www.theartnewspaper.com

Art Papers
1083 Austin Ave Suite 206, Atlanta, Georgia 30307, USA
http://www.artpapers.org

Art Press
8, rue François Villon, 75015 Paris, France
http://www.art-press.fr

Art Review
1 Sekforde Street, London EC1R 0BE, UK
http://www.artreview.com

Coagula Art Journal
http://coagula.com

Flash Art
Via Carlo Farini 68, 20159 Milano, Italy
http://www.flashartonline.com

Frieze
81 Rivington Street, London EC2A 3AY, UK
http://www.frieze.com

Journal of Contemporary Art
http://www.jca-online.com

The Jackdaw
93 Clissold Crescent, London N16 9AS, UK
http://www.thejackdaw.co.uk

Londonart
24 Deepdene Road, London SE5 8EG, UK
http://www.londonart.co.uk

Magnus
http://www.magnusmagazine.co.uk

Modern Painters
http://www.modernpainters.co.uk

Museo
http://www.museomagazine.com

New York Arts Magazine
473 Broadway, 7th Floor, New York, NY 10013, USA
http://www.nyartsmagazine.com

Parallel
PO Box 34, Sempahore, Australia 5019
http://www.va.com.au/parallel/x1

Postmedia
http://www.postmedia.net

Studio International
PO Box 1545, New York, NY 10021-0043, USA
and
PO Box 14718, St Andrews, Scotland KY16 9RZ, UK
http://www.studio-international.co.uk

Tate Etc.
Tate, Millbank, London SW1P 4RG, UK
http://www.tate.org.uk/magazine

X-TRA
PO Box 41437, Los Angeles, CA 90041, USA
http://www.x-traonline.org

FIND OUT MORE ABOUT CONTEMPORARY ART: WEBSITES

There are many websites devoted to contemporary art, ranging
from commercial sites to useful databases. We have listed some of
the more valuable sites, which provide information and links.

http://artfacts.net
A database for modern and contemporary art galleries and artists.

http://www.artist-info.com
Essentially a site for buying and selling modern and contemporary
art, with information about artists and their galleries.

http://www.axisweb.org
A site devoted to British artists and curators working today.

http://www.digitalconsciousness.com
Information about artists and galleries.

http://www.saatchi-gallery.co.uk
The site has a comprehensive database of contemporary artists,
galleries, dealers, art fairs, colleges and museums.

http://www.the-artists.org
A database for information about modern and contemporary
artists with links to related sites.

http://www.zeroland.co.nz
Describes itself as: 'Visual arts, performing arts and literature:
authoritative, premier (and often entertaining) web pages from
around the world.' In fact, it is a major resource, providing
thousands of links to other sites. On the home page, click on
'contemporary art' and go from there.

FINDING OUT MORE ABOUT CONTEMPORARY ARTISTS: BOOKS

A number of books offer both broad and comprehensive information about contemporary artists.

Phaidon Press
Regent's Wharf, All Saints Street, London N1 9PA, UK
http://www.phaidon.com
The 'Contemporary Artists' series, published by Phaidon Press Limited.
Each book is devoted to an individual artist and includes a critical essay examining the artist's career, a focus text on one key work, an interview with the artist and numerous images of their work.
To date, there are 56 titles in the series.
The 'Cream' series: surveys of international contemporary artists:
Fresh Cream, Phaidon, 1998
Cream 3, Phaidon, 2003
Sergio Edelsztein *et al.*, Ice Cream: Contemporary Art in Culture, Phaidon, 2007

Taschen
Hohenzollernring 53, D-50672 Cologne, Germany
http://www.taschen.com
To date, Taschen publishers have produced three volumes of *Art Now*, illustrated directories of hundreds of contemporary artists with short biographies, exhibition histories and bibliographical information. Volumes 1 and 2 are edited by Uta Grosenick, Volume 3 by Hans Werner Holzwarth.

Thames and Hudson
181 A High Holborn, London WC1V 7QX
http://www.thamesandhudson.com
Thames and Hudson publish and distribute a wide range of art and design books, including a number on aspects of contemporary art.

Claudia Albertini, *Avatars and Antiheroes: A Guide to Contemporary Chinese Artists*, Kodansha Europe, 2008

Rebecca Fortnum, *Contemporary British Women Artists: In Their Own Words*, I.B. Tauris, 2006

Amrita Jhavrevi, *101: A Guide to 101 Modern and Contemporary Indian Artists*, India Book House, 2005

Linda Weintraub, *Making Contemporary Art. How Today's Artists Think and Work*, Thames and Hudson, 2003

MORE INFORMATION ON BUYING: ART WEBSITES

In recent years specialist websites have been established to cater for buyers looking to purchase art online, whether original art works, reproductions, prints or associated merchandise.

Websites like Artchive (http://www.artchive.com), Art.com (http://www.artnet.com), World Wide Art Resources (http://wwar.com) and Artinfo (http://www.artinfo.com) provide information on artists, images and galleries with some comment and evaluation.

There is a very wide range of art sites showing work for sale, which keyword searches will find. Some recent and more established examples are: Newbloodart.com – art online in various media, including paintings, prints and photographs, with prices starting at £50. Established by Sarah Ryan, a former art teacher, the site hosts work by up and coming artists. Eyestorm.com and Galleryonline.com – these cater to more established artists.

If work by a particular artist catches your attention, try and do some research on where they have exhibited, or what their work usually sells for. For example, art data sites like Artnet, Artprice and Art Sales Index provide information on sales records and auction prices by artist, which enables useful price comparisons. Sites like Gabrius also enable fairly sophisticated and customized searches, depending on the area of interest or the extent of market detail required. Although coverage across sites inevitably varies,

consulting several can be a useful way of gauging general prices and relative interest among buyers across different types of art.

Search engines also provide information on galleries, directories of images and biographical information which can be useful for research and general interest. The major Internet providers of search facilities are Altavista (http://www. altavista.com); Microsoft Windows Live Search (http://www.live.com); Google (http://www.google.co.uk) and Yahoo (http://www.yahoo.com). Using a relevant keyword with your search engine will get you started, although experimenting with different word combinations (and comparing search engine results) will refine or expand the information fields which are shown to you.

However, as with any service provider, be aware that commercial relationships and sponsorships will usually determine what sites are shown and how they are presented. One further point to note is that although the World Wide Web (www) is a tremendous information resource, it is also an unregulated and open forum with all the benefits and problems this raises. If you are researching contemporary art on the web, whether for personal interest or investment purposes, be sure to cross-check and verify factual information from other sites, or external sources of information.

References

BOOKS

Throughout *Understand Contemporary Art*, the authors have made reference to texts, essays and articles, some of which have been reprinted in the anthology *Art in Theory, 1900–2000*, edited by the late Charles Harrison and his Open University colleague Paul Wood. This book has been described as an 'archaeology of modernism' because it provides the most incisive and comprehensive anthology of its kind, tracing twentieth-century ideas, debates and interventions. It is a clear and helpful introduction to many of the other texts noted here and is an excellent reference archive.

Banksy, *Wall and Piece*, Century, 2006

John Berger, *Ways of Seeing*, Penguin Books, 1977 rev. edn

Claire Bishop, *Installation Art: A Critical History*, Tate Publishing, 2005

Louisa Buck, *Moving Targets: A User's Guide to British Art Now*, Tate Publishing, 1998

Peter Bürger, *Theory of the Avant-garde*, University of Minnesota Press, 1984

Paul Celan: Poems, trans. Michael Hamburger, Carcanet New Press, 1980

Documenta 11, exhibition catalogue, Hatje Kantz, 2002

Francis Frascina and Jonathan Harris (eds), *Art in Modern Culture. An Anthology of Critical Texts*, Phaidon Press, 1992

Jason Gaiger and Paul Wood (eds), *Art of the Twentieth Century: A Reader*, Yale University Press, 2003

James Hall, *Hall's Dictionary of Signs & Symbols,* 2nd rev. edn, John Murray, 1996

Charles Harrison and Paul Wood, with Jason Gaiger (eds), *Art in Theory, 1815–1900: An Anthology of Changing Ideas*, Blackwell, 1998

Charles Harrison and Paul Wood (eds), *Art in Theory, 1900–2000: An Anthology of Changing Ideas,* Blackwell, 2003

Michael Heizer *et al., Michael Heizer: Sculpture in Reverse*, Museum of Contemporary Art, Los Angeles, 1984

Hannah Higgins, *Fluxus Experience*, University of California Press, 2002

Sarah Kent, *Shark Infested Waters: The Saatchi Collection of British Art in the 90s*, Philip Wilson Publishers Ltd, 1994

Rosalind Krauss, 'Sculpture in the Expanded Field', in *The Originality of the Avant-garde and Other Modernist Myths*, MIT Press 1986

Helen Luckett, *Walking in My Mind*, exhibition guide, Hayward Gallery, 2009

Maurice Merleau-Ponty, *The Phenomenology of Perception*, Routledge, 1998

Sandy Nairne, *State of the Art: Ideas and Images in the 1980s*, Chatto and Windus and Channel 4 Television Company, 1987

Richard Nelson and Richard Schiff (eds), *Critical Terms for Art History*, University of Chicago Press, 1996

Mignon Nixon and Cindy Nemser, *Eva Hesse (October Files)*, MIT Press, 2002

Jill O'Bryan, *Carnal Art: Orlan's Refacing*, University of Minnesota Press, 2005

Sophie Phoca and Rebecca Wright, *Introducing Postfeminism*, Icon Books, 1999

Carolee Schneeman, Imagining *Her Erotics: Essays, Interviews, Projects*, MIT Press 2002

Julian Stallabrass, *High Art Lite: British Art in the 1990s*, Verso Books, 1999

Jaime Stapleton, Text commentary on Juan Bolivar, *New British Painting*, Cornerhouse Publications, 2004

Kristine Stiles and Peter Selz (eds), *Theories and Documents of Contemporary Art: A Sourcebook of Artists' Writings*, University of California Press, 1996

NEWSPAPERS

Tim Adams, *The Observer*, 14 June 2009

Paul Arendt, 'Orgies and battles promised at Paul McCarthy's pirate theme park', *The Guardian*, 27 September 2005

Lucy Bannerman, *The Times*, 25 October, 2007

J. Dickie, *The Independent on Sunday*, 20 October, 2002

Jonathan Glancey, 'Magic to Stir Men's Blood', *The Guardian*, 12 December 2002

Nick Hackworth, *Times Review*, 25 June 2005

Tom Horan, 'The Olympics of the Art World', *Daily Telegraph*, 28 June 2004

Robert Hughes, 'That's Showbusiness', *The Guardian*, 30 June 2004

Jonathan Jones, an interview with Jake and Dinos Chapman, *The Guardian*, 31 March 2003

Sean O'Hagan, 'Bono and Hirst Head Art Sale to Fight Aids', *The Observer*, 3 February 2008

BROADCASTS

Front Row, BBC Radio 4, 14 December 2006

Newsnight Review, BBC2, 15 December 2006

WEBSITES

www.aleksandramir.info

Robert Ayers, 'Jeff Koons', *Artinfo*, 25 April 2008 (www.artinfo.com)

www.britishcouncil.org
ecva.org/exhibition/Gifts2009/Dolamore.htm
http://www.magazines.documenta.de/ geschichteo. html?&L=1
http://www.quotationspage.com/quote
http://www.saatchi-gallery.co.uk/artists/jenny_saville.htm
www.tate.org.uk
http://www. thisistomorrow2.com
www.tonidove.com
www.tracey-emin.co.uk

http://www.tract-liveart.co.uk (originally published as Jean Wainwright, 'An Interview with Mark Wallinger', *Audio Arts Magazine*, vol. 19, nos 3 and 4, 2001)

Index

Page numbers in *bold italic* are for illustrations

abjection, *194–7*

Abramovic, Marina, *Balkan Baroque*, *56–7*, 70, 83, 206

abstract art, *3–4*, 87–8

Abstract Impressionism, 24

Acconci, Vito, *Seedbed*, *32, 33, 136, 137*

advertising, *114*, 223–4

aesthetics, 2, 40–1

anti-Modernism, 27–9

art, concepts of, 5–9, 68–9, 104–5, 214–15

art fairs, 246–7

art market *see* awards; buying art; galleries

auction houses, 175, 238–40

authorship, 74–5, 92

autonomy, aesthetic, 40–1

avant-garde, 14, 21–3, 28, 88–9, 135–6, 148, 153
 and politics, 199–200
 see also historical avant-garde; neo-avant-garde

awards, 247–9

Baltic Centre, *234*, 245

Banksy, *Yellow Line Flower*, 75, *166*, 167–9, 174, 208–9, 226

Barney, Matthew, *Cremaster*, 48–9, 117, 220–1, *pl.3*

Barthes, Roland, 74–5

Baudrillard, Jean, 76–7

Beuys, Joseph, *36–7*, 38, 100, 141

Bijl, Guillaume, 228–9

Bourriaud, Nicolas, 162–3

Breitz, Candice, *Mother and Father*, 120–1

Broomberg, Adam, 113–14

Bürger, Peter, 22, 23, 37–8, 135, 136, 151–2

Burgin, Victor, *What does possession mean to you?*, 61, *62*, 70, 111–13, 114, 186–8, 223–4

buying art, 232–41, 243–4

canons, 86

Caro, Anthony, *Early One Morning*, *3–4*, *4*, 17, 22, 29–30, 34–5, 70, 100

Cattelan, Maurizio, *La Nona Ora*, 70, 101, 155–8, 161, *pl.7*

celebrity, 64–5, 226–7

Chanarin, Oliver, 113–14

Chapman, Jake and Dinos, *Great Deeds Against the Dead*, 101, 203, *204*, 205

collaborations, 91–2

collectors, 175, 233–8

combines, 25, 26

commodification, 64–6, 142, 232–5

consumer culture, *47–52, 219, 223–30*

contemporary art
 meanings of, *8–9*
 origins of, *12–23, 90, 98, 104, 116–17*

Courchesne, Luc, *The Visitor, 129–30*

creativity, and authorship, *92*

cultural contexts *see* socio-cultural contexts

De Stijl, *87–8*

deconstruction, *68*

Deller, Jeremy, *The Battle of Orgreave, 58–60, 69*

Derrida, Jacques, *68–9*

difference, *209–17*

digital media, *128–9*

Doig, Peter, *The Architect's Home in the Ravine, 2–3, 9, 96, 110, pl.11*

Dolamore, Mark, *The Pyramid Art, 96–8, pl.16*

Dove, Toni, *Spectropia, 130*

Duchamp, Marcel, *2, 52, 100, 153*

early modernism, *44–7, 90, 98, 105, 148*

environment art, *165–79, 207–8*

environments, *30*

exhibitions, *174–5, 234–6*

family resemblance, *5*

fauvism, 44–5

feminist issues, *138–40*

film, *48–9, 58–9, 116–19, 220–1*

Fluxus, *38, 118*

Foster, Hal, *40–1*

Foucault, Michel, *71–2*

Fried, Michael, *20, 89, 159*

Fukuyama, Francis, *206*

galleries, ***234***, *244–6*

gender/sex, *72–4, 185–94*

genres, *182*
 see also film; installation; painting; performance art; photography; sculpture; socio-cultural contexts

Gilbert and George, *141, 142*

globalization, *209–17, 232–3*

Goldsworthy, Andy, *Hanging Tree, 169–71,* ***170***

Gordon, Douglas, *24 Hour Psycho, 119, 120*

Gormley, Anthony, *Angel of the North, 176–8*

Goya, Francisco, *203–5*

graffiti, *168, 178–9, 207–9*

Greenberg, Clement, *16, 17–18, 20, 24, 25, 28, 88–90, 241*

Group 2, *92*
 see also This is Tomorrow

Gursky, A., *107, 109, 228*

Hamilton, Richard, *27, 46, 90–2, 99–101, 218–19*

happenings, *30, 136–7*
 see also performance art

Hazoumé, Romuald, *Dream, 53–4, 75, 163–4, 213–14, 216, pl.4*

high (elite) art
 photography as, *109–10*
 and popular culture, *48–52, 117, 125–6, 220–1*

Hirschborn, Thomas,
 Cavemanman, 146, 161
Hirst, Damien, *Mother and Child,
 Divided*, 154–5, 161, pl.9
historical avant-garde, 22, 23, 38,
 152, 153
Holzer, Jenny, *Survival
 Series*, 225–6
Hume, Gary, *Hermaphrodite
 Polar Bear*, 9, 95–6, 183, 184,
 211–12, pl.12
Hunter, R., 141–2, 143
hybrids, 92, 99–100, 179
hyperreality, 77

iconography, 53–60
iconology, 53–60
installation, 100–1, 146–65, 177,
 178
 video, 126–8, **127**
Institutional Theory, 5–8
institutions of power, 71–2
interactive works, 128, 129–30
intertextuality, 74
Ivekovic, Sanja, *Poppy Field*,
 55–6, 78, 201–2, pl.5

Judd, Donald, *Untitled*, 34–5, 100,
 158–9

Kiefer, Anselm, *Your Golden Hair,
 Margarete*, 75–6, 84–5, 86, 183,
 184, 200–1, 202, pl.8
kitsch, 28
Koons, Jeff, *New Hoover
 Convertibles*, 49–52, **50**, 70,
 77–8, 100, 226–7

Krauss, Rosalind, 35–6, 99
Kruger, B., 189, 224, 226

land art, 170–9, 207–8
late modernism, 13–14, 19, 21
Latham, John, 31, 32, 33
Lyotard, J-F., 69–70, 203

Man Ray, *Gift*, 6–7, **6**, 15, 17, 19,
 22–3, 38
Manzoni, Piero, 31, 32, 33
mass media, 47, 47–52, 218–23
McCarthy, Paul, *Caribbean
 Pirates*, 126–8, **127**, 144,
 221–2
McHale, John, 27, 46, 90–2,
 99–101, 218–19
medium specific, 25–7
Merleau-Ponty, M., 159–60
metanarratives, 70, 203
mimesis, 2–3, 5
Minimalism, 34–5, 100, 158–9
Mir, Aleksandra, *Daily News*,
 222–3
mixed media, 90–2
modern, 9, 14–16, 18
modernism, 13, 14, 18
 see also early modernism;
 late modernism
Modernism, 16–18, 19, 20
 challenges to, 24–39, 46,
 137, 159, 220
Modernist canon, 20, 87–9
Mondrian, Piet, 88
monetary values, 60–7, 174–5,
 210, 227–9
 buying art, 232–41

neo-avant-garde, *23, 24–39, 105, 117, 118, 136, 152*
Neshat, Shirin, *Rebellious Silence, 72–4,* **73**, *183, 184, 191–2, 215–16*

objectivity, *108*
Oldenburg, Claes
 Snapshots from the City, 30, 136, 137
 The Store, 29–30, 31, 101
online buying, *240–1*
O'Reilly, Kira,
 inthewrongplaceness, 132–4, 142, 143
originality
 and authorship, *74–5*
 and uniqueness, *61–3, 107, 111–13*
Orlan, *Omnipresence, 139, 140, 143*
Oursler, Tony, *128*

Paik, Nam June, *Participation TV, 118, 130*
paint medium, *85–6*
painters, Modernist, *20, 87–9*
painting(s), *81, 83–98*
 early modern, *44–5, 90*
 and photography, *105, 106–7, 109–11*
patronage, *241–4*
performance art, *30, 36, 56–8, 132–44*
Perry, Grayson, *Golden Ghosts, 83, 195–7,* **196**
philosophy, *68–78*
photography, *104–15, 193–4*

Piper, A., *141, 142, 143*
politics, *36–8, 53–60, 198–217, 222–3*
Pollock, Jackson, *24*
Pop Art, *28–9, 92, 219, 220*
popular culture, *28–9, 47*
 and high art, *48–52, 117, 125–6, 220*
 and the media, *218–23*
post-colonialism, *210*
post-conceptual art, *93*
postmodernism, *13, 14, 18–19*
prizes, art, *247–8*
Pryor, Angus, *The Deluge, 94–5, pl.15*

Quinn, Marc, *Self, 101–2, pl.6*

Rae, Fiona, *Night Vision, 9, 93–5, pl.14*
Rauschenberg, R., *25, 26*
reality, *76–8*
recordings, *143–4*
regeneration, *175–6, 178, 245–6*
Rose, Barbara, *35*

Schneemann, Carolee, *Interior Scroll, 138, 140, 142*
sculpture, *82, 98–102, 158–9*
 abstract, *3–4, 34–6*
 large, *176–8*
sex/gender, *72–4, 185–94*
Sherman, Cindy, *Untitled (No. 224), 106–7, 108, 109, 110, 189–90, pl.10*
Shiraga, Kazuo, *Challenging Mud, 30, 136, 137*

Shopping exhibition, 228–9
signs, interpreting, 40–1
simulation, 76–8
Situationist International
 (SI), 38, 208
socio-cultural contexts, 44–78, 182
 access to art, 245–6
 early modernist, 44–7, 90,
 98, 105, 148
 gender and sex, 188
 installation, 152, 153
 land art, 173, 174–8
 performance art, 136, 137–8
 photography, 112–14
 see also consumer culture;
 monetary values;
 philosophical contexts;
 politics
sponsorship, 66–7, 242–3
street art, *166*, 167–9, 175, 178–9,
 207–9
subjectivity, 108
symbolism, 53
synchronicity, 97

television, 47, 117–18
theatre, 135
This is Tomorrow, 27–8, 46, 90–2,
 99–101, 218–19

uniqueness, 61–3, 107, 111–13

van Doesburg, Theo, *Counter
 Composition XIII*, 3–4, 15, 17, 19,
 22, 41, 86–8, pl.1
video, 119–28
viewer engagement, *1*, 128,
 129–30, 140
 gender and sex, 188–9, 191
 installation, 151, 157, 159–64
 signs and aesthetic
 autonomy, 40–1
 see also installation;
 performance art
Viola, Bill, *Emergence*, 124–5
Voelcker, John, 27, 46, 90–2,
 99–101, 218–19
Vostell, Wolf, 118

Walking in My Mind, 146–7
Wallinger, Mark, *Threshold to the
 Kingdom*, 121–3
war art, 201–5, 221–2
Warhol, Andy, 52, 219
Whistler, James M., 60–1
Wilke, Hannah, *Hello Boys*,
 138–9, 140
Wilson, Richard, *20/50*, 147–50,
 161, pl.13
Witkin, Joel-Peter, *The Three
 Graces*, 114–15, 193–4

Zhang Huan, 141, 143